Color Workbook

Second Edition

Becky Koenig

Illustrated by Becky Koenig

PEARSON

Prentice Hall

Upper Saddle River, New Jersey 07458

Library of Congress Cataloging-in-Publication Data

Koenig, Becky.
 Color workbook / Becky Koenig ; illustrated by Becky Koenig. — 2nd ed.
 p. cm.
 Includes bibliographical references and index.
 ISBN 0-13-195577-2
 1. Color. 2. Color in art. I. Title.

QC495.K75 2006
701'.85—dc22

2006016478

Editor-in-Chief: Sarah Touborg
Senior Acquisitions Editor: Amber Mackey
Editorial Assistant: Carla Worner
Director of Marketing: Brandy Dawson
VP, Director of Production and Manufacturing: Barbara Kittle
Senior Managing Editor, Production: Lisa Iarkowski
Production Liaison: Harriet Tellem
Manufacturing Manager: Nick Sklitsis
Manufacturing Buyer: Sherry Lewis
Cover Design: Bruce Kenselaar
Cover Illustration/Photo: *The Light Inside,* 1999. Painting by James Turrell, American, b. 1943.
 © The Museum of Fine Arts, Houston; commission, gift of Isabel B. and Wallace S. Wilson.
Imaging Specialist: Corin Skidds
Manager Rights and Permissions: Zina Arabia
Image Permission Coordinator: Debbie Latronica
Manager, Cover Visual Research and Permissions: Karen Sanatar
Cover Image Coordinator: Cathy Mazzucca
Composition: Pine Tree Compostion, Inc.
Full-Service Project Management: Karen Berry, Pine Tree Compostion, Inc.
Printer/Binder: Courier, Kendallville, IN
Cover Printer: Phoenix Color Corporation

To my father, James R. Koenig, who introduced me to the world of color and my mother, Catherine Catanzaro Koenig, who taught me how to teach, work, and listen.

Credits and acknowledgments borrowed from other sources and reproduced, with permission, in this textbook appear on appropriate page within text.

Pearson Education Ltd., London
Pearson Education Singapore, Pte. Ltd
Pearson Education, Canada. Ltd
Pearson Education—Japan
Pearson Education Australia PTY, Limited

Pearson Education North Asia Ltd
Pearson Educación de Mexico, S.A. de C.V.
Pearson Education Malaysia, Pte. Ltd
Pearson Education, Upper Saddle River, New Jersey

10 9 8 7 6 5 4 3 2 1
ISBN 0-13-195577-2

Brief Contents

Contents

Preface

Color is at the center of our strongest sense, vision. Color, in nature, influences our daily lives through our visual sensory input of skies, flowers, trees, stones, and water. Color is a product of the light that we experience in the course of days and seasons: cloudy, overcast, wintry, hot and steamy, sunny, clear and cool.

We replicate and reflect the colors of nature through our art, architecture, clothing design, graphic design, and functional objects. Color guides our preferences in both appreciation of aesthetic objects and also the purchase of functional items for our daily living: cars, color inside our homes, clothing, and food.

Color is both a physical and an emotional human phenomenon. We respond to color because of its associations. We each have our personal preferences for particular color combinations. Our experience of the world is in some ways characterized by our observation of color: a green apple, a red sports car, the pink sky of a sunset, the blue of a robin's egg. These colors evoke not only an outward experience but also form colors in our memory, our inner eye. Color is not simply a decorative element in art, but a part of our inner consciousness. Color is life enhancing.

For the artist and designer, color has the deepest complexity of any art element as well as being the most powerful and visually compelling formal and emotional factor in art creation. Color can soothe, disturb, express personality or culture, suggest or reflect reality, convey light or dark moods and emotions. Our personal color preferences may be rooted in our life experience, the collective unconscious, our physical surroundings, and our instincts. Color is unique among the art elements because it crosses the boundaries between art and science. Some of the information presented here may seem scientific to the student of art, but this is an essential link between contemporary art, design practice, and electronic technology. The scientific and technical content of this book also enhances a fuller understanding of color phenomena.

Color study is an undertaught yet ever-evolving field. There is now more color in our lives than ever before. More publications are produced in color, due to color copiers and computer printers. Web design is viewed in illuminated color. There are also more color choices available to the artist than ever before, new color media and pigments along with the capability of a computer to produce 16 million colors. Due to technology, the arena of color in art and design has virtually exploded. The role of color in art and design calls for a high degree of color knowledge for every artist and designer.

Color study is a misunderstood area of art. Artists often harbor preconceptions about color, either as a simple concept or a subject that is overly complex. Color study is often viewed as knowledge that hinders or inhibits the instinctive use of color. This is emphatically untrue. The study of color cultivates an innovative approach to color and helps us to

avoid color selections chosen in a simplistic manner from the computer swatch palette or directly out of a tube of paint.

Why another book on color? During my twelve years of teaching color theory, I used various texts, most of which only covered portions of color and design information that was useful to students. This led to my decision to put together a text myself. I wanted to represent color theory in a coherent manner and focus on the impact of color upon formal design. The color study activities in this text have been developed over years of teaching color theory in an ongoing pursuit to formulate experiential color study for students. In recent years, I have combined both formal and content-oriented approaches to color with students, allowing them to use color both technically and as an expressive tool. This new edition of *Color Workbook* includes more computer activities on the technical side and more creative, thoughtful activities for the study of color as well.

In this book, Part One is a complete color-study section, covering color basics, color theory and systems, attributes of color, color materials, and computer color. In Part One, color is addressed as an entity independent of composition. Part Two pertains to design, compositional theory, and the role of color in design, concept, and art. The two parts are meant to form a systematic journey for the student through color and design knowledge.

A primary factor in color and design knowledge is to allow students the experience of putting theory into practice. Hands-on study in color and design is invaluable. We cannot learn to be artists by simply listening to lectures or reading books. The point of the chapter activities is to make design and color theory accessible to all students.

This text can also serve as a self-guided tour of color for a dedicated student or artist. Even a sampling of the activities would be extremely helpful to a student's understanding of color. *Color Workbook* provides a broad base of knowledge that demystifies the complex world of color.

Becky Koenig
University at Buffalo, Buffalo, New York

Acknowledgments

Assembling this book has been a process enhanced by both professional and personal support.

I would like to thank Bud Therien, the editor for the first edition, for his patience, understanding, and belief in this project. The editor for the second edition, Amber Mackey, has also been very helpful and understanding. Keri Molinari at Prentice Hall and the production editor, Karen Berry at Pine Tree Composition, are greatly appreciated for their expertise and patience.

I would also like to thank the following reviewers for their critical input into the first edition: Douglas Latta, Oral Roberts University; Ken Burchett, The University of Central Arkansas; and Richard C. Green, Eastern Arizona College.

I appreciate the support and cooperation of the Adobe® Corporation for permission to use screen captures and for its invaluable software. I also wish to thank Pantone® for its color system and permission to use its product name. My thanks also go to Color Aid® Corporation for its great product and for permission to use its name.

Thanks to the administrations at both Villa Maria College and the University at Buffalo for the use of student works. Specific colleagues at both institutions have been very supportive, particularly Associate Professor Brian Duffy at Villa and Professors David Schirm and Adele Henderson at the University at Buffalo. Thank you also to my colleagues at the University at Buffalo Department of Visual Studies for all your support for this second edition.

The role of my students in this book cannot be overstated. Many of the illustrations from this book are the result of my students' hard work and dedication. My gratitude is extended to all of my students, at both Villa Maria College and currently at the University at Buffalo, who inspired and graciously contributed to this book. This book would not have been possible without you.

Last, I would like to thank my friends and family for their patience and unwavering support through this project. Thanks to Mary Mullet Flynn, Wendy Maloney, Barbara Baird, Deborah Swiatek, and my dear sister Karen Koenig and brother David Koenig, for their support and enthusiasm from the beginning. David Koenig also did some of the photography and has been solidly behind me in many ways throughout this project. Thank you to my cousins Valerie Colangelo, Maria Waldmiller, and Nina Jablonski and her husband George Chaplin for their support and input on this whole process. I am appreciative for the encouragement of my entire extended family as well.

My love of art, painting, and color started with my wonderful parents, Catherine Catanzaro Koenig and James R. Koenig, both fine artists. My mother was always understanding and supportive of my hard work, and this book is dedicated to the memory

of both her and my father and the immeasurable gifts that they gave to me throughout my life.

My love and thanks to my children, Kate and Sean, who have been remarkably patient and supportive of their preoccupied mother. Special thanks to my daughter Catherine Emery, who has spent time as an editor for the second edition. My special love and thanks go to my dear husband, George Emery, who has been both a sounding board and editor, and whose encouragement and love have helped to bring this idea into being.

Notes on Materials

There are some basic materials necessary to execute the color and design studies in this book. There are four main types of activities in this book: color studies, design studies in neutral colors, color design studies, and computer studies. A range of materials is needed for each type of study.

COLOR STUDY AND DESIGN MATERIALS:

Acrylic or gouache paints as follows:

Yellow: Cadmium Yellow Light or Hansa Yellow or Spectrum Yellow

Orange: Cadmium Orange or Orange Lake

Red: Cadmium Red Medium or Permanent Red or Napthol Red, and Magenta or Quincridone Red

Violet: Dioxizine Purple or Permanent Violet or Spectrum Violet

Blue: Cobalt Blue or Brilliant Blue, and Ultramarine Blue

Green: Permanent Green Light or Green Medium and Viridian Green

White: Titanium White or Zinc White

Black: Ivory Black

Note that there are many more pigment color choices than are included here. Sometimes several versions of a color are necessary. For instance, both Permanent Red and Magenta are needed to mix a full range of colors. For a more complete hue and pigment list see Chapter 5.

Brushes as follows:

Rounds: #2 and #7 or #8

Flats: 1/4″ and 1/2″ widths

Note: Short-handled watercolor brushes work best for the studies and nylon fiber is more affordable than sable.

Illustration board and good quality drawing paper

Color Aid® Paper Pack

Miscellaneous supplies as follows:

Drafting and clear frosted tape

Knife and extra blades

Glue stick and/or rubber cement
Ruler
Grid paper
Trace paper
Metal ruler

NEUTRAL COLOR MEDIA FOR DESIGN STUDIES:

Fine- and medium-tip black markers
Variety of drawing pencils
India ink and dip pens
Charcoal and graphite sticks
Erasers

COMPUTER MEDIA:

Computer setup with printer
Graphic drawing and/or painting program
Manual for specific graphic program
CDs or flash drive for graphic file storage

These supplies should cover the needs for most of the activities in this book. To understand the nature of color, at least some of the chapter end studies should be executed.

Chapter 1
The Nature of Color
Color Physics and Perception

INTRODUCTION

Color truly exists in the eye of the beholder. Color is a human experience generated collectively by the eye and the brain. In the concepts of both light and substance, the art and science of color are completely interconnected.

The first half of this book is devoted to color study. *Color study* is an objective examination of the many aspects and attributes of color. It encompasses information about color and the process of assimilating color knowledge through direct experience. Each chapter contains activities that facilitate the student's hands-on experience of color study and enhance the information in the text. Factual knowledge of color frees the student to manipulate color in either a formal or instinctive fashion. The study of color exists in the arenas of both visual art (aesthetics) and science (physics). For artists, groundwork in the physics of color is essential for the comprehension of color phenomena and color perception.

Color has three important aspects. Color's *physical aspect* pertains to color physics and perception, covered in this chapter. The *psychological aspect* of color encompasses color psychology, expressive color, and color intuition, covered in Chapter 11. The *chemical aspect* of color refers to color media (traditional media: pigments, dyes, and inks, or electronic media: computers and video, discussed in Chapters 5 and 6).

The nature of color is based on three basic concepts: color perception (how we receive color information), the relationship of color and light (additive color), and physical colored substances (subtractive color). *Additive color* is the color system of light and color perception. Color is defined as a component of light; light is how our eye receives color information. *Subtractive color* is the system of surface color and colored substances. The subtractive color system describes the way light reflects from and is absorbed into colored surfaces. Subtractive color also pertains to the physical colors of pigments, inks, and dyes and how colors are affected in the mixtures of these substances.

Of these three basic concepts, the interrelationship of color and light to colored physical surfaces and materials can be the most problematic for art students. Because artists traditionally use the physical substances of color, namely, paints, inks, dyes, and colored surfaces, they find it difficult to conceptualize color as light (additive color). The science of color and light seems to exist outside the realm of traditional art materials. However, computer art and web graphics have caused the additive color system to become the essential alternate color vocabulary for artists working in electronic media.

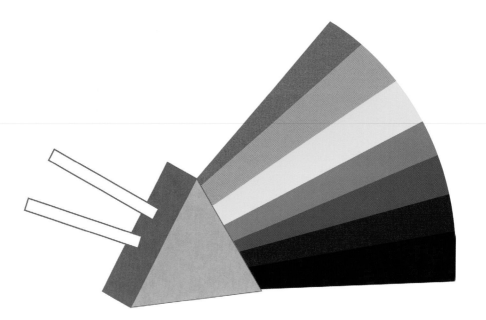

Figure 1–1 In 1676, Newton's experiment proved that color is a component of light. The seven distinct colors produced by the refraction of white light by a prism are called spectral hues: red, orange, yellow, green, blue, indigo, and violet.

COLOR PHYSICS

Color physics is the science of color. Color has been explored, systematized, and interpreted throughout human history. Isaac Newton (1642–1727), the English mathematician and physicist, experienced a groundbreaking moment in his scientific exploration of color in 1676. In 1676, Newton projected white sunlight through a prism and a spectrum of colors was cast onto a white surface. [1.1] This color spectrum appeared because a prism *refracts* light, bending the light rays and sorting the colors of white light into their individual wavelengths. Newton then projected the spectrum back through a prism to re-form white light. From this seminal experiment, Newton concluded that the refraction of white light proved that the individual components of white light are separate colors called *hues.* Newton's experiment definitively illustrated that color was a property of light and he concluded that light was composed of seven distinct hues: red, orange, yellow, green, blue, indigo, and violet. [1.2] In 1704 Newton published *Opticks,* in which he detailed his optical light theories in a complete volume. Newton's discoveries, which are now taken for granted, were controversial in their time. The experiments of Newton led to the current definition of *color* as a visual sensation caused by the components of light either transmitted or reflected to the receptors in our eye.

By refraction, the components of light were identified by Newton as seven separate hues, which are called *spectral hues, or prismatic hues.* We are perhaps most familiar with the spectrum in the form of a rainbow. A rainbow appears in the sky as an ordered band

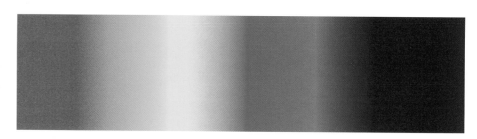

Figure 1–2 The color spectrum as it appears when white light is refracted; the hues gradate into each other.

of spectral hues refracted from sunlight by water droplets in the atmosphere. Newton chose the seven hues in the spectral band to correlate with the notes in a musical scale, one of the many analogies made between color and music that recur throughout the history of color. Newton added the color purple (red-violet) to the spectrum to connect the spectral band to itself, thereby forming a continuous color circle. [1.3] He formulated the color circle as a scientific device to illuminate relationships between the spectral hues.

Electromagnetic Spectrum

As the continuation of the study of light and color continued, the white light containing all of the spectral hues was found to be a very small part of the *electromagnetic spectrum.* [1.4] James Clerk Maxwell (1831–1879), a Scottish physicist, presented the theory of electromagnetic waves in the 1860s. Maxwell theorized that visible light was an electromagnetic phenomenon. Wavelengths of light (color) are radiant energy that originates in sunlight. The electromagnetic spectrum represents the energy waves produced by the oscillation of an electric charge. Unlike other types of energy transmission, such as conduction and convection, electromagnetic waves do not need any material for heat transmission. Both light and radio waves can pass through space at great distances and allow us, for example, to be able to perceive the light from a star. Electromagnetic waves are arranged in a spectrum that organizes waves of high frequency (short wavelengths) to those of low frequency (long wavelengths). The electromagnetic spectrum ranges from gamma rays to radio wavelengths as shown. The visible light spectrum is a small portion of the electromagnetic spectrum that we can actually see. "Infra" and "ultra" prefixes signify the

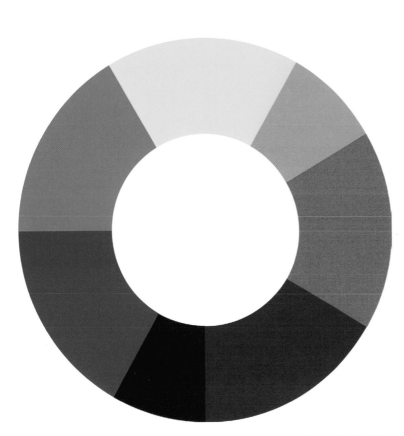

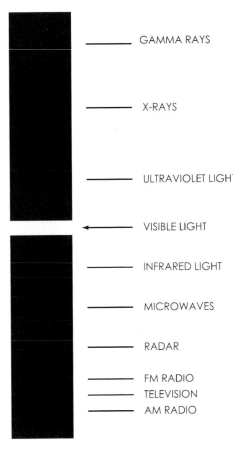

Figure 1–3 Newton attached the spectrum to itself to form a color circle. He added purple (red-violet) as an intermediate hue between red and violet.

Figure 1–4 Of the entire electromagnetic spectrum, the only section that is visible to humans is the area of visible light, which includes the spectrum and color wavelengths.

wavelengths of the electromagnetic spectrum that are out of our visual range or capacity to see, such as ultraviolet light.

Within the visible spectrum, each hue is individually defined by a specific wavelength. The wavelengths of light are measured in nanometers that are only one-billionth of a meter. Each hue is visually unique due to variations in tiny measurements between the crests of each wavelength. Red has the longest wavelength and violet the shortest wavelength. Within each hue, we can also see subtle differences, such as a red that is more orange, or a yellow that is greener. White light, theoretically, is all seven spectral hues in equal balance.

PRIMARY COLORS OF LIGHT

The visible light spectrum represents the light that we see and all the hue wavelengths. Of the seven Newtonian hues of the light spectrum, there are three primary colors or essential hues that are necessary to form the full spectrum. *Primary hues* are hues that are the components of all the other hues and form all the colors that we see. There are three primary colors for the formation of light, which are distinct from the three primary colors of paints: the *traditional pigment primaries* of red, yellow, and blue. James Clerk Maxwell identified the three *primaries of light* to be red, green, and blue, which we refer to as RGB. Maxwell based his theories, called the trichromatic theory, on the earlier research of Thomas Young (1773–1829) and Hermann Helmholtz (1821–1894). Young, a British physician, had proved that all colors were generated from the three spectral hues of red, green, and blue. [1.5] Helmholtz, a German physiologist and physicist, later expanded upon Young's ideas, and the two theories synthesized to form the Young-Helmholtz three-component theory. The three light primaries were determined to be the colors necessary to form all colors that we see because the color receptors in our eye correlate with these primaries. Maxwell presented the RGB additive perceptual hues in a color triangle. [1.6] The remaining spectral hues—yellow, orange, indigo, and violet—represent various intermixtures of RGB.

ADDITIVE COLOR SYSTEM

The *additive color system* is the color system relevant to colored light and our physiological color perception. Because light is the source of all colors, the additive system is the basis for all other color systems. When we see white, all the hue wavelengths are reflected

Figure 1–5 The primaries of light are red, green, and blue, or RGB. Notice that the primary red is a red-orange and the primary blue is almost violet.

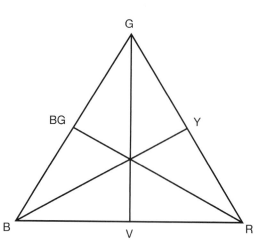

Figure 1–6 James Clerk Maxwell identified the three light or additive primaries as RGB and designed a triangle to demonstrate how they create all the colors.

Figure 1–7 The additive primaries, RGB, form white light when mixed together as colored spotlights. Mixtures of the additive primaries form secondary hues of cyan (blue), magenta (red), and yellow. The secondary hues of light are close to the primaries of pigment, and they are the primaries of process color.

or *added* together, hence the term *additive color.* This concept correlates with Newton's recombination of the spectrum to form white light. In the additive system, when colored light is mixed, it becomes lighter and closer to white. For example, if the three light primaries, red, green, and blue spotlights are overlapped, the result is white light as shown. [1.7] Thus:

$$Red + Blue + Green = White$$

In the trichromatic (meaning three-color) theory of light, RGB are the three source colors that combine to form all the other colors. Each additive light primary has its own character: The light primary red is rather red-orange, the light primary blue is quite blue-violet, and the light primary green is a slightly bluish green.

The surfaces of colored objects either reflect or absorb one or more of the wavelengths of light. Understanding how RGB wavelengths either reflect off or are absorbed into colored surfaces clarifies the relationship between color and light. For example, we perceive a red surface because a red wavelength is the only light primary that is reflected back to our eye. The other light primaries, the green and blue wavelengths, are absorbed into the red (appearing) surface. The chemical makeup or colorant of the red surface causes the phenomena of absorption and reflection to occur. This illustration displays how light reflection and absorption causes us to perceive red, green, blue, as well as black and white. [1.8] White reflects all of the primaries, which re-form into white light. Black reflects no light (all colors are absorbed), so we see a visual void, which is black.

Figure 1–8 This illustration shows the primaries of light either reflected from or absorbed into colored surfaces, causing us to see color. When we see green, for example, both the red and blue light wavelengths are absorbed. The only wavelength reflected is green, which is received by the color receptors in our eyes. With white surfaces, all the primaries are reflected; with black, none are reflected.

The additive primaries of RGB mix to create secondary hues. *Secondary hues* are defined as the mixture of two primary hues. The secondary hues of the additive system, cyan (blue), magenta (red), and yellow, are similar to the traditional primary hues of pigment, which we know as red, yellow, and blue. Cyan (C), magenta (M), and yellow (Y) are also process colors known as CMY. Process colors are the standard colors used in the four-color printing process and color photography. Process colors (CMY), together with black, create many of the colors we see in printed media. The light primaries mix to create cyan, magenta, yellow, and white as follows:

Blue + Green = Cyan
Red + Green = Yellow
Red + Blue = Magenta
Red + Blue + Green = White

The primaries of light, RGB, can be presented in an additive color circle with their secondaries placed between them to indicate additive color mixtures. [1.9]

COLOR PERCEPTION

Color is a uniquely human experience. We see color because our eyes are sensitive to a particular section of electromagnetic energy called the visible spectrum. A surprising aspect of color theory is that color actually is an illusion caused by reception of light wavelengths by our eye, which form colors in our brain. For example, the yellow of a lemon is not a property of the lemon skin itself, but is due to a lemon's capacity to absorb and reflect specific spectral elements from light, which our eye perceives as yellow. Yellow light, which is reflected off a lemon, is an example of residual light, since it represents only a portion (the red and green wavelengths) of white light. Residual light is an information transmitter rather than a color. A color exists only if there is a person or animal to receive the light/color information being transmitted. Light rays are messengers of color information to our eye.

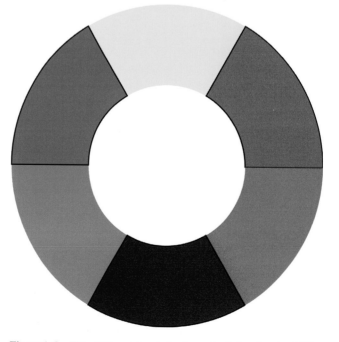

Figure 1–9 The additive color circle shows the light primaries RGB (outlined) in a circle format with the light secondary hues CMY, indicating how they mix.

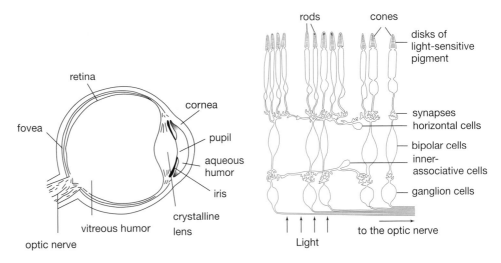

Figure 1–10 Color Perception. Our eye takes in color information through retinal cones, which have RGB receptors.

How do we receive light information to see a color? The human eye has two different types of color receptor cells. Rods are cells that help us perceive light/dark (value) differences and lighting strength, particularly in dim lighting situations. Cone cells are at the heart of our color perception. Cone cells selectively respond to specific colors. There are three types of cones: red cones, green cones, and blue cones. [1.10] Each cone type is thus receptive to each of the additive or light primaries (RGB). Obviously, a green cone is stimulated by green light to produce the sensation of green in our brain. However, cones also work together in combination to produce all of the colors that we perceive. For example, as yellow light stimulates both red and green cones, the optic nerve transmits this information, and RG combine to form a yellow image in the brain. Cones are receptive to RGB hues but are only active in adequate light. For this reason, it is difficult to discern hue differences at low levels of light.

Lack of green or red cones can cause difficulty in the ability to distinguish between greens, yellows, oranges, and reds. This is called red–green color blindness. Color blindness is almost exclusively found in males since color genes are linked to the female X chromosome.

Visual information that we receive is broken into dots or patterns. It is then re-formed in duplicate in our brain. We can also "see" a color mentally with our eyes closed during dreams, migraines, meditation, and the like. Factors that influence color perception include the following:

- The amount and quality of lighting on colored surfaces: natural or artificial, the level of light (as determined by the time of day and the weather), and so on.
- Our visual health, the condition of color blindness, and so on.
- The surface quality of the colored object itself: Is it light, solid, or textured?
- Color relationships: How is the color affected by its surroundings?

Since color is a property of light, we need light for color perception. The type and quantity of light greatly affects our color perception, as any given color will appear to change under varying lighting conditions. The same color in sunlight, in half-darkened rooms, under fluorescent light, or in light from northern- or southern-facing windows will all create different color sensations. Depending on the time of day, light can vary in color temperature. Morning and evening light tends to have red or orange wavelengths, whereas midday sunlight is a cooler light. This can cause walls of the same color facing in different directions to visually appear to change in hue, value, and/or color intensity

dependent on the light at that time. [1.11] Many artists have made a study of varied color effects based on time of day or season.

Lighting is also a critical factor in an artist's studio. Incandescent light is warm, and fluorescent light is cool. Southern light is too changeable and warm in the Northern Hemisphere, so north-facing window light is preferred. Southern light is the preferred light in the Southern Hemisphere.

ADDITIVE COLOR MEDIA

The importance of the additive system to artists has increased substantially over the course of recent years. Additive color used to be an interesting introductory concept that was put aside as students worked with traditional art materials. Today, artists and designers must understand additive color because of its pervasive uses in video, electronic media, and lighting. Primary applications of the additive system of colored light are television, computer graphics, web design, holography, and stage lighting. The additive color circle is also integral to photography, both film and digital.

Stage lighting utilizes colored light on colored surfaces to achieve dramatic and atmospheric effects. A lighting technician must understand the additive system to predict the effects of colored lights in combinations and their usage on various colored stage sets. Overlapping RGB spots will create a white spotlight. When a red light, for example, shines on a green area of a set, the resulting color is black. [1.12] We see black because the red wavelength is absorbed by the green surface, and there is no green light wavelength in the red spotlight to reflect green back to our eye.

Television color is generated from the three additive light primaries. Television uses tiny dots of projected RGB-colored light that visually mix to form a wide array of colors. Cathode ray tubes are equipped with electron guns that project RGB dots onto the surface of the screen in varying proportions to produce colors and movement. Projected RGB light is fed through a mesh of dots or stripes to form a pattern on the inside of the screen. If we

Figure 1–11 Quality and amount of light affect color. Note that the same surfaces appear to be different colors in light and shadow areas.

Figure 1–12 When a red light is directed onto a green surface, there is no green wavelength in the light to reflect, so the resulting color is black.

hold a magnifying glass to the surface of a television screen, we can see an elaborate configuration of RGB dots.

Computer display monitors are capable of a much wider range of colors than television screens. Computer color is also composed of combinations of RGB hues. The computer "thinks" in the additive RGB system when it creates or selects colors. The RGB system in a computer mixes colors in an additive manner and can be an aid in our comprehension of additive color mixing.

SUBTRACTIVE COLOR SYSTEM

While the additive color system pertains to intermixtures of light itself, *subtractive colors* are opaque surfaces that reflect light, rather than being source colors, such as light itself. The subtractive color system refers to surface colors and the physical colors of pigments, inks, or dyes. Subtractive color is defined as both the process by which we see colored surfaces as well as the way traditional colored materials are mixed together. The *subtractive color system* describes the way light reflects from or absorbs into the colored surfaces of objects. For this reason, pigment colors or colored objects are considered second-hand colors. In the subtractive system, as hues combine, light waves are absorbed or "subtracted" resulting in a reduction of the amount of light reflected to our eyes. The reduction of reflected light subtracts from the color intensity that we, in turn, perceive.

Subtractive color is an indication of the way that physical colors subtract intensity from each other when mixed together. The traditional way to alter or control colored surfaces is to use pigmented materials. As strange as this may seem to the artist, traditional colored media such as paint, inks, and dyes are not in themselves colored. The colored substances of art merely serve to reflect a specific colored light wavelength to our eye. Objects appear to be varied colors due to their differences in spectral composition and their ability to reflect light. Our brain creates the sensation of color by the absorption or reflection of light waves off colored materials to create color sensations on our retina.

Surface color reflects or absorbs one or a combination of the three light primaries, RGB as shown in Figure 1-8.

Subtractive Primary Colors

The subtractive system is the basis for the system of traditional pigment primary hues, red, yellow, and blue and the process primaries, cyan, magenta, and yellow. [1.13] There are subtractive primaries that apply to two different types of media. The *traditional subtractive pigment primaries* for paints, inks, and dyes are red, yellow, and blue, or RYB. The *subtractive process primaries,* used in process printing, photography, and computer printing, are cyan, magenta, and yellow, or CMY.

The German poet Johann Wolfgang von Goethe (1749–1832) developed a color theory based on subtractive color surface perception and traditional pigment mixtures. The original intent of Goethe's color theory was to refute Newton's theories of color/light optics. Goethe identified the color primaries as red, yellow, and blue. He formed primary and secondary hues into both a color circle and triangular configuration. [1.14] Goethe's theories filled the gap between art and science that began with the theories of Newton. In the artist's perspective at the time, Newton's theories of light and color seemed to be unusable to artists engaged with pigment manipulation. Thus, there is a seeming disparity between additive light (color sensation) and subtractive surfaces (physical pigmented surfaces).

Secondary subtractive colors are the mixtures of two primary colors. Both sets of subtractive primaries, RYB and CMY, mix to create secondary hues (different from the secondary hues of light). The *subtractive secondary hues* are green, orange, and violet as displayed on the two principal subtractive color circles: the *traditional pigment color circle* [1.15] and the *process color circle.* [1.16] Color circles are visual guides to color; one

Figure 1–13 Top: Cyan, magenta, and yellow are secondary hues of the light (additive) system; they are also known as the process primaries of the subtractive system. Bottom: The traditional pigment (subtractive) primary hues are red, yellow, and blue.

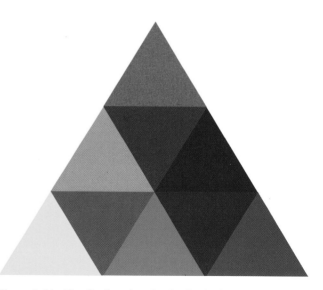

Figure 1–14 The Goethe color triangle. Goethe formulated a triangular configuration of the subtractive primaries to indicate the secondary colors and complementary mixtures in areas beween the primary and secondary hues.

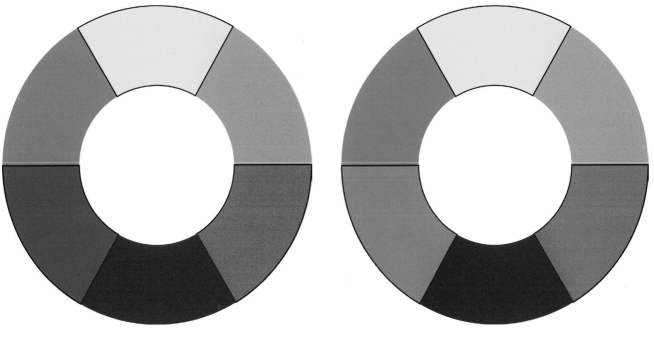

Figure 1–15 A simplified version of the traditional color circle or wheel. RYB are the pigment primaries and OGV are the secondary hues mixed from combinations of the primary hues.

Figure 1–16 Process Circle. A subtractive process color circle, in which the primary hues of CMY are outlined. The process colors also mix to create the secondary hues of orange, green, and violet.

of their functions is to demonstrate how primary colors mix to make secondary colors. Subtractive primary hues mix to form secondary hues as follows:

Pigment Primary to Secondary	Process Primary to Secondary
Red + Yellow = Orange	Magenta + Yellow = Orange
Blue + Yellow = Green	Cyan + Yellow = Green
Blue + Red = Violet	Cyan + Magenta = Violet

In mixtures of paints or dyes, subtractive colors lose intensity because the light wavelengths reflected to our eye are decreased or subtracted. For example, when red and green pigments are mixed, the two hues tend to cancel each other out, forming a brown or gray. The mixture of all three subtractive primaries, RYB or CMY, creates a void, black, in which no light wavelengths are reflected. [1.17]

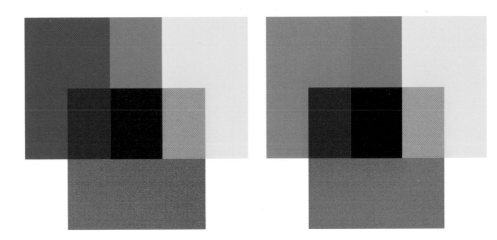

Figure 1–17 The subtractive primaries, RYB or CMY when mixed, form black, since no color wavelengths are reflected to our eye.

Theoretically, in paint, all the known colors can be generated from three subtractive primaries of RYB. In reality, pigments are rather unpredictable, which makes it a challenge to mix all the spectral colors from the three primary hues. Several versions of the primaries are needed to mix "clean" secondary colors, or secondary colors can be purchased ready-made. Painters can obtain a much wider range of color without the limitations of only RYB pigments.

THE RELATIONSHIP OF ADDITIVE AND SUBTRACTIVE COLOR

The seeming incompatibility of the additive and subtractive color systems is precisely what confuses many color-study students. The relationship between additive and subtractive color systems, however, is a clear inverse relationship. This integral relationship is as follows: The additive primaries (RGB) of light form cyan (blue), magenta (red), and yellow, the secondaries of the additive light system, which are also the process primaries of the subtractive color system. The relationship between the additive and subtractive colors can be clarified by the placement of hues on the color circles. A comparison of the additive color circle with the subtractive color circle will aid the student in the transition from one color system to another. (See 1.9 and 1.16.)

Artists and designers should be able to comprehend and control both functional systems of color: additive (of light) and subtractive (of surface color and pigments). Often this causes confusion in the modes of color mixtures. Process colors (CMY) and the traditional pigment colors (RYB) mix with each other, for instance, in a manner that completely opposes the additive system. We know that the RYB primaries, when mixed together, will produce a black or gray. The theoretical RGB light mixtures directly oppose our experience of mixing paint as we know that paint colors of red, green, and blue, when mixed together, would not produce white as they do when RGB lights are mixed. On computer, however, RGB is being mixed for every illuminated color that we see on screen.

For consistency, a major portion of this book is founded on the traditional color circle. In discussions of photographic and electronic color, however, we must shift to the additive RGB color circle. Color printing and photography use the process primaries CMY to create a wide array of colors. The CMY mode on computers re-creates this process. Cyan, magenta, and yellow on the computer can be manipulated by percentage or by sliders to form a huge range of colors.

Figure 1–18 Additive Complements. Complementary colors are directly across the color circle from each other. Additive complements affect how we see colored surfaces, since complements absorb the light wavelengths of each other.

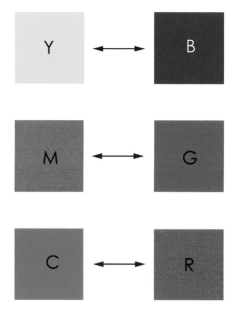

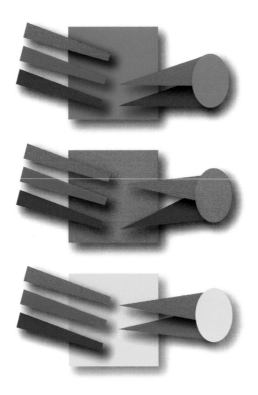

Figure 1–19 This illustrates how we see subtractive surface color of CMY. The RGB light primaries are either reflected or absorbed in varied combinations to give us the appearance of cyan, magenta, or yellow.

COMPLEMENTARY COLORS

In color study, the concept of color opposites or complements is significant. This relationship is particularly important to the phenomenon of subtractive color. *Complementary pairs* are composed of two hues located directly across from each other on the color circle. Refer to the additive color circle [1.9] to find the *additive complementary hues*. [1.18] In additive color the complementary pairs are as follows:

> Yellow—Blue
> Magenta—Green
> Cyan—Red

A complementary relationship in color is that of two opposite components that complete each other in a type of color balance. For instance, a yellow and blue complementary pair from the additive color circle represents the hue primaries as follows: yellow (red and green) opposite or opposing blue. In this manner, all three light primaries are represented in each pair of additive (light) complements. The same principle holds true for the subtractive complementary pairs.

Additive complementary hue pairs absorb each other, blue absorbs yellow light, red absorbs cyan light, and green absorbs magenta light, and each combination also absorbs in reverse, as shown below. The chart shown here [1.19] illustrates how complementary absorption and subtraction allows us to see the secondary colors of light. For example, the red light complement of cyan causes red to be absorbed into a cyan surface. Blue and green light primaries are reflected from this surface to create the appearance of cyan.

Thus we see CMY hues due to additive complements as shown below:

> Cyan absorbs red light — reflects blue and green light (C)
> Magenta absorbs green light — reflects red and blue light (M)
> Yellow absorbs blue light— reflects green and red light (Y)

Figure 1–20 In the photo of an apple, there are many more red variations than in our symbolic image of an apple.

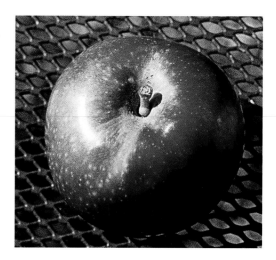

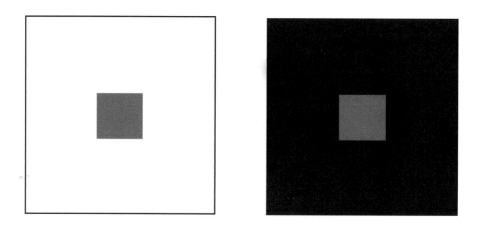

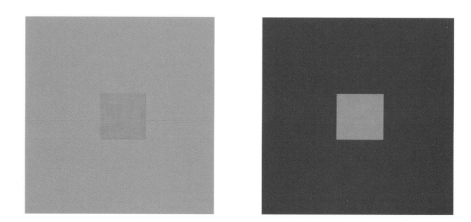

Figure 1–21 Color displays varied appearances depending on its surroundings. Notice the different look of the blue and red in each color environment. This is called relative color or color interaction.

LOCAL AND RELATIVE COLOR

Local color is the general color of an object under normal lighting (daylight or white light) conditions. Local color is a simple method of color perception and interpretation of a colored surface. For example, the sky is blue, an apple is red, and a lemon is yellow. Our mind tends to generalize color for object identification. For example, we know that an apple is red even in a dimly lit room because of our color memory. However, in reality, a single apple consists of many different reds or can appear to be magenta or purple, dependent on lighting. [1.20] Lighting, surrounding color highlights, and shadow areas all cause the reds in an apple to form many variations on red. The surface quality of an object can also influence color perception. Is the observed object emitting light, like a computer or video? Does an object have a matte or glossy surface? Is it highly textured or reflective? These are all factors in color perception.

Colors are also perceived in context. In reality, we rarely see a color isolated on its own. Even if we see color against a neutral color, such as black, white, or gray, that color is affected by its surroundings. The red shown here on the white surface looks heavier, darker, and larger than the red on the black surface. [1.21] Red on a black surface appears to be lighter, more luminous, and smaller in scale than the same red on a white surface. When colors are presented on competitive terms with each other, more radical changes can occur. On an orange surface, a blue appears to be enhanced in color intensity. On a dark blue surface, the blue seems lighter and much less intense. Thus, our color perception is based on comparison and contrast. This concept is called relative color or *color interaction.*

The color discoveries of Isaac Newton and Johann Goethe are still pertinent today. The two approaches of optics and light (additive) and of pigments and surface color (subtractive) coexist and interrelate in color study. Both theories are conceptually correct and can be applied to either color media or color perception. The additive and subtractive systems of color are interdependent systems that determine how light and pigment mixtures are made and perceived.

ACTIVITIES

1. COLOR AND LIGHT EXPERIMENTS

Objective: The student will gain an understanding of the nature of additive color through hands-on experiments.

- Use a prism or a crystal in a window to refract light into the spectral hues.
- Experiment with colored lights; use a red-, a green-, and a blue-colored bulb to understand both additive (light) and subtractive (surface) color systems. The room must be dark for these experiments with colored light to work. Example: Shine a red light on a green surface, a green light on a red surface, a blue light on a green surface. Overlap two or all three and shine onto a white surface. What colors result from each?

2. SUBTRACTIVE COLOR STUDY

Objective: For the student to understand the subtractive process by using physical paint mixtures.

- Use process colors (cyan, magenta, and yellow) in acrylic or gouache paints.
- Mix secondary colors by mixing two primaries [1.22] magenta + yellow, yellow + cyan, and cyan + magenta. Or: Mix traditional primaries, red + blue, blue + yellow, and yellow + red. Or you can do both and compare the results. How do the secondary hues compare between the process primary mixtures and the traditional primary mixtures?
- Now mix all the primaries, CMY or RYB, in order to make a neutral. The neutral should look close to black or gray.
- You can now form them into a chart as shown. [1.17]

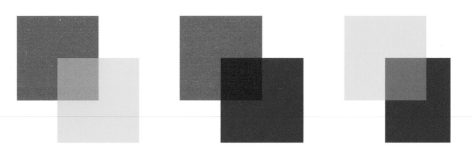

Figure 1–22 Traditional pigment primaries RYB mix to form secondary hues.

3. ADDITIVE COLOR ON COMPUTER

Objective: For the student to see how additive colors intermix. Also serves as an introduction to computer color mixing.

- On any computer graphic program go to the RGB color mode.
- Using the RGB sliders, slide red bar to 100% and green and blue to 0%. What color results? Why do you see it that way according to what you read in Chapter 1?
- Slide all bars to 100%. What color results?
- Slide all bars to an equal percentage. What color results?
- Slide R and G to 100%. What color appears?
- Slide B and G to 100%. What color appears?
- Slide R and B to 100%. What color appears?
- Try various other mixtures and try to explain them according to the information in Chapter 1.

Chapter 2
The Color Circle
and Color Systems:
An Exploration

INTRODUCTION

Throughout history, artists and scientists have studied color. Influential color theorists have been philosophers, scientists, and artists who illuminated the phenomena of color by the formulation of color circles and systems. Since the phenomenon of color is perceptual, scientific, physical, and expressive, over time color study has reached in many directions. The common thread of research by color theorists has been the attempt to organize, systematize, and associate our human experiences with color. *Color systems* are based upon a limited range of hues or principal colors that serve to organize the enormous number and variety of colors that we perceive daily.

Why is a color circle necessary to color study? First, a *color circle* or wheel organizes the spectral hues in chromatic (color) order. Second, the circle enables us to establish color relationships between the hues. Hue relationships are not readily apparent if we base color studies on the spectral color "band." Last, the circle allows us to view each hue as a separate color entity.

COLOR CIRCLES AND SYSTEMS—A BRIEF HISTORY

Color helps humans beings orient themselves to the world. Early in history, color was recognized as a concept that is independent of objects. The earliest concept of color was that of white and black: light and darkness. The first chromatic concept to be identified was red. Primitive man responded to its powerful associations with blood, fire, and the sun. The next hues were identified in this order: yellow, green, blue, orange, and brown.

Early color study was an aspect of philosophy. To philosophers, color represented one of man's ways of interacting with the world. The first documented color theorist was Pythagoras, the Greek mathematician, in approximately 500 B.C. He surmised that color existed on the surface of objects and was activated by a hot emission from our eyes. Empedocles, another Greek, concluded in 440 B.C. that energy flowed from both our eyes and the object itself to produce a color sensation. He associated colors with the four elements: fire with white, air with yellow, water with black, and earth with red. The ancient Greeks accepted the four basic elemental colors of white, black, yellow, and red as the primaries.

The Greek philosopher Aristotle (384–322 B.C.) formulated a color theory that was considered authoritative from his time through the Middle Ages. Aristotle's theory proposed that all colors were actually imperceptible mixtures of black and white; the interaction of white as light and black as darkness. His theories were based on the observation of color

Figure 2–1 Aristotle believed that all colors were the result of mixtures between white and black, or light and darkness.

in the sky throughout the course of a day, yellow at noon, changing to orange, then red, green, and finally dark blue. Aristotle envisioned the hues in a linear sequence; his seven basic hues: yellow, red, violet, green, and blue were placed between white and black. [2.1] Aristotle noted the gap between perceptual and physical color in that the hues seen in a rainbow could not be reproduced by the artist of antiquity, a notion that did not hold true as more pigments and dyes were found and developed. Another Greek, Theophratus (372–287 B.C.), concurred with Aristotle's theories but also conceptualized colors as a result of varied light sources.

Color research resumed in the Renaissance. Leone Battista Alberti (1404–1472), an Italian architect and painter, stated in his book *On Painting* that color perception was dependent on light. He also associated colors with the four elements: red–fire, blue–air, green–water and yellow–earth, which was later amended to gray for earth. [2.2] Alberti rejected Aristotle's theory that each hue was a mixture between black and white. He regarded the chromatic hues of red, yellow, green, and blue as separate from the achromatic neutrals of black, white, and gray. His color chart placed the hues in a square formation to show their interrelationship.

During the high Renaissance, the Italian painter and inventor Leonardo da Vinci (1475–1564) also sought to identify the principal colors that were the building blocks for all other colors. In his *Treatise on Painting,* published in 1651, da Vinci concluded that the

Figure 2–2 Comparisons have often been made between the hues and the four traditional elements. Alberti connected the elements with these hues, clockwise from top right: fire—red, air—blue, earth—yellow, and water—green.

principal colors were—listed in order of their importance—white (light), yellow (earth), green (water), blue (air), red (fire), and black (darkness). The impulse to equate colors with elements of our human experience of the world is a common theme in the history of color research. Yellow, green, blue, and red are today referred to as the medial primaries. [2.10]

At this point in time, a shift occured in the study and theory of color, steering it away from the province of art and philosophy and moving it toward scientific research. The English philosopher, Francis Bacon (1561–1626) introduced the inductive method in science, which encouraged scientists to prove theories by experimentation and data rather than by simple theoretical pronouncements. Using scientific data to form theories influenced all scientific research, including color studies.

Studies of light reflection and refraction were concurrent with the development of lenses for microscopes and telescopes. Rene Descartes (1596–1650), a French philosopher and mathematician, defined color as dependent on particles in light. He envisioned the speed and movements of these light particles as the cause of specific color sensations. He also came closer to an explanation of the formation of rainbows.

A Belgian Jesuit named Franciscus Aguilonius (1567–1617) created what is possibly the oldest known color system of subtractive primaries, naming the colors red, yellow, and blue. His system was presented in a linear formation similar to Aristotle's color sequence. Aguilonius also coined the term median or medial primaries.

In a text discovered in 1969, a Finnish astronomer and priest named Aron Sigfrid Forsius appears to be the creator of the first color circle. Forsius's volume on physics, dated 1611, contained the first color wheel, drawn in a sphere. It included red, blue, green, and yellow as the main hues, interacting with black, white, and gray.

Previous research on the association between color and light laid the groundwork for the discoveries of Isaac Newton (1642–1727), as discussed in Chapter 1. In addition to his discovery of the color components of light by refraction, Newton definitively identified seven spectral hues, the number chosen by his desire to correlate the hues with the musical scale. The concept of a musical scale as a parallel entity to the color spectrum denotes the ongoing history of efforts to align the senses of sight and hearing. By the refraction of light, Newton discovered the color components are red, orange, yellow, green, blue, indigo, and violet. [2.3] Newton surmised that all other colors are compounds of these spectral hues. The idea that the spectral hues can also create black and white is a theory that diametrically opposes the theories of Aristotle. Newton's other major contribution to color theory was the formation of the first widely known color circle. Since Forsius's color circle was not discovered until much later, Newton has been commonly credited with the origin of the color circle format. By adding one hue (purple or red-violet) to the spectral band, he attached the spectral band to itself in a circle [1.3]. Newton's circle represents the size of each hue in proportion to his perception of its width in the spectral band. The center of Newton's color circle is white, which is meant to indicate the additive intermixture of all the colors of light.

Artists involved in the color reproduction processes of printing and engraving made other major color discoveries. A French artist and printer, Jacques Christophe le Blon (1667–1742), discovered that careful mixing of three hues—red, yellow, and blue, along

Figure 2–3 Newton identified the seven distinct hues from the light spectrum to correspond to the notes of a musical scale.

with black—could create a large variety of colors. Today, he is considered to be an early developer of the four-color printing process used for commercially printed material. Le Blon's discoveries pointed the way to the first clear indication of the subtractive primary colors.

Moses Harris, an English engraver (1731–1785), took the discovery of the pigment/subtractive primaries one step further in his development of a color circle. In his book, *The Natural System of Colors* (1766), he depicted a detailed color circle founded on the subtractive primaries of red, yellow, and blue, which he placed in the central band of the circle. [2.4] He emphasized red, yellow, and blue as the greatest opposites of all the colors—therefore placing them at the greatest distance apart from each other on the color circle. Harris's color circle indicates tints of each hue around the outside of the circle, gradating toward the pure hues, and shades of each hue in progressive steps toward the center of the circle. His color circle indicates three primaries, which he called *prismatics* or *primitives*, three secondaries, called *mediate* or *compound* colors, and twelve tertiary hues.

Johann Wolfgang von Goethe (1749–1832), the German poet, was instrumental in the development of a subtractive color system and circle. In 1810, he published *The Theory*

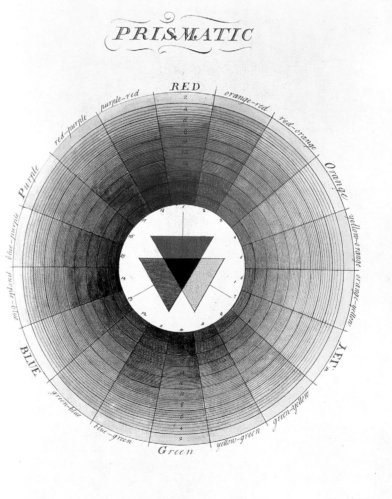

Figure 2–4 Moses Harris's wheel is based on the subtractive primaries and shows each hue tinted with white and shaded with black. From the Natural System of Colors, Collection Royal Academy of Arts, London.

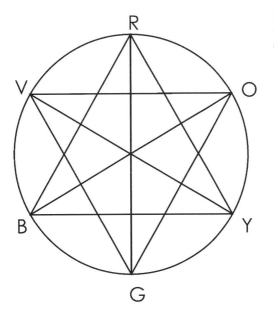

Figure 2–5 Goethe's color circle had three subtractive primaries and three secondary hues.

of Colors, a book that focused on visual phenomena such as colored shadows. He sought to bring order to the confusion of color. Goethe devised a color circle that was based on the laws of subtraction. Goethe's theories filled the gap between art and science that began with the theories of Newton. [2.5] His color concepts were meant to be in direct opposition to Newton's. In the artists' perspective at the time, Newton's theories of light and color seemed to be unusable to artists engaged with pigment manipulation. Thus, as stated in Chapter 1, there is was seeming disparity between additive light (color sensation) and subtractive surfaces (physical pigmented surfaces).

Goethe brought a subjective slant to his theories of color. He felt that blue and yellow were the hues that held the strongest contrast to each other. His obvious preference for warm hues is expressed by his description of them as "warm, lively, and exciting." Cool hues, in contrast, he considered "weak, unsettled, and yearning." Goethe was one of the few color theorists who gave attention to the use of color, materials, and methods in painting. In Goethe's theories, color was created by the interaction of light and shadow, an idea that he supported by experimentation. His color circle and triangle [1.14] clearly indicate the three primaries and three secondary hues of subtractive color.

Philip Otto Runge (1777–1810), a German painter, introduced the first spherical color system in 1810. This color sphere was the first system to take into account all three attributes of color: hue, value, and saturation. His theories were closely linked to a previous color sphere formulated by Aron Sigfrid Forsius, in 1611. The three subtractive primaries, red, yellow, and blue, and three secondary hues were included on the Runge sphere. [3.18].

Ogden Rood (1831–1902), a physicist with an interest in color, formulated a color circle based on his discoveries of precise complementary or opposing hues. He experimented with various complementary hue combinations with spinning tops to discover exact hue opposites. Color combinations that formed the most neutral grays when spinning the tops determined precise hue opposites. Rood also investigated the concept of optical mixtures. His color circle has both hue and pigment names to assist artists in finding the exact complement of each hue. Rood's theories were presented in a book titled *Modern Chromatics,* written in 1879.

Herbert E. Ives (1882–1953), a U.S. physicist, developed the hues that are now used as primary printing process colors CMY, namely cyan (syan), magenta (anchlor), and yellow (zanth). Ives's goal was to select the three hues that, when mixed, would produce the truest secondary and tertiary hues. Ives's color circle indicates the primaries as cyan,

magenta, and yellow; the secondaries as green, orange, and violet; and the tertiaries as purple, blue, blue-green, yellow-green, yellow-orange, and red. His circle was an early version of what is now known as process color circle.

Albert Munsell (1858–1918) was a highly influential U.S. color theorist whose color theories and systems are still widely in use. Munsell's major contributions to color study include a careful color notation system that became standard in the United States, Great Britain, Germany, and Japan. He developed a color circle with ten hues—five primary or "principal" hues: red, yellow, blue, green, and purple. He called his secondary hues "intermediate" hues. Munsell also developed a more extensive color circle that is comprised of 100 separate colors. Munsell emphasized the establishment of an objective color standard. His color system evolved into the development of a color "tree" that addressed all the variables of color. [3.14, 3.16]

Ewald Hering (1834–1918), a German physiologist and psychologist, was interested primarily in color perception. He established the psychological or medial primary hues as the primary colors of perception. [2.6] His color circle presented the four primary hues in equal proportion, opposing each other. Hering's color circle was the basis for the Natural Color System also known as NCS.

The German chemist Wilhelm Ostwald (1853–1932) won the Nobel Prize for chemistry in 1909. He founded his color system on the theories of Ewald Hering. Hering's theory presented the concept that three opposing pair combinations, the red-green and yellow-blue pairs from his color circle as well as black and white, result in all the visible colors. Ostwald adopted this concept and expanded upon it. He developed a highly technical approach to pigmented color. His color circle is more heavily weighted towards the cool area of blues and green than on the warm area of reds and yellows. [2.7] Ostwald also compiled a color system that was comprehensive for its time in its organization of the saturation variety of each hue.

In the more recent history of color study, the focus has been on a scientific understanding of the physics of light and color perception and on the international standardization of colors themselves. As mentioned, the Munsell system is considered standard in some countries. The Commission International D'Eclairage or CIE introduced a standard color table in 1931. The objective of this group was to formulate a Color Standard Table based on the perceptual additive primaries of red, green, and blue. Precise color matching was achieved by using a colorimeter, which measured hue, luminance (light

Figure 2–6 Hering's color circle indicated opposing hue pairs, which he felt determined perceptual color.

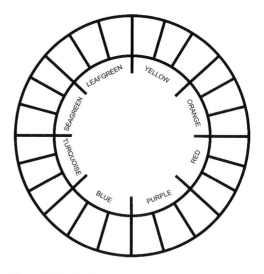

Figure 2–7 The Oswald color circle has eight main hues and it is weighted toward the cool colors.

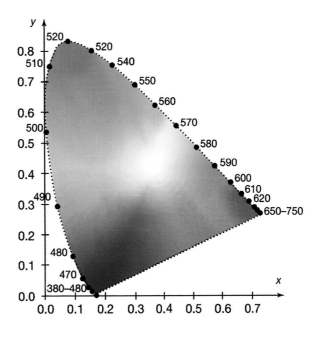

Figure 2–8 The CIE color chart is based on visual perception of color.

intensity), and saturation (purity). These three components determine the overall "chromacity" of a color. [2.8] CIE employs a mathematical formula to form color areas, providing an objective international color model. A more recent incarnation of the CIE system (1976) is called CIE L*A*B* color, a more specific color guide, designed for color standards in industry.

Frans Gerritsen is a contemporary color theorist with an interest in color perception and the history of color theory. In his book, *Evolution in Color* (1982), Gerritsen presents a chronology of historical color systems followed by a description of his own color system. Gerritson classifies all of the principal color systems into four major categories. The first of these categories is of color theory is *color ordering* between light and darkness, as in the theory of Aristotle. An *opponent or unique color system* is the second type identified by Gerritsen: color systems focused on identification of primary hues and their color opposites, as in Hering's color wheel. The third category of color theory involves the *physical mixing characteristics of colors,* as in a painter's color wheel. The fourth category includes color systems with *color perception* as the basis of their color organization, such as the theories of James Clerk Maxwell, CIE color, and Gerritsen's own color theory. Gerritsen's color theory contends that human color perception, namely RGB additive color, is the ultimate guide for all color theoretical systems.

The total research in scientific, perceptual, and artist-oriented color systems makes it difficult to select a single principal color system. No one color circle or system is technically suitable for all the aspects, dimensions, and applications of color. The history of color theory is a progression of steps toward our current color knowledge. The theory of color is ongoing, as the nature of color always leaves us with more to discover.

COLOR CIRCLES—A RATIONALE

Artists work in one or the other of two main color modes: additive or subtractive. There are three color circles that are significant for our use today: the *additive color circle,* the *subtractive process color circle,* and the *traditional color circle.* All of these color circles are functional for artists in diverse applications.

Artists and designers are primarily work and think in the subtractive color mode. The traditional color circle operates best for laws of color subtraction, which employs

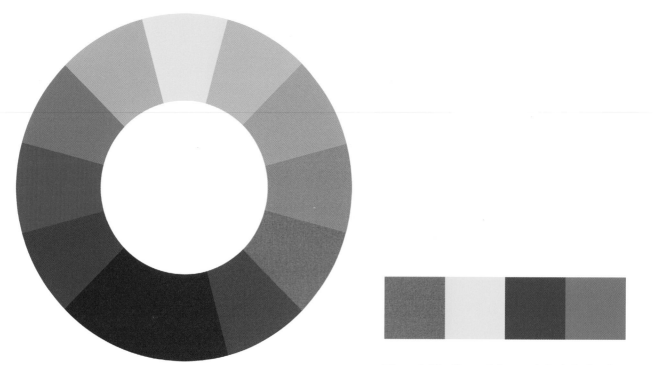

Figure 2–9 The traditional color circle has three primary hues, RYB; three secondary hues, OGV; and six tertiary hues: RO, RV, YO, YG, BV, and BG.

Figure 2–10 The medial or psychological primaries are the combined primaries of both the additive and the subtractive color systems.

artists' materials such as pigments, inks, and dyes. [2.9] Most artists use at least one type of traditional media; thus a traditional twelve-hue color circle is the rational choice for reference.

For graphic designers, the subtractive process color circle based on the primaries of CMY is the proper reference for printed color. [1.16]

The additive color circle is significant for color/light processes such as photography, the RGB mode in computer color, and color lighting. [1.9] It should be noted that the additive circle should not be used as a reference for the printing process or traditional art materials.

Because both additive and subtractive color circles serve as references for specific art processes, a larger group of colors called the *medial* or psychological primaries forms a core group of primary hues: red, yellow, green, and blue. [2.10] The *medial primaries* are colors with unique, independent hue identities, produced from the combined two groups of primaries, additive RGB and subtractive RYB. A group of four primaries instead of three slightly deviates from the traditional approach to color, but it does not prevent us from using the traditional color circle as a tool. For clarity and consistency, much of this book is based on the traditional subtractive color circle. When important for understanding a particular media, the additive circle or process circle are also used as references.

THE TRADITIONAL SUBTRACTIVE COLOR CIRCLE

The *primary hues* are subtractive colors that contain no other hues. We must have primaries to create all the other hues. The traditional color circle has three primary hues: red, yellow, and blue. The primary hues of the traditional color circle match our mental and cultural image of pure red, yellow, and blue. There are also three secondary hues: orange, green, and violet, and six tertiary hues: yellow-orange (YO), yellow-green (YG), blue-green (BG), blue-violet (BV), red-violet (RV), and red-orange (RO) to make a total of twelve hues. [2.9]

The color circle is an organizational system that permits us to perceive the unique appearance of each hue, clarifying the *chromatic* aspect of color. Johannes Itten stated that

a functional color circle should be simple enough to carry in our memory. Distinct hue characteristics of the traditional twelve-hue color circle are an essential element of a serviceable color system.

The physical layout of the traditional color circle helps us to formulate numerous relationships between the hues. The color circle is a representation of the gradual change from one hue to another. It also is a means of identifying opposite hues, neighboring hues, or hues spaced apart in relationship with other hues on the color circle.

The traditional color circle clearly portrays how the secondary and tertiary hues are produced. The primaries are placed equidistantly from each other on the circle, with yellow at the top. The secondary hues, which are the mixtures of the primaries, are placed at the halfway points between the primary hues. [2.11] These mixtures are as follows:

yellow + blue = green
red + yellow = orange
red + blue = violet

The *tertiary hues* are those produced by the mixtures between a primary and a secondary hue. [2.12] The tertiary hues are mixed as follows:

Y + G = YG
Y + O = YO
R + O = RO
R + V = RV
B + V = BV
B + G = BG

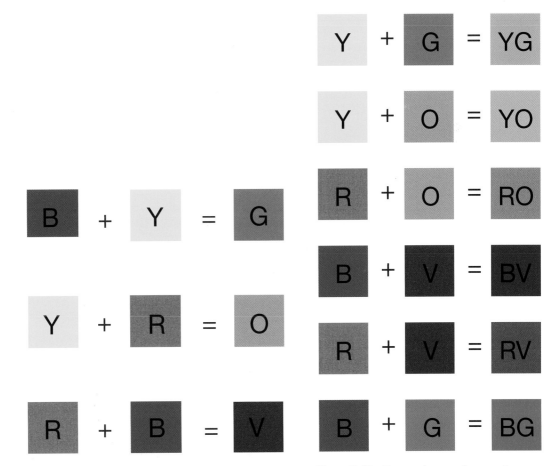

Figure 2–11 Mixtures of the traditional subtractive primary hues form secondary hues, as shown.

Figure 2–12 How a primary and a secondary hue mix to form each tertiary hue.

Tertiary hues are the visual halfway points between primary and secondary hues. Historically, color circles have had a wide variety of names for tertiary hues. In the traditional color circle, the tertiary names are easy to remember—each name is preceded with the name of the primary hue followed by the secondary hue in each mixture, such as blue-green. Often, the traditional subtractive circle is shown with a gray or black circle in the center to designate that the result of all the hues mixed together subtractively is a neutral color.

HUES—COMPONENTS OF A COLOR CIRCLE

The word *hue* is defined as either a specific wavelength from the spectrum or a color, in its pure state, from the color circle. The word *color* means a color derived from any hue; for example, violet is a hue and light violet is a color. Unlike a hue, a color is not necessarily chromatically pure. Each hue has its own characteristics that describe its visual impact. Both primary and secondary hues have qualities that vary in lightness, density, warmth, or coolness, as well as associations with reality. A brief overview of the primary and secondary hues is detailed in Table 2–1.

ACHROMATICS AND THE COLOR CIRCLE

The traditional color wheel contains no black, white, or gray. These neutral colors are considered to be *achromatic,* meaning that they contain no chroma or hue. White, black, and neutral grays define our concept of steps from light and to dark. Often white and black are not regarded as "true" colors because white is a representation of light and black represents the absence of light in the additive color system. However, in color study, achromatics are often regarded as neutral "colors" in themselves. Black, white, and grays are essential en-

Table 2–1
CHART OF PRIMARY AND SECONDARY HUES

Color	Characteristics	Temperature	Descriptive Names	Pigments
Red	Heavy in density, highly saturated, and medium in value. It is stimulating and active. Refers to blood, fire, and the sky at sunset. It seems to "glow within itself" (Kandinsky). A subtractive and an additive primary.	Warm	Scarlet, Crimson, Maroon, Flame, Burgundy	Cadmium Red, Quinacridone Red, Alizarin Crimson, Indian Red
Yellow	The lightest value hue, high saturation, low in density. Seems to emit its own light. Reflects both red and green wavelengths. A subtractive primary. Refers to the sun and activity.	Warm	Lemon, Brass, Gold, Sand, Amber	Cadmium Yellow, Hansa Yellow, Zinc Yellow, Naples Yellow, Gamboge
Blue	Medium in value and density, saturation, and weight. Quiet and restful. Refers to distance, the sky, and water. An additive and subtractive primary hue.	Cool	Sky blue, Azure, Navy blue, Indigo	Ultramarine Blue, Cobalt Blue, Cerulean Blue, Phthalo Blue, Prussian Blue
Green	Medium density, saturation, and value. Quiet and soothing. Refers to plants, trees, water, and landscape. An additive primary and a subtractive secondary hue.	Cool	Sea green, Emerald, Leaf green, Jade, Apple green, Sap green, Olive	Permanent Green, Green Earth, Viridian Green, Sap Green, Cadmium Green
Orange	Has light from yellow and glows like red. Light in value and low in density; high in saturation. Associated with warmth and assertiveness. A secondary hue.	Warm	Pumpkin, Peach, Sunset, Rust	Cadmium Orange, Cadmium Yellow Deep, Azo Yellow Orange
Violet	Darkest hue, heavy in density and weight, and medium in saturation. Dignified and rich; suggests darkness, night, and water. A secondary hue.	Cool	Mauve, Purple, Plum, Lavender	Dioxazine Purple, Manganese Violet, Cobalt Violet, Ultramarine Violet

Figure 2–13 The neutrals or achromatic colors can be seen as hue effectors. Color variations are made from combinations of neutrals and hues.

tities of value (light and dark) and are hue *effectors*. Neutrals are hue effectors because of their ability to effect or change value or saturation when mixed with any given hue. The value stages between black and white generate a series of grays called an achromatic scale. Grays are gradual steps from light to dark that connect black with white or perfect light with perfect darkness.

The achromatic scale has a distinct relationship with the color circle. The achromatic scale paired with a color circle reveals an interactive relationship between two essential components of color, hue and value (see Chapter 3). Chromatic hues that are mixed with achromatic colors are a common starting point for a large array of color variations. [2.13]

HUE CONTRAST

The strongest type of color contrast is value contrast, pure white to pure black. However, spectral hues also have a characteristic ability to contrast. In chromatic hues, the strongest contrast is between the subtractive primaries, red, yellow, and blue. Juxtaposition of pure primary hues displays a potent contrast, because each hue is unique and contains neither of the two other hues. Secondary hues, green, orange, and violet also visually contrast with each other; however, secondary contrast is softened by secondary hues having primary

Figure 2–14 Hue contrast. The highest color contrast is between black and white. The strongest chromatic contrast is between the primary hues. The secondary colors have somewhat less contrast. The greater the separation of hues on the color circle, the stronger the contrast between hues.

hue components in common, such as red in both violet and orange, yellow in both orange and green, and blue in both green and violet. [2.14]

Some informal hue contrasts are achieved by a combination of opposing hues or light/dark combinations. Pure undiluted hues (high saturation hues) form the most potent hue contrast. When black and white are included in a color contrast grouping, it intensifies the disparity. Hues widely separated on the color circle generate a stronger hue contrast than neighboring hues. [2.9] For example, a yellow and blue-green combination has a stronger hue contrast than the contrast of yellow and orange. The maximum contrast (besides the contrast between primary colors) is of hues located directly across from each other on the color circle. These are called *complementary* hues. [2.18]

HUE RELATIONSHIPS ON THE COLOR CIRCLE

Hue Values

As we explore the color circle, we can distinguish several types of hue relationships. The relative light/dark value of the hues on the circle can discerned, because the color circle itself is an informal value chart of the hues. As we view the color circle from the top to the bottom, the hues gradually become darker. Yellow, at the top of the circle, is the hue with the lightest value. Violet, placed at the base of the color circle, is unquestionably the hue with the darkest value. Red and green are located at approximately the same middle level as medium value hues.

Color Temperature

The color circle also charts relative *color temperature* of hues. We instinctively associate the notion of temperature with color connecting two sensory experiences. Strong visual associations from our culture and environment cause us to feel that red is warm in temperature because of its reference to blood, fire, and the sun. A similar correlation causes us to feel that blue is cold in temperature because it refers to water, ice, and the sky. Warm hues seem to emit light and heat, and cold hues suggest coolness, distance, and shadow. The color theorist Charles Hayter, an English architect and painter (1761–1835), in his book, *Introduction to Perspective,* was perhaps the first color theorist to base his color circle, which he called *A Painter's Compass,* on color temperature.

The placement of cool and warm hues on the color circle roughly divides the wheel into two halves, a cool side and a warm side. [2.15] The section of the color circle of yellow through red is definitively warm, whereas the slice of green through violet is definitely cool. Tertiary hues of yellow-green and red-violet are borderline hues. Color theorists are divided on whether these hues are warm or cool so they can be regarded as flexible in temperature. Warm colors are thought to be more powerful and dominant hues than cool hues. Brilliant warm hues or colors can make an object appear to be larger. Warm hues such as red and yellow also form distinct boundaries, differentiating or segregating from each other better than cool hues.

Cool and warm hues refer not only to temperature, but also create a perceptible temperature sensation in the viewer. This effect is noticeably strong in interior design, when colors visually surround the viewer. A pure red interior is stimulating and creates a warming effect on the occupant of the room. A blue in an interior has a restful, yet cooling sensation on the occupant of the room. There is no definitive data on which hue is the coldest and which is the hottest, as color temperature is a subjective experience. According to the Swiss artist and color theorist Johannes Itten (1888–1967) in his book, *The Elements of Color,* the warmest hue is red-orange and the coolest is blue-green. Most theorists concur, identifying a red as the warmest hue and some type of blue as coolest hue, respectively.

In addition to the identification of each hue by its location on the cold or warm side of the color circle, each primary and secondary hue can also possess a cool or warm *aspect.* For example, red, a warm color, can be made even warmer when yellow is added to it to make red-orange. Red is cooler with blue added, which creates a red-violet. [2.16] Cool and warm aspects of each secondary hue may also be perceived, such as a warm violet that is a red-violet. Color theorists do not concur on which type of blue is cool and which is a warm blue. A cool blue, can be one that leans toward blue-green, but often a blue-violet-based blue is thought of as cool. For painters, however, a cool blue always bends toward blue-violet, such as ultramarine blue, whereas a warm blue is a blue-green like cerulean blue.

The concept of cool and warm color helps artists or designers to create striking color contrasts and visual effects. Manipulations of the cool and warm aspects of a color may bring about an illusion of spatial depth. Cool colors are traditionally thought to recede spatially. Warm colors are traditionally viewed as colors that advance spatially. This "rule," though valid, is easily broken. Cool colors may advance if they are sufficiently pure or

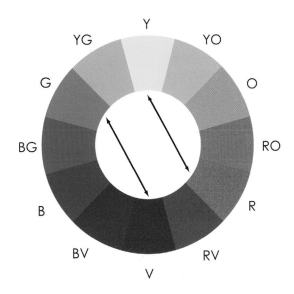

Figure 2–15 Cool and warm sections of the color wheel. Approximately half of the color wheel is considered warm and half is cool; RV and YG are the borderline hues.

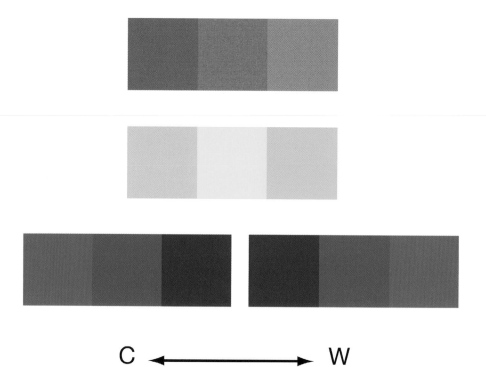

Figure 2–16 Each primary can have either a cool or warm aspect, as shown here. The cool/warm aspect of blue can be seen two ways, with either BG or BV regarded as a cool blue.

high in saturation. Warm colors can recede if they are low in saturation or muted. Cool/warm contrasts evoke the following visual opposites:

Warm		Cool
light	—	shadow
summer	—	winter
fire	—	water
fall	—	spring
dry	—	wet
close	—	distant

Color Harmony

Color is a wide and rich element of visual art. It is also extremely complex, due the sheer number of color variations. For this reason, color theorists, artists, and designers have always been in pursuit of *color harmony,* which is the formation of a group of colors that visually unify in some manner. The layout of the color circle serves as a guide to formulate color harmonies based on the relative placements of hues. The circle provides a guide for choosing color families, color opposites, and color chords.

Color Families

A key relationship between the hues on the color circle is the concept of color families, also called neighboring or analogous hues. *Analogous hues* are groups of two or three neighboring hues on the color circle. [2.17] Analogous groups are adjacent to each other on the color circle; example is a group of blue, blue-violet, and violet. The binding relationship that links this analogous group together is the fact that each hue contains blue in some proportion, visually connecting them. Working with a color family is a simple and harmonious way to organize color.

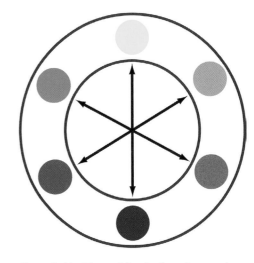

Figure 2–17 Hues that are neighbors on the color circle have an analogous hue relationship.

Figure 2–18 The traditional subtractive complementary pairs are red-green, blue-orange, and yellow-violet.

Color Opposites

The importance of hue opposites, called complementary colors, cannot be overemphasized in color study. Chromatic opposites are two hues located directly across the color circle from each other. They are called *complementary hues,* or complementary *dyads,* since they are always in pairs. [2.18] The complementary opposites from the traditional subtractive color circle are blue–orange, yellow–violet, and red–green. Each one of these pairs has one primary and one secondary color. Complementary pairs are chromatically balanced because each pair contains all three primaries as follows:

> Red—Green (yellow + blue)
> Blue—Orange (yellow + red)
> Yellow—Violet (blue + red)

Note that the subtractive complements vary slightly from the additive color complements of magenta-green, yellow-blue, and cyan-red, described in Chapter 1.

We also have a physiological relationship with complementary hue contrast. When our eye becomes tired or saturated with one hue, our eye spontaneously produces its visual opposite or complement. This phenomenon is called an *afterimage.* The concept of afterimage is an important part of color interaction. [4.1]

Complementary hues also neutralize each other. In the subtractive color system, the three primaries cancel each other out to create a near neutral when mixed together (as with paint). As each complementary pair has all three primaries in varying proportions, each pair will neutralize each other, forming achromatic colors such as brown or gray when mixed. A red-to-green scale exhibits how complementary mixtures create somewhat muted hues towards the ends of the scale and neutralization of the hues in the center of the scale. A complement or dyad pairing is also considered to be type of color harmony. [2.19]

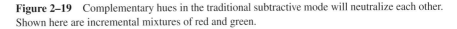

Figure 2–19 Complementary hues in the traditional subtractive mode will neutralize each other. Shown here are incremental mixtures of red and green.

Color Chords

Groups of hues that are spaced apart on the color circle are called *color chords.* Color chords are hue selections from the color circle that create particular color harmonies. The musical chord analogy refers to varied spacing of three or four notes to create a harmonious sound. Color chords are similarly made from hues spaced at intervals on the color circle. Each color chord has a different quality of harmony, as a musical chord has a different quality of sound. For example: A triadic chord has hues that are spaced equidistantly apart: red, yellow, and blue. A tetrad color chord has four hues in an evenly spaced arrangement: yellow, blue-green, red-orange, and violet. A color chord unites three or four seemingly unrelated hues to produce a color harmony.

COLOR PROPORTION

Throughout color study, there has always been an ongoing quest for color harmony. Color proportion utilizes measured relative areas of pure hues to attain color balance and harmony. Color proportion is based on the dissimilarities in saturation or color intensity levels of pure hues. In order for pure hues to balance compositionally, a proportional system based on relative value and saturation level hues can be employed. Johann Wolfgang von Goethe, the author of *The Theory of Colors* (1810), originated a system of color proportion that is a simple ratio system for relative areas of pure hues. Goethe reasoned that yellow, as the lightest hue and the highest saturation hue, should occupy the least relative space in a composition. According to Goethe's rationale, since violet is the darkest and a lower saturation hue it should occupy more physical area than yellow for compositional balance. In Goethe's system, the physical area for each hue is based on a numerical code assigned to each hue. [2.20] This code dictates how much space each hue should occupy relative to other hues. The numerical value for each hue is as follows:

<div align="center">

Yellow—3 Orange—4 Red—6 Green—6 Blue—8 Violet—9

</div>

According to this proportion, harmonious areas of red and green should be equal, each using 50 percent of any given space. Violet and yellow would use 1/4 yellow to 3/4 violet, since the value of violet is three times as much as yellow. [2.21] Yellow's proportion to green would be 1/3 yellow to 2/3 green. Goethe's proportional "rule" should be taken merely as a guideline. To increase hue contrast, the harmonic area ratios can be ignored or even reversed. To create a more visually exciting proportion, for example, the yellow can be allowed to dominate violet.

Figure 2–20 In Goethe's numeral value system of color proportion, each hue should occupy a designated area for color balance.

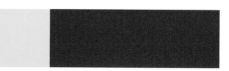

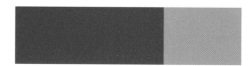

Figure 2–21 On the left, Goethe's proportional system applied to design. On the right, this proportional system can be inverted for a more exciting color effect.

The exploration of the color circle leads to several conclusions. First, the color circle is an essential tool for the study of color relationships. Second, the color circle provides us with a guide from which to select hues for color harmony. Third, the color circle is the starting point, in conjunction with the achromatic neutral scale, to create the millions of colors that we see.

ACTIVITIES

1. COLOR CIRCLES

Objective: For the student to formulate multiple types of color circles in order understand the distinctions between the traditional color circle, the process color circle, and a subjective color model.

Media: Gouache or acrylic paint on paper, mounted on illustration board.

A. Traditional Color Circle
- Make a traditional color circle using tempera, gouache, or acrylic paint.
- Make sure that you have both primary and secondary color paints, RYB and orange, green, and violet before you start. See notes on materials.
- First paint out swatches of the three primary hues, RYB. Pure colors out of the jar or tube are the best. Next, paint the three secondary hues OGV. Each swatch should be painted out on good drawing paper at least 3 inches square.
- Next, mix the tertiary hues, YO, YG, BG, BV, RV, RO. When mixing light value hues such as yellow-green, start with the lighter hue, yellow, and add green to it. Make sure that you use a magenta-based red when mixing RV. Compare each tertiary hue to make sure it is a visual halfway point between your primary and secondary colors.
- Color circle wedges are made by using a compass to make an 8- or 10-inch circle. A protractor can then divide the circle to make twelve sections by making a line every 30°. Make a template from one of the wedges from this circle. Each of the twelve painted hues can be cut using the template as a guide. Draw another color circle indicating the divisions as before. This circle will be used as a guide for gluing the cut wedges into a complete circle with twelve divisions shown, with the parts correctly placed. [3.29]

B. Process Color Circle
- An alternate color circle can be assembled from the process hues, cyan, magenta, and yellow. Many brands of paint offer a reasonable facsimile of these hues.
- In this color circle, all of the twelve hues should be made from the three process primary colors. First paint out the process primaries, and then mix the secondaries as follows: cyan and yellow for green, magenta and yellow for orange, cyan and magenta for violet.
- Mix six tertiary hues carefully, considering relative proportions of each CMY primary involved in each color mixture. YO, for example, would be yellow with just a tiny

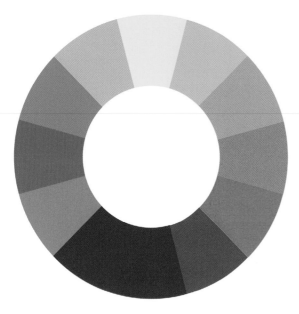

Figure 2–22 The subtractive process color circle uses CMY primaries mixed to form the secondary and tertiary hues.

Figure 2–23 An invented subjective color wheel based on personal color preferences.

amount of magenta. BG is cyan with just a small amount of yellow and so on. [2.22] Assemble the color circle as indicated in activity A.

C. Subjective Color Model
- Make a color model based on a personal concept of the most important hues. The circle can, for example, have more cool colors than warm hues. Use your own conception of pure red, yellow, blue, and green, even if you have to mix the colors. Come up with a format (it doesn't have to be in a circle) based on your own design. [2.23]

2. Complement Scale

Objective: The student should understand the neutralization of each hue when mixed with its complement.

- Make a scale based on each major primary–secondary complement pair or dyad: blue to orange, yellow to violet, red to green.
- Make all swatches on good drawing paper. Start with one hue; for example, first make a swatch of pure red. Then add small amounts of green to the red. Paint a swatch after each addition. As the green is added, red will become successively more neutral, toward brown or gray. Then start with pure green and gradually add more red, painting a swatch each time the color changes.
- Present the entire scale with red at one end and green at another as shown. There should be nine or eleven steps in this scale, each represented by a 1-inch square. The central step in the scales should be the most neutral color. [2.19]

3. Warm/Cool Aspects of Hue

Objective: The student should be able to create or choose warm and cool variations of hues.

- Use each primary color to make warm and cool hue variations.
- For example, paint a swatch of primary red or pick out one from a Color Aid® paper pack.
- Now make a warm red. Adding a tiny amount of yellow or a larger amount of orange can do this. With colored paper, be sure that your warm red has a slightly more orange cast than your primary red.
- Make a cool red. Adding a tiny amount of blue or a larger amount of violet will achieve this. In doing this with paper, you will look for a red with a more violet cast.

Figure 2–24 Hue Contrast Study. Hue and color choices in juxtaposition emphasize maximal hue contrast.

- Repeat the same process with red and yellow. This study can be also executed with secondary hues. How can a violet be cooler? Warmer?
- Present each hue adjacent to the main hue in the center and the cool and warm aspects of the hue on either side. Make each part using 1-inch squares of color as shown. [2.16]

4. HUE CONTRAST STUDY

Objective: To perceive and juxtapose the strongest hue contrasts.

- From colored paper or painted swatches, pick out ten strongly contrasting hues or colors. Black, white, and gray can also be included.
- Place colors in a grid that maximizes the contrast between the hues, as shown. Each grid piece should be 1 by 2 inches, making the overall size 4″ × 5″.
- For maximal color contrast, try adjacent placement of complementary colors or pure hues contrasted with neutrals such as black or white. [2.24]

5. COLOR PROPORTIONAL STUDY

Objective: To use the balanced proportional system for pure hues as devised by Goethe to create an opposing system to make an exciting combination of hues.

- Use two or three hues in a simple proportional study. Try to employ correct proportions for each hue according to Goethe's numerical system as described in the text. [2.20]
- For example, if you made a study out of violet and yellow, use three times as much violet as yellow (be sure to measure square inches of each) You can use painted paper or Color Aid® paper. [2.21]
- Cut apart the colors into simple geometric shapes and then make your design only using the "correct" Goethean proportions.
- Next make a study where you reverse or invert the proportions. For example, you can use more yellow and less violet.

Chapter 3
Attributes of Color

INTRODUCTION

The complexity of color offers the artist a world of choices. The enormous volume of perceptable colors inspired color theorists to design systems to organize color. James Clerk Maxwell (1831–1879), the Scottish physicist who made important contributions to color research, identified three distinct color dimensions or characteristics to illuminate color's complexity. These color characteristics are called *color attributes.* Comprehension of the attributes, characteristics, or dimensions of color illuminates the process of color selection.

The three principal attributes of color are the characteristics of hue, value, and saturation. *Hue* refers to a specific color wavelength from both the spectrum and color circle. *Value* means simply the lightness or darkness of a color. *Saturation* is the property of color that highlights its purity, intensity, or chroma. Because it is difficult to conceptualize all three color characteristics at once, each color attribute—hue, value, and saturation—is explored here as a separate entity of color.

HUE

The term hue refers to a spectral color in its pure state. A *hue* is a color selection from the color circle, such as violet. [3.1] A hue is also *defined* by its location on the color circle. Often a hue selection is the first choice that an artist makes about color, the basis for all other color dimensions. For instance, the selection of hue such as BG determines the source for a group of colors that are different versions of BG—light, dark, muted, or brilliant.

Hue Names

The terms hue and color have separate and distinct definitions. A *hue* is a particular spectral color from the color circle, while a *color* is any variation on a hue or neutral. Thus, a hue is the basis for all color varieties. The neutrals are *achromatic,* containing no hue or color, whereas colors are *chromatic*—meaning that they contain some hue. The name of each spectral hue can be used to reference its many color alternatives. For instance, red mixed with white (commonly called pink) may be referred to as a tint of red, which clarifies its hue basis. Pink is a *descriptive color name,* as opposed to a spectral name for a color. Descriptive color names are numerous and often fanciful. Some examples are: fire engine red for a warm red, teal for blue-green, and chartreuse for yellow-green. [3.2] Descriptive names for colors are helpful in identifying large numbers of colors for commercial or con-

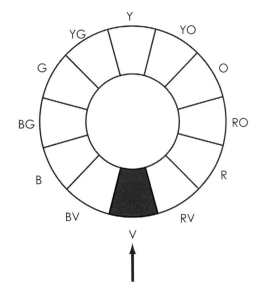

Figure 3–1 A hue is, in part, defined by its location on the color circle.

sumer product items, such as the colors of makeup or interior wall paint. For color-study purposes, however, it is clearer to refer to a color by the hue from which it is derived such as: a tint of red-violet, rather the descriptive name of "hot pink."

Color names also refer to pigments, which are colored powder materials that form paint. Pigment names can be confusing. Students want to know which pigment is the "true" red, blue, and so forth. Pigment names often refer to the chemical or mineral content of the colors. We *do* need to know at least some pigments and their hue equivalents on the color circle. Cadmium Red Light is, for instance, a red orange, Magenta is a red violet, and Napthol Crimson is a spectral red. Familiarity with pigment names is essential when working with various types of paint (see Table 2.1 on page 26).

Hue Standards

Throughout the history of color theory there have been various attempts to create international systems to standardize hues. Printer's process inks in CYMK hues: cyan, yellow, magenta, and the achromatic black (the letter K is used as an symbol for black) are used internationally, with some variations of color by manufacturer and country. Computer graphic color modes, such as RBG and CIE color, are also standardized. An older standard for hues is the Munsell system of colors, which is a color standard in the United States (the National Bureau of Standards), Great Britain, Japan, and Germany.

Hue Identification—Base Hues

In order to effectively manipulate color, the eye must first be sensitized to heighten one's color perception. Hue perception aids in a process called hue identification, which is recognition of the base hue of a color. The *base hue* of a color is the spectral hue origin of each color—the hue from which each color is derived. For example, the base hue of the color lavender is blue-violet, since the components of lavender are essentially BV with white

Figure 3–2 Descriptive names for colors include, from left to right, fire engine red for RO, teal for BG, and chartreuse for YG.

Figure 3–3 Base Hues of Colors. Notice that each color on the left visually relates to a base hue on the right: red, yellow, and blue.

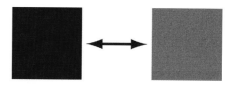

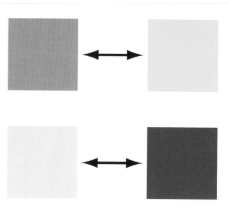

added. All of the thousands of colors that we perceive (with the exception of neutral colors) can be visually traced back to the twelve hues of the traditional color circle. This is the core supposition of the concept of a base hue. [3.3] Colors that have no identifiable spectral base hue are pure neutrals (achromatics) that contain only black and white. A true neutral has no discernable chroma or hue base. Even a metallic color such as gold can have a hue relationship to yellow, red, or orange. Earth colors are often based on a hue; for example, burnt sienna can be traced back to a red-orange.

To effectively select colors and invent color harmonies, our eye should be able to discern the base hue of almost any chromatic color. A simple hue identification exercise sensitizes our eye for this process. For this exercise, sample colors are first taken from several types of sources: colors from found colored paper, magazine stock, fabric, wall-paint samples, and/or Color Aid® paper. Each color sample should then be visually identified in connection to a specific primary, secondary, or tertiary hue. To accurately identify hues and aid color perception, each color in question should be isolated against a neutral background of black or white. Each color should be placed on an appropriate neutral; light colors are best identified against white, dark colors against black. [3.4] Each color should be identified in association with a single hue, a sea foam color, for example, has a base hue of BG. This exercise seems to be rudimentary, but is in fact quite complex. A even greater challenge is the identification of colors that are very muted, neutral and dull, very dark value colors, and very pale colors.

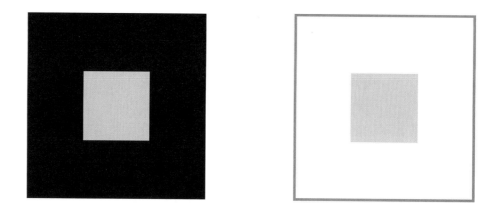

Figure 3–4 A questionable color placed against a neutral helps to determine its base hue.

Hue Variation

After the student gains proficiency at base hue identification, the second step is to produce hue variation studies. The purpose of a hue variation study is to find or make as large group of wide ranging color variations on one hue as possible. One study can be made with at least ten variations on any chosen base hue (such as violet) from colored paper [3.5]. This study is called a found hue identification/variation study.

A second hue variation can be made manually with paint. The purpose of this study is to radically vary colors by paint mixtures while still retaining the same base hue. For example, a large group of colors can be mixed—light, dark, dull, and bright—that all share the same base hue of green. To vary green, green paints can be mixed with white in a number of lightening steps, or shaded with black in a number of darkening steps. The green can also be mixed with gray in varying proportions to create more colors. A hue such as green can also be intermixed with other hues in modest proportions to produce even more colors. Care must be taken that green still ends up being visually dominant in each mixture; the resulting color should not be too blue-green or yellow-green. All colors yeilded by these mixtures must be visually linked with green as the common base hue. Hue variation studies are wide ranging variations on a single hue.

During the process of mixing paint (in studies for this chapter), one discovers the relative strengths of pigment color in mixtures. For instance, light hues such as yellow are easily changed by the addition of any other hue. Darker hues, such as red or violet, are stronger in retaining their power to dominate color mixtures with other hues or neutrals. In any hue-to-hue mixtures, a base hue is strongly affected by additions of other hues that are located farther away on the color circle. For example, when blue is added to red, a very strong change occurs in the original hue of red, pushing the red toward the secondary color of violet. Neighboring hues do not affect the base hue as strongly those that are located farther away on the color circle. For example, a red is only slightly affected by the addition of RO, yet it is strongly affected by the addition of green.

The process of hue identification and variation introduce the student to color perception and the formation of many colors, even within the restriction of a single hue.

VALUE

Value is an attribute of color as well as an element of design. *Value* refers to all the perceptible levels of light and dark colors from white to black. Value levels are most easily comprehended as a series of neutral grays. Our eye can discern a surprisingly large number of neutral gray steps between white and black. A workable value scale, however, is most

Figure 3–5 A hue identification exercise on the hue of violet. The aim of this exercise is to find or make a wide variety of colors that share in common same base hue.

Figure 3–6 A neutral or achromatic scale with ten value steps, including black and white.

often a reasonable size. Standard value scales used by color theorists usually have between ten to twelve value steps, including white and black. [3.6]

Value Scales: Tints and Shades

The value of a hue may be controlled by adding varied amounts of white or black to a hue. The simplest way to lighten the value of a hue is to add white. The simplest way to darken the value of a hue is to add black. A hue + white is called a *tint*. A hue + black is called a *shade*. [3.7]

When hue is linked with value, our perception of value is increased. Our eye can acutely discern many more value steps in a color gradation between white and black than in a neutral (gray) scale. In gradating a hue in a value scale, the inherent value of each pure hue is lightened and darkened by tinting and shading the hue. The word "shade" is often used to describe any type of color variation. For clarity, in this book, a shade always refers to a color mixed with black. The term *shadings* of a color in a painting are perhaps a more appropriate way to describe subtle color variations.

A good quality painted value scale is achieved by controlling white and black pigments very carefully. Most students master this quickly. Students will find that both color mixing skill and value perception improve simultaneously. The act of mixing colors manually is one key to better color perception. Most students will end up making many more colors than necessary for a ten-step hue value scale simply because they are able to mix and see the color distinctions more accurately as they work.

The traditional primary hues of red, yellow, and blue, and three secondary hues of orange, green, and violet, when scaled out modestly into ten steps each, make a range of forty-eight colors, not including black and white. Shown here, the hue value scales have similar value increments when compared to the neutral gray scale. [3.8]

Inherent Value of Hues

Note that the value scale chart shown has pure primary and secondary hues that vary in location on each scale. The diverse placement of pure hues in each scale occurs because each hue has its own light/dark value level called inherent value. *Inherent value* refers to the light or dark value of a hue at its maximum saturation or purity. [3.9] Pure hues are

Figure 3–7 A tint is a hue + white and a shade is a hue + black.

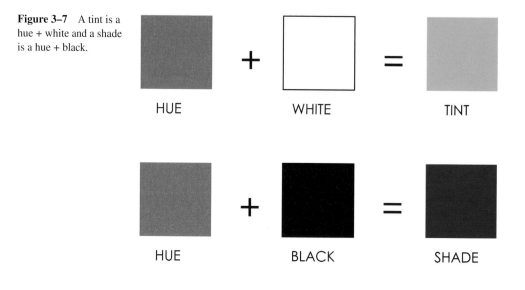

HUE + WHITE = TINT

HUE + BLACK = SHADE

Figure 3–8　A primary and secondary tint/shade value chart; note the varied placement of pure hues in each value scale.

Figure 3–9　This chart shows the inherent value of hues. Notice that the layout of hues in this chart is identical to their placement in the traditional color circle. The lightest hues are at the top and the darkest hues are at the bottom.

Figure 3–10 All the colors in this group are light in value key.

Figure 3–11 These colors are all value-keyed to a medium-value level.

placed at different levels in each value scale because of the value disparity between hues. The color circle is not only a hue selector, but also a simple value guide to the inherent value of hues. Yellow's position at the top the color wheel signifies its role as the lightest value hue. As we scan the wheel downward, the hues gradually darken until we get to the bottom, where violet is the darkest hue. Pure hues have an approximate light-to-dark range as follows: yellow, very light; YO and YG, light; orange and green, medium light; RO and BG, medium; red and blue, medium; RV and BV, dark; violet, very dark.

It can be perplexing to judge pure hues in terms of merely light and dark value. Most people tend to respond to the identity of a hue—its associations, personality, and characteristics. We react to the identity and warmth of red, not to red as a medium-value color. On the value chart, notice that the neutral black, white, and gray value scale is positioned in direct relationship to the hue value scales with the gray scale matching the exact value step of each hue. [3.8] As the student generates value scales, the neutral gray scale will operate as a value *key* or guide. For example, pure yellow is very close to white, pure red is approximately halfway between black and white, and violet is much closer to black because it is the darkest hue. Value/hue relationships are notoriously confusing for students. Most people want to believe that all the pure hues have the same placement within each value scale, which would be convenient, but not accurate.

Value Keys

Color value steps in a scale can also be imagined as keys on a light-to-dark value keyboard, a visual analogy for the concept of color value levels or keys. High-value key colors "notes" are light-value steps, inherently light hues and tints. [3.10] Middle-value key colors are medium-value range hues and darker tints. [3.11] Low-value key colors "notes" are the darkest hues and shades. [3.12]

When colors are *value-keyed,* they are brought as closely as possible to the same level or value key range. This process involves selection of assorted colors and keying them as closely in value as possible. When a diverse group of colors is keyed to the same value correctly, one color does not recede or come forward more than another. To distinguish colors that match in value level, a group of possible colors may be viewed in a dimly lit room. A low lighting situation makes it easier to see similarities in value because low light decreases hue perception and increases light/dark sensitivity. Colors in a half-lit room are discerned more by value contrast than color contrast. Colors can also be keyed to any value level by manually mixing paint. A group of light value colors can be obtained, for example, by tinting (adding white) to each of group of varied hues. Dark value keys are relatively easy to perceive and execute by shading numerous hues to the same dark value

Figure 3–12 Dark-value key colors.

range. Attempting to key middle-value range colors can be more challenging. Medium-value colors tend to be purer, and it is harder for the eye to perceive the value differences in colors that are at full saturation.

SATURATION

The third characteristic of color is saturation. The attribute of color *saturation* refers to the purity or intensity of a hue or color. It is also sometimes referred to as chroma. High saturation colors are pure, bright, and intense. Low saturation colors are duller, subtle, and muted.

Saturation and Value

When manually mixing colored pigments, we are working with the subtractive color system. The more colors are subtractively mixed together, the duller the potential mixtures become. For instance, mixtures such as tints and shades of hues are lower in color intensity than a pure hue. Tinting lightens a hue to a higher value level, yet lowers its saturation (intensity) level. Compare a pure red, for example, with a tint of red (such as pink), and we can see that, although lighter, the pink is not as intense or pure as red. [3.8] The same effect occurs when shading a red by adding black, which both darkens and lowers its saturation.

Students are often confused by separating the color characteristics of saturation and value. They will refer to a highly saturated red, for example, as "dark" red. A pure red is both high in color saturation as well as having a medium value key. A dark red should refer to a dark *value* of red, possibly a shade or another dark mixture of red. [3.13] If we separate the concept of light/dark as variables of value from the concept of bright/dull as variables of saturation, then both concepts are clarified.

Systems of Color Saturation—Color Solids

Several color theorists made significant contributions to the notion of color attributes by the formulation of color solids. *Color solids* are three-dimensional color notation charts. Several theorists devised color solids, notably Albert Munsell, Otto Runge, and Wilhelm Ostwald. Each of their color notation systems simultaneously exhibited the all the attributes of color, hue, value, and saturation in an organized framework. Some color theorists felt that color solid charts were the only way to explicitly represent all the dimensions of color in a single visible structure.

ALBERT MUNSELL The foremost color theorist of this group was the American Albert Munsell (1858–1918). Munsell presented his color system in detail in the 1905 book entitled *Color Notation*. Munsell's color circle was based on ten rather than twelve hues.

Figure 3–13 Sometimes colors are mistakenly called dark, when in fact they are pure, high in saturation. The pure red is both high in saturation and light in value. Shades of red that are darker in value are also lower in saturation.

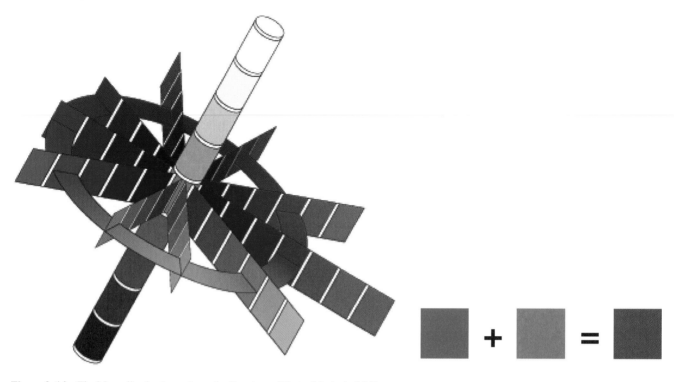

Figure 3–14 The Munsell color tree schematic. Courtesy of GretagMacbeth, LLC. Photographs provided by Munsell, A Division of GretagMacbeth, LLC.

Figure 3–15 A hue plus gray is a tone.

Munsell's principal contribution to color theory was the development of a three-dimensional color tree that illustrated the color characteristics of hue, value, and saturation all at once. Munsell envisioned the color circle with a white-to-black gray value scale serving as its central axis in a three-dimensional structure. [3.14] In this color system, the pure hues are laid out in a circle ringing a nine-step value scale. Each pure hue is located at a different level and value-keyed with each corresponding gray. Munsell displayed each pure hue in graduated steps to the inner gray scale to concurrently indicate the tints, shades, and tones of each hue.

Munsell coined the term chroma, a synonym for color saturation. A pure color in Munsell's system is regarded as having a high *chroma*. A *tone,* a hue + gray, according to his system, is a way of controlling the chroma of a color. [3.15] There are many saturation steps from each pure hue to a perfectly neutral gray. In Munsell's color tree, each hue is scaled in sequential steps to white, black, and seven gray value steps. [3.16] The large amount of resulting colors in this solid demonstrates Munsell's motivation in designing a three-dimensional color model. The color tree illustrates a large and complex color system, which allows many variations of each hue to be perceived, created, and organized with relative ease.

WILHELM OSTWALD The research of German color theorist Wilhelm Ostwald (1853–1932) closely parallels the color theories of Albert Munsell. Ostwald's color notation system also emphasizes saturation variety, yet it is even more complex than Munsell's. Ostwald, like Munsell, created a color solid with a color circle analogous to a central value scale. [3.17] Ostwald formulated an extremely scientific method of incrementally mixing pigments in order to achieve controlled results. While Ostwald's system has a more solid color structure than the Munsell system, it uses essentially the same concept of pure hues gradated into a series of tones for saturation variety. A key difference between the two systems is that hues are aligned in a circle on Oswald's color solid, the instead of being staggered by value as they are on Munsell's color tree.

PHILIP OTTO RUNGE An early color solid was developed by the eighteenth-century German color theorist Philip Otto Runge (1777–1810). His color sphere has a twelve-hue color circle in correlation with a central core of a middle-value gray. [3.18] Hues are

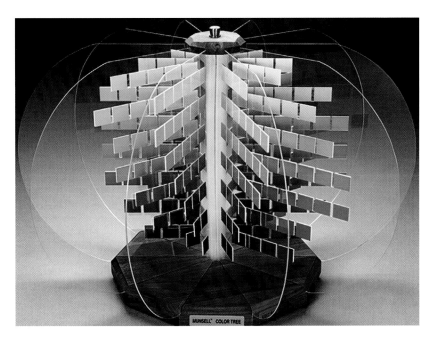

Figure 3–16 The Munsell color tree displays the three attributes of color in a three-dimensional form, indicating hue, value, and saturation. Photographs provided by Munsell, a Division of GretagMacbeth, LLC. Courtesy of GretagMacbeth, LLC.

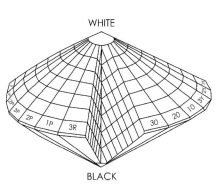

Figure 3–17 The Ostwald solid is similar to the Munsell color tree in its three-dimensional structure and its use of sequential tones.

Figure 3–18 The Runge sphere seen sliced in half along its equator; the sphere gradates into lower saturation tones toward a central gray core.

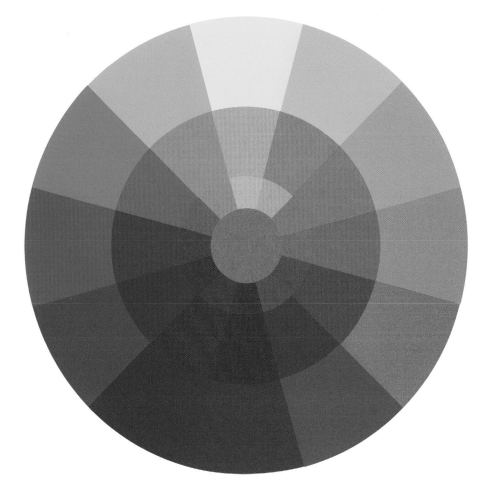

gradated in tones toward the gray core. The upper pole of the sphere is white and the lower pole is black. [3.19] This configuration permits tints and shades of the hues to logically relate to the tones. The Runge sphere predates both Munsell's and Ostwald's color solids by almost a century and is perhaps a clearer presentation of similar concepts.

JOHANNES ITTEN Johannes Itten was an artist, color theorist, and teacher at the Bauhaus School in Germany. He developed a color study course that addressed the aspects, characteristics, and contrasts of color. In his book *The Elements of Color,* Itten designed a two-dimensional version of the Runge's color sphere in the form of a color star. [3.20] The color star is essentially a view of the color sphere, cut apart and spread out two dimensionally. On the equator of the sphere are pure hues, its inner circle has tints gradating toward a white center and the outer points have incremental shades. A cross section of Itten's sphere is based on Runge's design, with hue gradations toward an inner gray.

Methods to Vary Color Saturation

There are four main techniques to manipulate the saturation of a color, either with pigments or computer color. The first method is to add neutrals to a hue. The second is to intermix complementary hues. The third method is to layer combinations of transparent colors. And the fourth method is experimental hue-to-hue mixing.

 To change the saturation of a color, one can simply add a neutral to a pure color to create a tint, shade, or tone. A *tone* is a hue plus some level of gray. As indicated by the color systems of Munsell, Ostwald, Itten, and Runge, tones have a greater range of subtle color variations than either tints or shades. The tonal chart [3.21] shows a hue mixed with a light value, a middle value, and a dark value gray by gradating a neutral gray in incre-

Figure 3–19 The Runge sphere outside view displays the pure hues on an equator that gradate toward white at the top pole and black at the bottom pole.

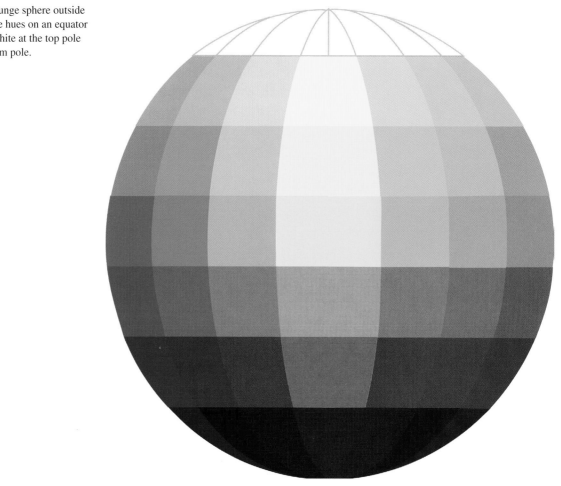

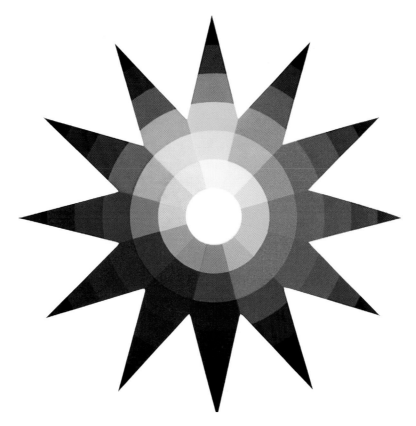

Figure 3–20 Johannes Itten, Color Star, from *The Elements of Color* © 1970 Johannes Itten. Reprinted by permission of John Wiley and Sons. The Itten color star opened the three-dimensional color solid into a two-dimensional color model.

mental steps toward a pure hue. Tonal variations are formed by simply manipulating each hue in varying proportions toward any neutral gray value to affect saturation. Tones do not substantially change the character of a color, permitting colors to remain identifiable when scaled out to different tonal levels.

Color saturation can be affected by mixing a hue with its complement to mute or neutralize the hue. Complements neutralize each other because all three subtractive

Figure 3–21 A simplified tonal saturation chart presents a pure color gradated to light, medium, and dark gray in a series of tones.

Figure 3–22 Complementary Scales. When subtractive complements are mixed together, they lower the saturation of each other, ultimately forming chromatic neutrals. From top: red-green scale, yellow-violet scale, and blue-orange scale.

pigment primaries, RYB, are present in any complementary pair. For example, in the complementary pair of yellow and violet, violet is red and blue, thus the pair includes all three pigment primaries, red, yellow and blue. Painters mix complementary hues as a method for modulating a color. When mixed in the correct proportions, each hue will completely extinguish its complement. [3.22] Complementary mixtures can control color saturation, creating neutral colors that are called *chromatic neutrals*. Painters prefer chromatic neutrals because they are chromatically "cleaner" than gray-based tones, particularly when oil paint is used.

Transparent media, such as watercolor, printing inks, dyes, and markers permit layering of transparent colors on top of one another. A combination of colored layers can lower the saturation of a color. Transparent neutral color layers such as black or gray can be placed over high saturation colors, or complements can be layered atop each other together to reduce the intensity of any given color. [3.23]

When working manually with paint, intermixtures between hues may influence the saturation of a color, while producing many new colors. In hue-to-hue mixtures, subtle color changes result from mixing neighboring hues such as red and red-orange. More radical color changes occur when mixing hues that are spaced farther apart on the color circle, such as green and orange. Saturation changes can occur as a result of trial-and-error mixing. [3.24]

On a computer, color saturation is variable in the S portion of the HSB color mode. This control makes it easy to use a slider bar or numerical coding to control the maximum-to-minimum saturation of colors. Complementary mixing in CMYK mode, or mixing by adding black or white to a hue, can also lower color saturation.

Figure 3–23 Transparent colors can be lowered in saturation by layering with neutrals or complementary colors.

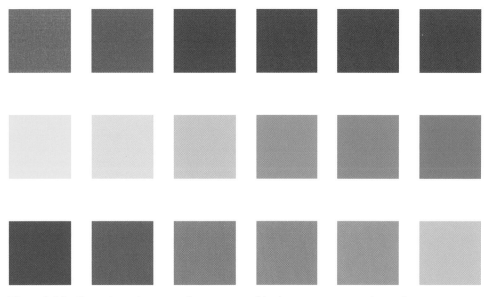

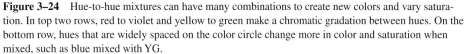

Figure 3–24 Hue-to-hue mixtures can have many combinations to create new colors and vary saturation. In top two rows, red to violet and yellow to green make a chromatic gradation between hues. On the bottom row, hues that are widely spaced on the color circle change more in color and saturation when mixed, such as blue mixed with YG.

Saturation Keys

The concept of color keys pertains to color saturation as well as to color value. The terms used here are slightly different: Color *saturation keys* are referred to as high, medium, or low saturation colors. Low saturation colors are dulled or neutralized. [3.25] Middle saturation colors are medium intensity or partially muted. High saturation colors are full intensity pure hues or strong colors. [3.26] Some artists prefer to work in a high saturation key. [3.27] Others use mostly low chroma or saturation colors. Still others use saturation contrast to draw the eye to specific areas of a composition.

The three attributes of color—hue, value, and saturation—can be manipulated to control and generate a wide range of colors. Color solids notate all the dimensions of color reflecting the almost infinite possibilities of color.

ACTIVITIES

1. HUE IDENTIFICATION AND VARIETY STUDIES

Objective: The objective of these studies is to train the eye to correctly identify a color in relationship to its base hue on the color circle. Also, the student should be able to produce and identify many colors generated from this base hue.

Figure 3–25 Low saturation key colors are colors that are duller or muted.

Figure 3–26 High saturation key colors are colors that are very intense or pure.

Figure 3–27 James R. Koenig, Untitled, acrylic on canvas. 1973 Collection Catherine C. Koenig. © James R. Koenig 2001. This painting displays mainly high-saturation key colors.

A. Hue Identification Study
- Using Color Aid® paper, found color paper, samples from a paint store, or other materials, gather as many varieties as possible of one base hue (any primary, secondary, or tertiary hue), such as violet.
- Go through the assorted colored papers, identifying the colors one by one. Light colors should be identified on a pure white background and dark colors can be identified against a pure black background. Make sure to identify each color sample one at a time, not as a group.
- All colors should be visually identified has having the same base hue that you have chosen. [3.28, 3.5]
- Try to find as many varied colors as possible, based on your chosen base hue. For example, for green, there should be muted tones, strongly saturated pure colors, light tints, dark shades, and slightly more yellow and slightly blue-green varieties.
- The format is ten 1″ × 2″ rectangles placed in a 4″ × 5″ format as shown. The colors should be arranged to maximize their contrast and color variations.

B. Hue Variation Study
- Make another study in the same format. This time, with paint, mix a number group of colors based on the same hue. The difficult part of this exercise is to vary the hue as much as possible without jumping into another hue category.
- To mix these color variations, begin with any primary, secondary, or tertiary hue. Make various tints, shades, and tones. Make some hue-to-hue mixtures, being sure that your chosen hue still dominates the color mixture. For example, blue can be mixed with small amounts of red or orange, without allowing the mixtures to become violet. These mixtures, in turn, can be tinted or shaded.
- Present the hue variations in the same manner as above.

2. VALUE STUDIES

Objective: the student should understand and manipulate the concept of neutral value and color value.

A. Value Scales: Neutral Gray Value Scale
- In this exercise, there are four value scales.
- The first scale is a gray scale of ten or twelve steps including white and black.
- Mix at least fifteen possible steps from white to black, painting them on good sketch paper. The paint should be opaque and evenly applied.
- Make the paint swatches approximately 2 inches square.
- Create many more grays than you need, perhaps as many as fifteen to eighteen. Take care that there are no abrupt jumps in value.
- When mixing light values, start with white and gradually add black. When mixing very dark values, start with black and gradually add white.
- When the paint is dry, cut the swatches into 2″ × 2″ squares. Remove away the white paper from one edge on each swatch and then overlap the pieces in order, creating a color scale.
- Edit the scale down to ten or twelve steps, making sure that they are even steps.
- Assemble the swatches, according to the directions, into a scale that consists of ten 1-inch adjoining squares. [3.29]

B. Primary Tint/Shade Scales
- Make a value scale using each of the three subtractive primary hues: red, yellow, and blue.
- Make ten- or twelve-step scales, including black and white.
- Paint out a swatch of each primary hue to be included in each of these scales.

Figure 3–28 A hue identification study on green, has a wide variety of colors based on a green hue.

Figure 3–29 Color circle and scales. Student work by Marlene Shevlin.

CUT

OVERLAP
SWATCHES

Figure 3–30 A guide for making scales. Use grid paper and overlap swatches, then cut as shown.

- Mix tints of the hues (by adding white) and shades (by adding black), at least six of each.
- The best way to mix tints of a hue is to mix the pure hue in steps to black and a pure hue in steps to white.
- When you are making light tints of red, for example, start with white, adding small amounts of red. For the darker tints, start with red and add small amounts of white.
- For shades, it is best to start with the hue, such as red, and add small amounts of black in stages; otherwise the black will completely cancel out the hue.
- Do not add both black and white to your hue. This makes a tone, which does not belong in a tint/shade scale.
- Use the same process of selection as with the gray scale. Cut away the white edge on each piece of color and overlap the pieces in order. If there are large jumps, try to mix a shade or tint to fill the gaps. If two colors look the same, omit one. Select scale down to ten to twelve steps, including black and white, finding the appropriate place for the pure hue.
- Assemble scale as shown in the illustration.
- Make a separate scale each for red, yellow, and blue. Present all scales on a black or white board with the neutral gray scale. [3.29]

C. Scale Assembly Instructions
- The easiest way to assemble scales is by using grid paper as a guide.
- Make sure that each color swatch has one straight edge.
- Use the grid paper as a guide for overlapping swatches at 1-inch increments as shown, gluing them onto the grid paper as you go.
- Glue each swatch onto the grid paper until the whole scale is complete. Then trim the scale strip from the back to a 1-inch wide strip using the grid paper as a guide to form $1'' \times 1''$ squares. Grid paper can be used as a guide for the $1'' \times 2''$ pieces as well. [3.30]

D. Additional Value Exercises
- Make a value scale of ten or more steps using Color Aid® or found paper. In this scale use various hues and colors and try to put them in order sequentially from light to dark.
- Make keyed-value grids. Using found or Color Aid® paper, pick various hues that are as close to the same value as possible. Use the same $1'' \times 2''$ grid format as the hue variations for these studies. A grid of all light-value key colors, one of medium-value key colors, and one of dark-value key colors can be made. Looking at colors in a half-lit room will aid this process. [3.31]

3. SATURATION STUDIES

Objective: For the student to understand and manipulate the concept of color saturation. Also, for the student to use a modified approach to the Munsell color system.

- Pick any primary or secondary hue and paint out a swatch of that pure hue.
- Mix three neutral grays, one light value, one middle value, and one dark value.

Figure 3–31 A value key grid of all light value colors.

- Make a simple tonal scale of about five or six steps from the hue to each gray. You will probably have to mix more than five to get even steps. The steps should represent the hue gradating to each gray value.
- The hue will still be recognizable as it gradates toward gray, but the colors will become lower in saturation and may change in value. For example, an orange will change in value and intensity when dark gray is added to it. Light gray will only make orange lose its intensity.
- This exercise forms a family of related tones from one hue.
- Present as illustrated. [3.21]

A. Additional Saturation Exercises
- Using Color Aid® or found colored papers, make a saturation scale from various colors and hues. The scale should range from the strongest, most saturated colors to the dullest, most muted colors. This scale will represents high-, middle-, and low-key saturation or chroma. Remember to go from brilliant to dull rather than from light to dark. [3.32]
- Using the same format as the hue variation studies, make a grid of high-saturation key colors, middle-saturation key colors, and low-saturation key colors. Try to equalize the saturation level visually for each grid. This exercise may be done on a computer using the HSB mode in any graphic program. The saturation slider bar should be used to pick colors varying in hue but not in saturation.

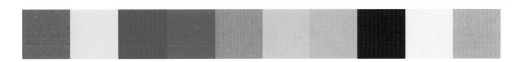

Figure 3–32 A saturation scale of different colors arranged in order of their saturation or purity, from intense to muted.

Chapter 4
Color Interaction

INTRODUCTION

Color study traditionally includes the origin and physics of color, the attributes of color, and color systems. None of this information, however, addresses the phenomenon of relative color that is called color interaction. Color interaction is an illusion that occurs within our perception of color. *Color interaction* upholds the viewpoint that color perception is dependent on color relationships. We rarely see colors as independent entities in reality or in art, because color is frequently seen and used in groups. Our visual reality is composed of color masses in juxtaposition to each other. Through color juxtapositions, we perceive colors in interconnected relationships. Color relationships are ever-changing, and each color's appearance fluctuates as a consequence of these relationships. The manner in which color interacts is a mysterious yet fascinating area of color study.

COLOR RELATIVITY—CHEVEREUL AND ALBERS

Simultaneous Contrast

Because color is a phenomenon that exists in the human brain, individual experience guides our color perception. Each person's personal concept of red, for example, is individualized, fluctuating from one person to another regardless of any international color standards. Our eye receives color in a variety of ways, dependent on light and color relationships. Perception of each color is also dependent upon its visual context. For instance, the color impression of a pink (a tint of red) flower has one appearance in sunlight and another look in shadow. A shift in the color surroundings and lighting conditions for the same pink flower results in several assorted versions of pink. Which of these pinks is the true color of the flower? Every pink is subject to its color surroundings, illustrating the uncertainty of color and demonstrating that color itself is relative.

Artists have always been cognizant of the concept of color relativity. Experienced painters are familiar with a color's alteration from its appearance or visual "read" on the palette to its impression within the context of a painting. In the Renaissance, Leonardo da Vinci observed that color perception is dependent on the color interrelationships present in a work of art.

The French chemist Michel Eugene Chevereul (1786–1889) explored the concept of color relativity in detail. Chevereul worked as a supervisor of dye production in a carpet manufacturing plant. In the course of his work, Chevereul discovered that colors often failed to produce their predicted effect within the pattern of a carpet. He realized that the

Figure 4–1 Afterimage. Try this experiment to understand the phenomena of afterimage. Stare at the dot in the RO square, and then quickly switch to the blank square. What do you see?

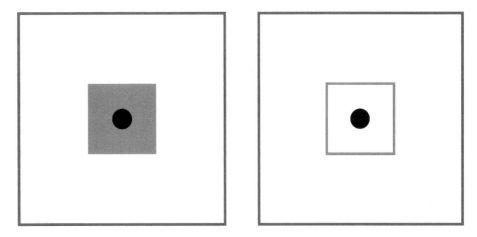

obstacle was not chemical but optical. The inconsistencies in human color perception led to Chevereul's research and theories, presented in the 1839 book, *The Principles of Harmony and Contrast of Colors.* This book puts forward the rationale that color perception is affected by fluctuations in color relationships. Chevereul discovered and coined the term simultaneous contrast. *Simultaneous contrast* can be *generally* defined as the manner in which colors interact and affect each other. When colors interact, they are capable of changing in appearance, depending on particular relationships with adjacent or surrounding colors. This concept is strongly tied to the phenomenon of afterimage. [4.1] An *afterimage* occurs when the eye grows tired of a given hue and spontaneously creates the visual complement of the hue. For instance, after staring at RO and quickly shifting our eyes to a blank white sheet of paper, the eye will spontaneously produce a momentary afterimage of BG. This phenomenon is also known as *successive contrast,* since an afterimage occurs in direct succession to the eye's overexposure to a full saturation color. A more specific definition of simultaneous contrast accounts for the phenomenon of afterimage. In this context, simultaneous contrast means that the eye simultaneously "wants" to see the complement of any given hue for color balance. The eye spontaneously generates the complementary color even when the hue is absent.

Chevereul concluded that afterimage is so pervasive that one color will "push" a second adjacent color toward the complement of the first color. This type of color interaction is dependent on the direct proximity of adjacent colors. For example, in the illustration, YO causes violet to appear to be more BV. YO pushes violet toward BV because BV is the complement of YO. The YO, surrounded by violet, appears to be more yellow because yellow is the complement of violet. [4.2] The simultaneous contrast effect is most pronounced when one color is completely surrounded by another.

Figure 4–2 Simultaneous Contrast. Left: The violet appears to be more BV near the YO since YO is the complement of BV. Right: The YO may appear slightly more yellow in relation to the violet since yellow is the complement of violet.

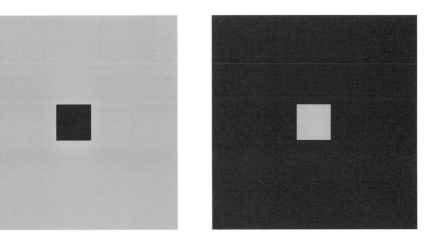

Figure 4–3 Contrast Reversal. Stare at the dot amidst the orange circles, and then quickly shift to the dot in the blank rectangle. What do you see? See the text for an explanation.

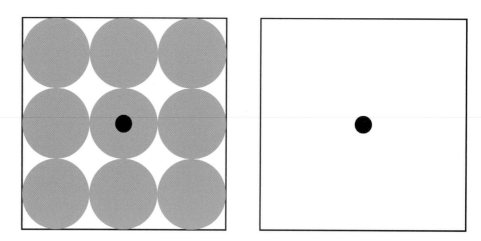

Afterimage

Why do we see an afterimage of a color? Why don't we see it all the time? First of all, an afterimage is usually only perceptible in a controlled or extremely strong color situation. Otherwise, we would be seeing distracting afterimage colors all the time. An afterimage occurs due to fatigue in the hue sensors (cones) in our eye. This forces our eye to revert to the other remaining hues to which our eye is sensitive. So, when the red cones in our eye tire of a strong red, the eye reverts to the two other remaining cones, the green and blue, which, in turn, form a brief sensation of bluish green. Thus, we may think of afterimage as a color overload or reaction. "Negative" afterimages, tied with the research of Chevereul, were first investigated by Robert Waring Darwin, the father of Charles Darwin.

Figure 4–4 Simultaneous Contrast. The complementary effect is so pervasive that it influences even neutral grays. Note that each gray is tinged with the complement of each ground color. For example, the gray on the orange ground appears to be bluish.

In this experiment, the afterimage is so strong that it actually works in reverse. Stare at the dot in the illustration of circles, and then quickly shift to the other dot on the white surface. Can you explain what you see? This afterimage effect is called a *contrast reversal.* [4.3] While we are staring at the orange circles, our eye is filling in the white spaces with blue, although we cannot perceive this. Thus, when we look at the blank square, the white spaces between the orange circles reverse again from a blue afterimage to the complement of blue, making orange shapes.

The effects of afterimage and simultaneous contrast are so pervasive that they can even influence our perception of neutral colors. [4.4] All the grays in the illustrations are the same perfectly neutral gray. However, there are slight visual discrepancies in the grays' appearances based on their placement on pure hue grounds. Gray on the red ground appears to have a greenish tinge, since our eye "wants" to see the complementary hue of red. The same gray on an orange ground displays the most striking effect, seeming to have a bluish cast. Simultaneous contrast causes this color distortion because of our need to see the blue-orange complement in balance. The same gray has a subtle reddish quality on green, a yellowish cast on violet, and an orange tinge on blue. In this manner, the theory of color interaction hinges upon the effects of simultaneous contrast and afterimage.

Simultaneous contrast has also been the subject of art work, mainly in an art movement called *Orphism,* a term coined by the French poet Apollinaire in 1912. The French artists Robert and Sonia Delaunay (Robert a painter, and Sonia, a painter and designer) were the principal proponents of this art movement, also known as *Orphic Cubism.* The Delaunays manipulated theories of simultaneous contrast in abstract paintings. By juxtaposition of complementary hues, the colors were meant to create a sensory effect of rhythm, light, and movement. The painting shown here is a work in gouache entitled *Electric Prisms,* 1914, by Sonia Delaunay, who laid out the composition to suggest light emanating by distinct color areas and pure hues that are grouped by complementary contrasts. [4.5]

Figure 4–5 This painting by Sonia Delaunay presents combinations of contrasting complementary hues to generate dynamic movement through color. Sonia Delaunay, *Electric Prisms,* 1914, goauche, Musee d'Art Moderne Centre Georges Pompideau, Paris, France. © L & M SERVICES B.V. Amsterdam 20060403. Photo: Scala/Art Resource, NY

Sonia Delaunay collaborated with her husband Robert in a common pursuit to reveal the theories of Chevereul through both paintings and modernist design.

Albers and Color Interaction

Josef Albers (1888–1976) was a German painter, educator, and color theorist. He taught at the Bauhaus School in Germany prior to World War II. The Bauhaus School was a seminal art institution that melded fine art, design, crafts, and architecture. Albers later came to the United States, where he taught at Yale University. Albers probably would not have considered himself a color theorist in the traditional sense. His educational method was first to visually sensitize students to color before they learned about traditional color systems and charting. Albers' significant contributions to color education were presented in a famous book, *The Interaction of Color,* published in 1963. In his book, Albers outlined specific color exercises for students, focusing primarily on the notion of color interaction. Albers stated that one color could have many "readings," dependent on both lighting and the context in which the color is placed. He felt that the comprehension of color relationships and interactions was the key to gaining an eye for color. Albers' ideas were based on the research of Chevereul as well as extensive classroom experience and experimentation.

Josef Albers also put his ideas about color into his own paintings. In 1949, he began a series of paintings entitled *Homage to the Square,* which he continued to produce throughout his life. Through this series of paintings, Albers continually explored shifting color relationships between hues, value, color temperature, and saturation in a quest for ever-changing color harmonies. [4.6]

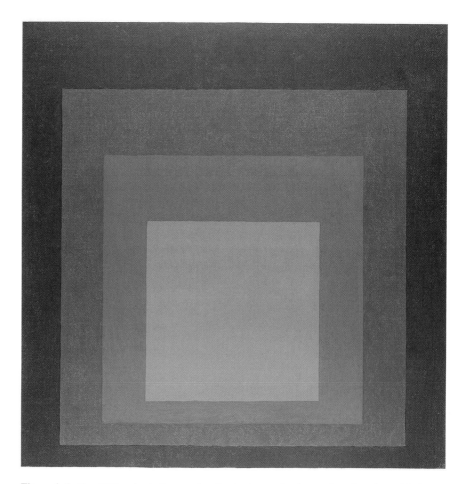

Figure 4–6 Josef Albers' paintings explored color interaction in a series of works entitled *Homage to the Square.* Josef Albers, *Homage to the Square, Open Outward,* 1967, oil on canvas, National Gallery, Berlin, Germany. © 2006 The Josef and Anni Albers Foundation/Artists Rights Society (ARS), New York. Bildarchiv Preussischer Kulturbesitz/Art Resource, NY.

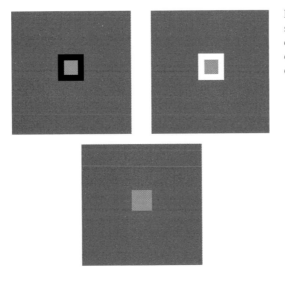

Figure 4–7 Color interaction studies should show direct interaction of adjacent colors. Black outlines seem to constrain colors, while white outlines isolate and expand color.

Color Relativity—Principles of Color Interaction

Many color classes are based solely on Albers' experiments and studies. Albers' methods are direct, meaningful, and sensitize students to color. Several important factors can be gleaned from *The Interaction of Color*. The content of Albers' book can be streamlined to aid in the comprehension of his concepts, as well as in positioning his ideas in the larger context of color study.

According to Albers, we rarely see a color that is not affected by other colors. Even when a color is placed against a pure neutral of black, white, or gray, the color is affected by that neutral ground. The study of color interaction entails a series of color "experiments" that illuminate our knowledge of how colors operate in relationships. The color transformations that result from these experiments are both striking and surprising.

For color interaction experiments, a relationship between two colors must be unequal, in which one color dominates another. Colors do not necessarily need to be dominated in order to be modified, but dominant color relationships dramatize our perception of color shifts. The ideal setup is a relatively large ground color in proportion to a much smaller area of the color to be affected. A smaller area of color is strongly affected because a large environment of color surrounds it. Colors for interaction studies also must be directly adjacent to one another without white or black outlines. [4.7] Color interaction is minimized by the containment of outlines.

Colors interact and are modified in appearance by other colors in accordance with three guiding rules or concepts. These rules are called the *Principles of Color Interaction*. These principles function either separately or simultaneously. The rules are presented in order of conceptual difficulty.

PRINCIPLES OF COLOR INTERACTION

1. Light/Dark Value Contrast
2. Complementary Reaction or Effect
3. Subtraction

LIGHT/DARK VALUE CONTRAST The first principle of color interaction is light and dark value contrast. The most efficient way to effect a color change is to utilize the principle of light/dark value contrast of grounds. Logically, a color will appear lighter on a black or dark ground and appear darker on a white or light ground. A light or dark value environment affects even an achromatic color like gray. The gray scale shown here has a circle of an

Figure 4–8 This gray scale illustrates how even achromatic colors can change our perception of value by color relationships. The gray circle inset in the gray scale is all the same value gray, which seems to change in comparison to the surrounding values.

identical gray value running through it. [4.8] Note the radical changes in the appearance of the same gray value throughout the scale.

Colors also react in a similar manner. For instance, red on a black ground seems to be both lighter in value and less heavy when compared to the same red on a light gray surface. On a light gray ground, red seems to be both darker and denser in saturation. [4.9] Colors appear to be lighter in value on dark grounds due to the comparative relationship between them. Similarly, colors appear to have a darker value on light grounds due to contrasting value relationships. A dramatic example, shown here, is the same light green presented on both a dark blue ground and a light blue ground. [4.10] It is difficult to tell that both greens are exactly the same; the green on the dark ground seems to be much lighter. In another example, the green has a different appearance from one ground to another, light in value on the dark ground and darker in value on the light ground. [4.11] In this manner, light/dark value contrast controls the perceptible value level of a color.

COMPLEMENTARY REACTION OR EFFECT The second principle of color interaction, called complementary reaction or effect, is a bit more complex. This principle exploits the concept of simultaneous contrast, a strong factor in color interaction. Remember that our eye "seeks" the complement of any given color, especially high-intensity colors. For this reason, a green on a red ground appears to have a higher saturation or intensity when compared to the same green placed on a neutral gray ground. [4.12] The complementary effect causes a color to "bend" toward the complement of a ground or dominant hue. Our eye causes the high-saturation red to make us "want" to see green, because it is a complement of red, for hue balance. This effect enhances the green and makes it seem to be more saturated.

In the second example, YG on a violet ground appears to have a more yellow cast than the same YG on a neutral gray ground. This illusion occurs because when we perceive violet, we simultaneously "seek" yellow, violet's complement, so YG is pushed slightly toward yellow. The principle of light/dark value contrast is also in play here.

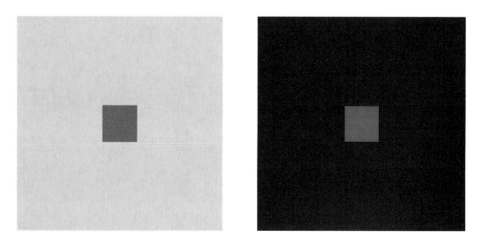

Figure 4–9 Color Interaction. Colors appear to be visually different dependent upon their context. Red appears lighter on black but heavier and darker on light gray.

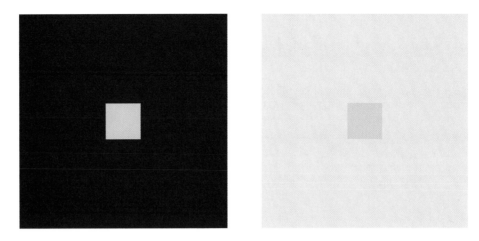

Figure 4–10 Value Contrast Principle. This tint of green seems to be lighter on dark blue and darker on light blue.

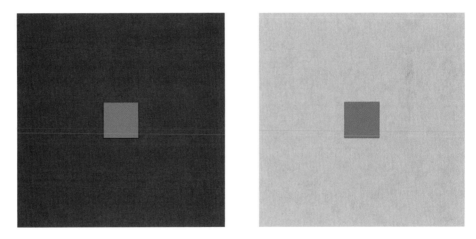

Figure 4–11 In this use of value contrast, the green seems lighter on a dark gray and darker on a light value gray.

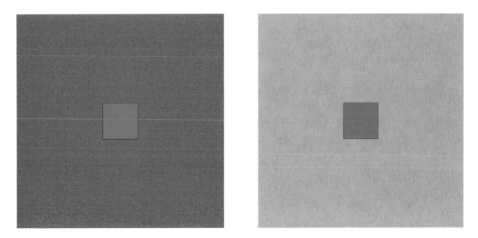

Figure 4–12 Complementary Reaction. Green appears more intense on the red ground when compared to how it appears on gray. This is caused by the complementary effect.

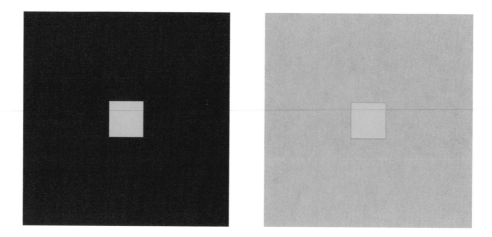

Figure 4–13 YG appears more intense on violet due to complementary reaction.

The YG appears to be lighter against the dark value of violet than it is on the paler gray ground. [4.13]

SUBTRACTION The last principle of color interaction is the rule of subtraction. This is perhaps the most difficult idea of the three principles to grasp. According to this concept, a strong or dominant color will actually subtract itself from a smaller or less dominant color. For example, a YO on an orange ground seems to be less orange, leaving it more yellow, when compared to the same YO on a neutral gray ground. The dominant color, orange, is subtracting itself from the YO, leaving a visual effect of simply yellow. In comparison, the YO also appears to be more orange against a gray ground. [4.14] The influence of the orange ground changes YO slightly in hue and lowers its saturation due to subtraction. In this manner, subtraction can slightly change a hue as well as the saturation of a color.

COLOR SUBTRACTION EQUATIONS The principle of subtraction can become rather complex. Therefore, we might regard color subtraction as a color equation. The equation, for example: $YO - O = Y$ explains briefly the color change in the previous example. In a second example, the same BV is placed on both a blue and a violet ground. [4.15] The BV in the violet environment looks bluer according to this equation: $BV - V = B$. The BV on the blue ground looks more violet according to this equation: $BV - B = V$. This study

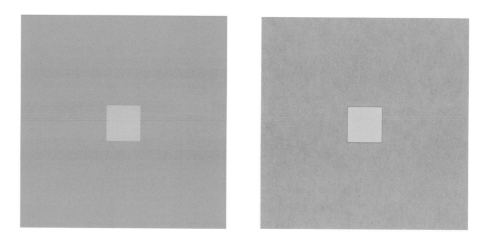

Figure 4–14 Subtraction. YO seems to be somewhat yellow on an orange ground due to subtraction. The orange subtracts itself from the YO, leaving more yellow.

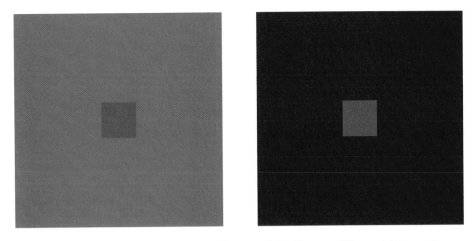

Figure 4–15 BV on a blue ground appears to be more violet. The same BV on a violet ground appears to be bluer. Both effects are caused by subtraction.

proves that by the careful manipulation of a color's surroundings even the base hue of a color can be altered.

Subtraction may also operate in the following manner. When a green is placed on a dominant blue ground, the blue will subtract its own component from the green as follows: $G(Y + B) - B = GY$. [4.16] This forces the green to appear more yellowish. The same relationship, when inversed, changes the color dynamic. The strong green ground causes us to "seek" red due to complementary effect. This "bends" the blue toward red, making it seem slightly more BV. In this manner, even saturated hues can be visually distorted due to their color environment.

ALBERS' STUDIES To demonstrate the principles of color interaction, Albers designed two color study experiments, which are classic in their simplicity, yet illuminate the idea of color relativity. Knowledge of color interaction principles is essential for execution of Albers' color interaction studies. These studies are best made with colored paper. When choosing the colored grounds, one should try to pick colors that are very different in both hue and value. This exercise is fairly easy to do. Often, the student has great success with the first study by trial and error without fully understanding the three principles of color interaction. However, to truly comprehend color relativity, students should attempt to

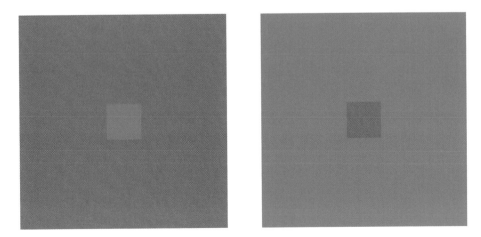

Figure 4–16 Examples of subtraction. In this case the colors are in an inverse relationship to demonstrate subtraction. The green on the blue ground seems slightly more yellow; the blue on the green ground seems slightly more violet.

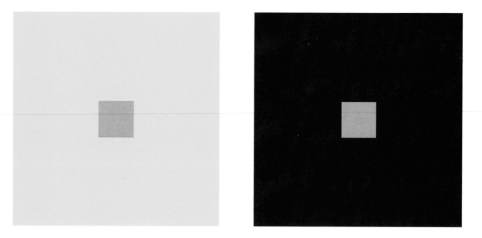

Figure 4–17 Value Contrast and Subtraction. Light violet appears to be more saturated and darker on a yellow ground. The same color looks lighter and less saturated on a dark violet ground due to subtraction.

explain why their color experiment works, citing the principles involved. Some colors react more strongly to color surroundings and others resist change. For instance, very saturated or warm colors can be very hard to change. A full-saturation yellow, in particular, resists being changed in appearance under many circumstances. In contrast, most low-saturation colors change easily. Experimenting with a wide variety of colors ensures success.

In the first study, the goal is to *make one color appear to be two colors* by changing the color of the ground or context color. Two examples of the first Albers' study are presented here. The first example exhibits all of the three principles. [4.17] A light violet appears to be darker on the yellow ground because of the light value of yellow. The violet also seems to have a higher saturation (to be stronger violet) on the yellow ground due to complementary reaction. Remember, we "want" to see violet when we perceive yellow, thus, the violet hue is enhanced. The same light violet appears to be even paler and duller (lower in saturation) on a dark violet ground. Subtraction occurs here; the strong violet ground subtracts itself from the light violet, lowering its color intensity. Both of these col-

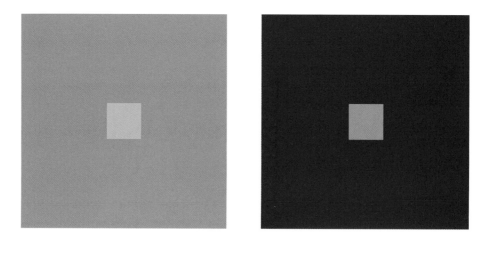

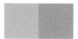

Figure 4–18 Albers' Study. Two colors look like one color. The light warmer tint of red appears more RV against the RO ground. The darker RV tint appears to be lighter and is pushed toward orange by the dark blue ground.

Figure 4–19 The lighter BG looks darker and less green on the YG ground due to subtraction. The blue appears lighter on the dark RO ground and also slightly greener because of the complementary effect.

ored grounds have effectively changed our perception of the violet color in two ways, shifting both its value and intensity.

The second classic Albers' study is to *make two different colors look like one color* by the illusion of color interaction. This is a more challenging study to execute. When choosing two different colors for this study, one may select two value steps of one hue, two slightly different hue variations such as blue and BG, or two different saturation levels of the same color. Logic, as well as a grasp of the color interaction principles, makes this study easier to execute.

For the first example, a light and a darker tint of red (pinks) have been chosen. The goal is to visually equalize these two colors by manipulation of ground colors. [4.18] To make the lighter pink appear darker, it has to be placed on a lighter value ground. To make the darker tint of red appear to be lighter, it has to be placed on a darker value ground. The lighter pink has an RO cast, so it is placed on a full saturation RO, to subtract some orange and leave it a cooler pink. The lighter pink, in turn, can be pushed toward RO by placing it on a blue ground to bring about the complementary reaction. The dark blue forces the pink to have an orange cast as well as making it slightly lighter in value.

Two slightly different hues can also be visually equalized. [4.19] A lighter BG and a slightly darker blue can be made to look the same by careful experimentation. The lighter BG can be placed on a YG ground to make it darker in value and pull some of the green cast out of it by subtraction. The yellow also pushes the BG toward violet, making it seem more like a BV. The darker blue looks lighter and more BG on a dark red ground. This occurs because the red ground brings out any green component in the blue due to complementary reaction.

OPTICAL MIXTURES

Optical mixtures are a type of color interaction that expands upon color relativity by finely interwoven areas of color. In optical mixtures, two or more colors can either oppose or blend with each other. *Optical mixtures* of color employ tiny amounts of two or more colors, which visually blend to create yet another (third) color. Either pigmented materials or light may form an optical mixture. In light, optical mixtures are responsible for the colors that we see on our television screens and computer monitors. In the four-color printing process, subtractive optical mixtures create all the colors. The process primaries, cyan, magenta, yellow, plus black, are printed in tiny dot patterns to mix visually.

The human eye is incapable of signaling rapid fluctuations of light and dark to the brain. Film, for example, has a frequency of 48 individual flashes of light per second. Our eye and brain process these flashes as a continuous moving picture. This optical phenomenon is known as the *persistence of vision.* The idea of optical mixture is interrelated with the notion of persistence of vision. An optical mixture is a blend of two or more colors that occurs in the eye and brain and creates a single color sensation. There are two major color theorists who broke ground in the area of optical mixture. James Clerk Maxwell and Michel Eugene Chevereul, the researcher of simultaneous contrast, both explored optical mixtures. Chevereul discovered that many color mixtures were obtainable from a relatively small number of colored yarns in textile manufacture. He explained that these colors were produced by optical combinations of yarn in the fine thread grid (the warp and weft) of woven fabric.

Color Mixing Discs

Nineteenth-century color theorists' research was directly aimed at assisting artists in the practical use of color. The device created to demonstrate visual mixtures was an optical mixing disc, sometimes called Maxwell's disc after James Clerk Maxwell (1831–1879), the Scottish physicist. Maxwell used the mixing discs in his research on the light primaries. Chevereul, Goethe, Ostwald, and Albers also did research with a mixing disc. An optical mixing disc is essentially like a toy top with a pattern of two colors in a stripe configuration. The top is spun to see how the colors "mix." When we see rapidly alternating colors in sequence, the colors appear to be continuous. Due to persistence of vision, the two colors seem to be a single color.

Color discs or tops can be constructed and spun manually or on a drill bit to form optical mixtures. For example, a disc that alternates blue and green will produce a color sensation of cyan when rotated. [4.20] When two colors are optically mixed by movement, the resulting color is an additive rather than a subtractive mixture. For example, when a disc with stripes of blue and green is twirled, we see the additive mixture of cyan rather than the subtractive mixture of BG. [4.21] Theoretically red and blue should result in magenta; green and blue should make cyan; and red and green should appear yellow when visually mixed by movement. [4.22] In reality, the mixing discs form muted rather than pure versions of these colors. [4.23] Stripes of complementary hues on a cardboard disc or top emulate the experimentation of Nicholas Ogden Rood (1831–1902), an American scientist and artist color theorist who explored optical mixtures. Rood's experiments with color discs verified the exact complements of hues in artists' pigments, as presented in his book *Modern*

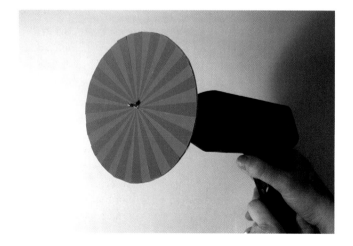

Figure 4–20 A stationary analogous mixing disc.

Figure 4–21 Analogous optical mixture by motion. Analogous colors keyed to the same value will visually mix and become lighter because they mix additively when in motion.

Figure 4–22 A complementary mixing disc.

Figure 4–23 When moving, the mixing disc appears as a red/green chromatic neutral, tinged with yellow, which is the additive mixture of red and green.

Chromatics (1879). He experimented with mixing discs using complementary colors to fabricate grays and to pinpoint exact pigment complementary colors. Optical mixing discs can also produce lower saturation colors when a color is alternated with gray, black, or white.

Broken Color

The static juxtaposition of two or more colors can also produce the sensation of a third color. This technique is also called broken color. Eugéne Delacroix (1798–1863), the French artist, used color hatching to make new colors from optical mixtures of small marks of color. Optical mixtures can produce a type of color atmosphere in a painting. The Impressionists, for example, felt that small marks of color adjacent to each other in a painting would create a more vibrant sense of light than a flat or gradated tone. Broken color was a strategy used by painters throughout history, but most vividly put to use by the Impressionist painters and by a Post-Impressionist named Georges Seurat.

Georges Seurat (1859–1891) was a French artist very engaged with a new approach to color in painting that he dubbed divisionism. [4.24] *Divisionism,* sometimes called *pointillism,* was a sophisticated method of generating color luminosity in a painting. The colors that Seurat used, for example, to make a brown, are tiny dots of red and green placed next to each other. The small marks of color, even though they were not physically mixed, generated brown by optical mixture. This brown is similar to the chromatic neutral made from a physical mixture of red and green pigments. However, Seurat created color sensations with pointillism that were lighter in value than physically mixed colors. Optical mixtures seem to blend in a quasi-additive manner, producing both higher luminosity and color saturation.

Optical Mixtures of Pigmented Color

An optical mixture of traditional materials such as pigment, inks, or dyes involves the use of tiny dots, dashes, or marks of at least two colors. [4.25] Optical mixtures may create a hue, value, or saturation change depending on what colors are mixed. To understand the concept of optical mixtures, the student can formulate simple two-color studies. Each color in these studies should occupy an equal amount of surface area. There are many types of color combinations that readily mix, however, two specific types of optical mixtures can illuminate how colors harmonize or contrast.

The first type of optical mixture is called a *sympathetic analogous mixture.* Analogous hues are neighbors on the color circle, causing them to be both sympathetic and harmonious with each other. The color similarity of analogous colors allows ease of

Figure 4–24 Georges Pierre Seurat, *Evening Honfleur,* 1886. Oil on canvas, 25-3/4″ × 32″ (65.4 × 81.1 cm). The Museum of Modern Art, NY. Gift of David M. Levy. Photograph © 2003 The Museum of Modern Art, New York. Seurat employed a form of optical mixing by using small dots of color. He dubbed this method "divisionism."

visual blending. Theoretically, a wide gap between hues can form an optical mix, such as blue and red to make violet. In a fine pattern of two colors as in pointillism, the optical mixture imparts an effect similar to a subtractive pigment mixture but with additional luminosity.

A pair of neighboring hues from the color circle such as YG and green yield a more subtle optical mixture. If a fine mosaic is created with these hues, it results in a visual mixture of a color between YG and green. [4.26] When manually creating a mosaic from colored paper or paint, it is difficult to form a mesh fine enough to visually blend. The result may become a pattern with too much value contrast. If colors are keyed to the same value level, in this case by lightening the green to the same value level as YG, this achieves a more convincing visual mix. Contrasting values do not fuse as readily as value-keyed colors because colors of a close value blend together, seeming to exist within the same spatial plane.

The second type of optical mixture is quite different. This optical mixture is made from opposing or complementary hues. In a very fine pattern, a complementary pair such as yellow and violet will neutralize each other in the same manner as they would in a pigment mixture. However, if a coarser textured mosaic is formulated, a phenomenon called *complementary vibration* occurs. Our eye "wants" to see the complementary colors simultaneously for visual balance. However, when we do see the pure complementary hues simultaneously, something unexpected occurs. The complements seem to repel each other, causing an illusion of movement or visual vibration. [4.27] Note that this study is difficult to stare at for any length of time! High saturation (pure) opposing hues vibrate in the most

Figure 4–25 Optical mixtures of small areas of color. Clockwise, from top left: complementary colors, analogous colors, two hues, and a color and gray.

dramatic fashion. Red and green create one of the strongest complementary vibrations because the hues are close in inherent value.

The painting by Richard Anuszkiewicz takes advantage of the complementary vibration of red and green to create a luminescent effect that emanates from the central square. [4.28]

OTHER TYPES OF COLOR INTERACTION

The Bezold Effect

Wilhelm von Bezold (1837–1907) was a German scientist who attempted to create a color system based on perception. Like Chevereul, he was involved in textile production. In the course of his research, he noted that a single color change within a pattern affected the appearance of all the remaining colors in the pattern. In this type of color interaction, the substitution of a single integral color causes multiple color alterations in a design, a phenomena known as the Bezold effect. Bezold's theories are practical for artists or designers who work with groups of color combinations. The Bezold effect is most noticeable in a pattern

Figure 4–26 If YG and green are to form an analogous optical mixture, they have to be adapted since there is too much value contrast between the hues. Colors that are keyed to the same value level will visually mix more readily; YG and green formulate a color between the two hues.

Figure 4–27 A strong complementary vibration is caused by the juxtaposition of pure red and green.

rather than in composition because compositional forces do not interfere with color perception in simple patterns. In Bezold studies individual colors not only change in appearance, but relationships between colors are also affected. Shifting the appearance of an entire group of colors is more challenging than modifying a single color. In this example, the contrast between the blue stripe and the yellow circle seems to be stronger on the left section of the illustration than on the right [4.29]. Colors seem to change in a different manner dependent on each relevant principle of color interaction. For instance, the colors

Figure 4–28 Richard Anuskiewicz, *Iridescence,* 1965. Acrylic on canvas, 60″ × 60″. Albright-Knox Art Gallery, Buffalo, NY. Gift of Seymour H. Knox, Jr. 1966 © Richard Anuskiewicz/ Licensed by VAGA, New York, NY. This painting by Richard Anuszkiewicz produces a luminescent effect by the complementary vibration of the red and green optical mixture relationship in the central area of the painting.

Figure 4–29 The Bezold Effect. Note that the colors and color relationships appear differently from only a single color change.

in the illustration do not all change equally; the yellow, blue, and green circles have the most dramatic color change, while the pink stripes shift only slightly.

Color Dominance

The Bezold effect is created by a single color change integral to or dominant in a composition. Color dominance occurs when a single hue, value, or saturation is permitted to be preeminent in a composition. A dominant color influences all the colors in a composition by covering the most physical area of a composition. When a dominant color is relocated to another place or given another proportion within a composition, the color dynamics of the entire composition are changed. [4.30] In order to understand color dominance, one can reposition an identical set of colors to various locations in identical compositions. One can also manipulate proportions of the same set of colors in identical compositions. Variations in color proportion and location can rearrange the compositional forces of visual weight and balance. The same color palette and composition is used for all of the examples shown.

COLOR TRANSPARENCY

Actual Transparency

Actual color transparency is either the perception or use of transparent colored materials. Actual transparent materials are colored glass, filters, acetates, transparent plastic, and other items. [4.31]

Most color perception is a result of either reflection or absorption of various light wavelengths. In our perception of a transparent object, a different phenomenon occurs. Light is transmitted when it passes through a transparent object that filters light wavelengths to create a color sensation. For instance, green glass blocks both blue and red light wavelengths and transmits only green light.

The only transparent traditional art material is watercolor. The transparent films of watercolor achieve glasslike effects and a sense of volume on a two-dimensional surface because of the many paint layers.

Transparent media creates actual transparency with either watercolor or thinned acrylic paint (using no white). Colored washes or glazes are actually transparent films of color. Shapes can be overlapped in a design to demonstrate color transparency. Where

Figure 4–30 Color Dominance. One color dominates each composition showing that the dynamic of a composition can be shifted with the repositioning of color. An identical group of colors is used in varying proportions and positions within each composition.

colored shapes overlap, layers of paint form a visual mixture of the colors involved. For example, yellow glazed over blue produces green. In transparent washes, care must be taken to equalize each wash's color saturation and value. Otherwise, stronger or heavier colors will dominate, reducing the color transparency.

Simulated Transparency

A type of color interaction in which opaque media produces the illusion of an actual transparency is called *simulated transparency*. Two opaque colors overlap and seem to "mix" into a third color (also an opaque color) creating an illusion akin to colored glass or film.

Figure 4–31 Transparent colored objects transmit a particular color wavelength, blocking other wavelengths.

Figure 4–32 Student example by Merrill Stephens of simulated transparencies in a design.

Opaque colored paper is the optimal medium to formulate simulated transparency. Colored paper studies help us to visualize "mixtures" between two "parent" colors, instead of manually mixing paints. [4.32]

Any two-color combination can be selected to formulate simulated transparencies. To envision a subtractive color in between two parent colors is a logical process based on the color circle. For instance, the artificial transparency between the hues blue and red is violet. Various violets can be selected to approximate the in-between color mixture. By physically placing the violets in between the parent colors, one color will seem to "click" to form the optimal illusion of transparency. An in-between color that simulates transparency cannot be higher in saturation or darker in value than either of the two parent colors.

Simulated transparencies can also be formed from virtually any color pairing. Some examples shown here are two-value variations of the same hue, complementary colors that form chromatic neutrals, and two different hues that make a third hue. [4.33]

Another way to create a simulated transparency is to use opaque paint to mix the color between the two parent colors. This is usually more difficult since in painting, subtractive mixtures of color have a tendency to become darker and less saturated than the parent colors. To alleviate this problem, the in-between color can be lightened in value.

Color is a relative visual sensation. This makes it subject to change based on lighting, color environment, surrounding colors, optical mixtures, and transparency. The study of color relationships sensitizes us to the interaction of color.

ACTIVITIES

1. COLOR INTERACTION STUDIES

Objective: For the student to understand that color perception is influenced by surrounding colors. The following are classic Albers' studies of color interaction.

Media: Colored paper.

A. Make one color look like two colors.
- Using the concepts in this chapter, take one color and place it on two different grounds to make it appear to be two different colors.
- The proportion should be approximately 6″ × 6″ or 5″ × 5″ square for the ground and a 1″ × 1″ square or a 1/4″ stripe for the color to be changed.

Figure 4–33 Simulated transparencies made with opaque colored paper. The correct choice of an in-between color must be chosen from the two parent colors. Simulated mixtures clockwise from the top include two value levels of one hue, hue-to-hue mixtures, two analogous hues, and complements that mix to form a chromatic neutral.

- The point is to make the same color look radically different by manipulation of various colored grounds. Try many possibilities with colored paper until you get a major color change.
- Remember to make the grounds as different as possible. Differences in hues (opposite hues), saturation, color temperature, and/or value are needed to truly change the color you have chosen.
- When the color interaction is complete, cite the principles used that implemented your color change. [4.12, 4.15]

B. Make two different colors appear to be the same color.
- This study is invariably more difficult than the first study.
- Pick two slightly different colors from colored paper.
- The colors may vary in value, for example, a lighter and a darker orange. They also can be slightly different in hue, a green BG and a bluer BG, for example. The two colors might be slightly varied saturations of one color, for example, blue and a tone of blue.
- Now pick two different grounds to try to equalize the two colors that you have chosen.
- Try to use the three principles of color interaction to implement this. Example: If you are using a lighter and darker value of one color, you can put the light color on a light ground and the dark value on a dark ground. Also use subtraction and/or complementary reaction if necessary.
- Save an extra piece of each color used and place it as shown with your study. This will indicate where each color is placed and indicate the color differences. [4.18, 4.19]

2. OPTICAL MIXING STUDIES

Objective: The student will create two optical mixtures, one that makes two colors blend visually and one to create complementary vibration. Physical movement can be used to create additive color mixtures.

Media: Colored paper.

A. Analogous Optical Mixture
- Pick a pair of analogous or almost analogous hues (by skipping the in-between hue) from the color circle. Example: Blue and BG or red and violet.
- The colors should be keyed to the same value as closely as possible. The value match will create a better optical mixture.
- Make a pattern or fine mosaic of stripes, dots, a grid or any pattern using equal surface area for each of the two colors. This will let them blend visually when viewed from a reasonable distance.
- The result will be two colors that blend optically to create a third color that is in between the two. Example: yellow + orange = YO or yellow + YO = YYO. [4.34]

B. Complementary Vibration
- This visual mixture is the opposite of an analogous mixture.
- Pick any dyad or complementary pair from colored paper.
- Make sure that the colors of the dyad are high in saturation, as shown.
- Create a similar or the same pattern mesh as in exercise 2A.
- You should notice a strong movement or vibration as you look at this study.
- If you view it from across the room, you will notice a change in contrast and possibly a neutral color. [4.34] [4.27]

C. Optical Mixture Discs
- Make several optical mixing discs to show additive color mixtures.
- The discs should be circular, either glued or painted on a toy top or made of a flat cardboard disc to be spun on an electric drill.
- You can use two analogous hues, complementary hues, or black and white. Glue or paint the two colors in an alternating stripe pattern, or make them on the computer and print out and adhere onto heavy paper or light board.
- What color sensations do you get when the discs are revolved? How are the results different from what you would expect?

3. BEZOLD EFFECT STUDIES

Objective: These studies are meant to explore the concept of the Bezold effect, multiple color interactions, and color dominance.

Media: Colored paper, paint, or a graphic program on a computer.

A. Bezold Effect
- Plan a simple geometric pattern that uses four or more colors.
- Choose two different grounds for your studies that substantially change the appearance of all the colors in the study. Try to choose grounds that are opposing light and dark values, complementary hues, or colors that are high and low in saturation.

Figure 4–34 Student examples of optical mixtures. Left: vibrating complements. Right: analogous by Marlene Shevlin.

- The design should appear to be very different chromatically from one ground to another.
- Make sure to let the colors in each design interlock so that the change in interaction between them can also be noted. [4.29, 6.19]

See Chapter 6 Activities for a version of this study on computer.

B. Color Dominance Studies
- Pick five or more colors to create two or four studies. Create a simple design or pattern.
- Make two studies using the same color selection and the same design.
- Each study should have one color (from your chosen group) that dominates the whole study. You can also change the location, proportion, or repetition of colors from one study to the next.
- The point is to radically change the appearance of the same design and color grouping by the location and proportion of the colors. [4.30]

4. TRANSPARENCY STUDIES

Objective: The student will work with both actual transparencies (transparent media) and with simulated transparencies (opaque media) to understand the differences between the two concepts.

Media: Colored paper, watercolor or acrylic paint.

A. Actual Transparency Study
- Choose at least four hues or pigment colors with which to work.
- Make a simple overlapping design of geometric shapes or brush strokes on cold press illustration board or watercolor paper. Draw design out in pencil.
- Try to have some areas where at least three shapes overlap.
- Use either watercolor or acrylic paint (watered down and without white) to create washes of each of your chosen colors.
- Make sure all of your colored washes are of approximately equal intensity.
- Carefully fill each shape of your design with the washes. Make sure that you let each layer dry before washing over with another color. Layer color carefully to create transparencies.
- As desired, you may leave the background white or paint it black. [4.35]

See Chapter 6 activities for a computer version of a similar study.

B. Simulated Transparency Study
- From colored paper, choose at least four pairs of colors that you want to overlap in a design. Make sure each pair is a different type of color combination.

Figure 4–35 Actual Transparency Study. Transparent color media can be used to create a study that is made from washes of overlapping color.

Figure 4–36 Student example of a simulated transparency study by Kristen Walkowiak.

- Design a simple overlapping structure using geometric or free hand shapes.
- Pick colors that represent the in-between or offspring color between all four sets of parent colors that you have chosen. [4.33]
- Where the components of your design overlap, place the appropriate colors to simulate the illusion of transparency.
- The negative or ground color should be dark or neutral to accentuate the illusion of transparency. [4.36]

Chapter 5
The Materials of Color

INTRODUCTION

Artists and designers have a wide assortment of colored materials to adopt for color harmony, expression, and design. Colored media is wide ranging, from physical materials like pigments and dyes to printing processes and including light itself. *Physical color materials* are those used directly, such as paints, colored drawing materials, and textile dyes. *Process media* is used indirectly through printing, photography, and computer graphics.

PHYSICAL COLOR MATERIALS

Physical color materials are called colorants. A *colorant* is a compound that imparts its color to another material. The word colorant has multiple definitions. A colorant may be formulated from the color component of a natural object, such as a stone. It also may be the colored ingredient of a mixture, like the pigment in paint. A colorant is also defined as an agent that lends its color to another substance, like a fabric dye.

Pigmented Materials

Pigment is the oldest form of colored art material used by man. Cave paintings are comprised of assorted earth pigments. A *pigment* is defined as a colored powder that imparts its color effect to a surface when distributed over that surface in a layer. A pigment is a chemical substance capable of reflecting a particular light wavelength, which then generates a specific color sensation. Pigments are finely ground powders that are insoluble in a binder. [5.1] Pigments must be mixed with a binder, also known as a *vehicle,* to become paint. Without a binder, a pigment cannot adhere to a surface, but simply dusts off as a powder. When pigment is ground into or mixed with a binder, it does not dissolve but instead forms a liquid/solid suspension. Pigment powders are made of the same chemical substances regardless of the type of pigmented painting or drawing media. For example, ultramarine blue pigment always has the same composition, whether it is formulated into tempera, oil, acrylic, or watercolor paint. [5.2] Each type of painting media is distinguished by its binder which determines the paint character, handling, and the color appearance of each pigment. The surface or *support* (such as canvas) to which paint is applied also affects each painting media's individual personality and disparities.

Most artists' pigments are colorfast. *Colorfastness* is the resistance of a color to losing its original color quality, which means that it will not darken, fade, bleed, or wash out

Figure 5–1 A pigment is a colored powder that is mixed with a binder to make paint. Shown here are an earth pigment and titanium white pigment.

over time. Artist's colors generally have high colorfastness ratings, although there are a select few colors that are somewhat less permanent.

Pigments do not adversely react with vehicles or binders since they are chemically inert. Pigments also vary in opacity or transparency levels. Although the same pigments are used throughout every painting media, some are more suited to a particular medium. For example, transparent pigments (such as ultramarine blue) are especially suited to watercolor, a transparent painting medium. Opaque pigments (such as cadmiums) are particularly appropriate to oils, an opaque painting medium. There are U.S. government standards for labeling pigments; all pigments contained in each particular color must be listed on the label of the paint container.

Types of Pigment

There are two categories of pigment, organic and inorganic, which are further divided as follows:

INORGANIC

Earths—Ochres, umbers
Calcined Earths—Burnt Umber, Burnt Sienna
Artificial Mineral Colors—Cadmiums, Zinc Oxide

ORGANIC

Vegetable—Gamboge, Indigo, Madder
Animal—Cochineal, Indian Yellow
Synthetic Organic—Phthalos, Alizarin, Azo, Hansa, Quinacridone

Before the nineteenth century, most coloring agents were derived from natural sources. Many of these sources were difficult to obtain or time-consuming to process.

Figure 5–2 The same pigment, Ultramarine Blue, is shown here in different binders. From the left: pastel, oil, watercolor, acrylic, and gouache. Notice the differences in color and surface.

Bright colors such as blues, reds, and yellows were more expensive or unavailable. The plentiful and inexpensive pigments were the earth colors. Earths are native clays (inorganic) with high metal content such as red ochre, iron oxides, siennas, umbers, ochres, and green earth. Inorganic minerals were rarer, as they were ground natural ores, such as cinnabar, malachite (green), azurite (blue), ultramarine (lapis lazuli), which were essentially ground colored stones. Most surprising to today's artists are the contents of the pigment compounds made from animals. Examples of these are sepia (ink of cuttlefish), crimson (dried lice), carmine (cochineal insects), Indian yellow (cow urine). Other organic sources included plants, roots, berries, flower heads, barks, and leaves. Examples include the root of the madder plant to make rose madder, a red; chamomile flowers for yellow; iris or ragweed for green; and an Indian plant, indigo, for blue.

In the nineteenth century, pigments and dyes were beginning to be chemically produced. Many of these pigments were dyes fixed to inert inorganic pigments. Some examples of these are the red and orange lake pigments. Major synthetic organic pigments that are still in use today are phthalos (greens and blues), azos (yellows, reds, and oranges), and quinacridones (reds and violets), along with many more. Natural pigments from organic sources are much less permanent than the organic synthetics, which are permanent and intense colors. Inorganic pigments are still used today, in particular, the earth colors and artificial mineral colors such as the cadmiums. The number of pigment colors available today would stagger the artist of the Middle Ages or Renaissance.

Hues from the color circle do not always correlate with a single pigmented color. Often there are several pigment color choices for each hue; for example, a blue-green may be cerulean blue, manganese blue, or phthalo blue. Some common pigments equivalent to the traditional twelve-hue color circle are outlined on Table 5–1, which also includes the chemical content of each pigment.

Vehicles and Binders

The definition of a *vehicle* or *binder* is a substance that holds and binds pigment particles together. A binder also assists in easy application of a pigment to a surface. A vehicle must dry to a durable film that both suspends the pigment and binds it to a surface support. A *support* is an appropriate surface to which each paint medium is applied, whether paper, wood, or canvas. All vehicles or binders have a measure of plasticity, in order to allow paint to flow or be paintable onto a surface. The texture of the binders can range from a thin liquid to a thick paste. Binders include an array of substances: fats, oils, gums, waxes, resins, and polymers. [5.3] Each type of vehicle causes pigments to behave in a particular way when light is absorbed or reflected from the painted surface. Pigments are generally darker when a binder is added because the pigment's refractive index (how much light refracts or bends when in contact with the surface) is lowered. Each pigment has a reflective surface quality dependent on the type of particles involved. Since pigments are derived

Figure 5–3 Vehicles bind a pigment to the surface support. Clockwise from top left: linseed oil for oil paint, gum arabic for gouache and watercolor, acrylic polymer for acrylic paint, and beeswax for encaustic.

Table 5-1

Chart of Hues and Pigments

Hue Name	Pigment Name	Pigment Characteristics	Pigment Source
Yellow	Cadmium Yellow Medium	Opaque, warm yellow	Cadmium Yellow
	Hansa Yellow Light	Transparent, cool yellow	Arylide Yellow and Zinc White
YO	Cadmium Yellow Deep	Opaque, very warm yellow Semi-transparent, YYO	Cadmium Yellow Deep
Orange	Cadmium Orange Hue		Arylide Yellow and Perinone Orange
	Cadmium Orange	Pure orange, opaque	Cadmium Orange
RO	Cadmium Red Light	Opaque, warm red	Cadmium Red Light
	Napthol Red Light	Semi-opaque	Napthol Red and Zinc White
Red	Cadmium Red Medium	Opaque	Cadmium Red Light
	Permanent Red	Semi-opaque	Napthol Red and Arylide Yellow
RV	Quinacridone Red	Transparent	Quinacridone Red
	Alizarin Crimson	Transparent, warm RV	Alizarin Crimson
	Cobalt Violet	Transparent, cool RV	Cobalt Violet
Violet	Dioxazine purple	Semi-opaque	Dioxazine Purple
	Permanent Violet	Semi-transparent	Ultramarine Violet and Dioxazine Purple
	Manganese Violet	Transparent, slightly BV	Manganese Violet
BV	Ultramarine Violet	Transparent	Ultramarine Violet
	Ultramarine Blue	Transparent	Ultramarine Blue
Blue	Cobalt Blue	Semi-opaque, cool	Cobalt Blue
	Brilliant Blue	Semi-transparent	Phthalo Blue and Ultramarine Blue
BG	Phthalo Blue	Semi-transparent, intense	Phthalo Blue
	Cerulean Blue	Opaque	Cerulean Blue, Chromium
Green	Cobalt Green	Semi-opaque	Cobalt Green
	Cobalt Turquoise	Semi-opaque	Light Green Oxide
	Permanent Green Light	Opaque	Phthalo Green and Arylide Yellow
	Phthalo Green	Transparent, cool, intense	Phthalo Green
	Viridian Green	Transparent, cool	Viridian
	Cadmium Barium Green Light	Opaque	Cadmium Barium Yellow and Phthalo Green
YG	Yellow Green	Semi-opaque	Phthalo Green, Arylide Yellow, and Zinc White

from widespread sources, occasionally a binder will cause a pigment to become more opaque or transparent. [5.4] Overall pigment color quality is affected by the following factors: the nature or type of vehicle used, the gloss or matte quality of the paint surface, the type of light on the colored surface, the interaction of colored areas, the transparency or opacity of the medium, and the type of paint application.

Figure 5–4 Notice the color differences between cerulean blue dry pigment (on left) and cerulean pigment in a binder, shown here in oil paint.

Opaque and Transparent Media

Opaque paint is sometimes referred to as "body color" because it completely covers the surface onto which it is painted. No light filters through a paint film that is opaque; rather, the colors are made visible through the absorption and reflection of light. Opaque color can also be thinned and used in a transparent or translucent manner. The *undertone* of an opaque color is the appearance of a color when it is used in a transparent manner or tinted. [5.5]

In transparent media, light can pass through the paint layers to the support below. Watercolor, oil glazes, markers, dyes, and some inks are transparent. In transparent media, light value colors are attained without the use of white since the white support shows through a thin film of color. The effect of transparent colors is due to the transmission and reflection of light. [5.9]

Colorfastness of Artist's Materials

The permanence of colored materials is an important concern to artists and designers. We tend to assume that all materials sold by the art retailer or the inks printed from our computer are permanent. This is certainly not always the case. It can be reliably said, however,

Figure 5–5 Body color in opaque paint is the color seen when the paint is applied heavily and used as a mass. Undertone is the color seen when the paint is applied thinly or tinted with white. Shown here from top: Dioxizine Purple, Cadmium Red Light, Phthalo Blue, Alizarin Crimson, and Permanent Green Light.

that most pigmented materials are tested for lightfastness and permanence ratings. Sometimes a paint manufacturer will have the color's permanence rating listed on the paint container. U.S. paint manufacturers are required to supply permanence information, but since many brands of paint are imported, the ratings may often be found on color charts, in product catalogs, or on the website of each manufacturer. Note that permanence ratings only apply if art materials are properly used. Pastels used on Mylar or oil paint on glass may present problems that the manufacturer could not anticipate. In the United States, toxicity ratings and the exact pigment content of each color must be listed on the packaging of artists' colors. Often the paint's opacity and tinting strength is also included. It is best to purchase paints that list the true pigment components of each color on the container.

All artists' pigments are rated for lightfastness. Artists' pigments are held to a much higher standard than, for instance, commercial wall paint. Lightfastness tests are done on both full strength pigments and tints of the pigments. The pigments are exposed to approximately 600 hours of sunlight, then they are checked for fading. Lightfastness ratings range from I to V, I being the highest rating. Paints are also checked for tinting strength, opacity, and toxicity. Sometimes they are checked for drying rate, consistency, and paint composition.

Student- and Professional-Grade Colors

When shopping for art materials, we are confronted with a dizzying number of options, particularly when buying paint. There are usually two or more quality grades of paint, which may not be evident to the student or novice reading the label. Student grade paints have a slightly lower quality level than artist-grade paints. Student colors are just as permanent as artist-grade paints, but there are some key differences. Student colors are lower in cost, contain somewhat less pigment, use alternate pigments, and have a more limited color selection than artist-grade paints. In student paints, there can be pigment substitutions labeled as "hues." [5.6] For example, a tube labeled "cadmium yellow hue" indicates that the pigment content is not true cadmium but a substitute pigment, such as Hansa Yellow mixed with a little white to give it the appearance of true cadmium yellow. A cadmium yellow hue

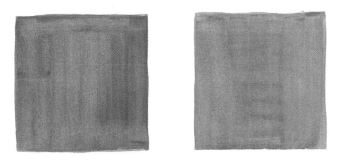

Figure 5–6 Student versus artist-grade color. Notice the difference between true Cadmium Yellow Light, artist grade (top right) and Cadmium Light Hue, student grade (top left). Notice also real Cerulean Blue, artist grade (bottom right) and the student grade (bottom left). All the colors are permanent but the student grade paints use alternate pigments.

may handle and mix with other colors differently than true Cadmium Yellow, but otherwise it is a safe, permanent color. Note that student-grade paint does not include children's art supplies, which are meant for fun and not tested for permanence. Children's art supplies are not recommended for any serious artwork.

Painting Media

ENCAUSTIC One of the earliest forms of painting media is encaustic. Encaustic is pigment mixed with melted beeswax and resin. The colors must be warmed (melted) to be applied. A process called "burning in" finishes off the paint surface. In this process, the paint surface is smoothed with a hot metal implement. Encaustic and waxed-based painting methods were used in Egyptian and Roman funerary portraits. The Roman portraits' lifelike effects attest to the skill of these unknown artists as well as to the permanence of the painting medium. Some contemporary artists make use of this ancient medium, which is characterized by high luminosity colors and a matte, satiny finish. [5.7]

FRESCO Fresco painting is a method of mural or wall painting in which the pigment binds with the plaster support. The fresco technique is unique in this regard, not having a traditional binding agent. Pigments are ground in water and then applied onto wet lime plaster. The plaster must be wet or damp for the binding properties to work correctly, which gives the artist a limited time to work. As the plaster dries, the pigment penetrates into its surface, cementing itself to the lime. In Secco fresco technique, specific colors, such as Azurite Blue, are painted onto dry plaster. Fresco technique has been used from Minoan times (2300–1100 B.C.), most notably seen at the palace of Knossos in northern Crete. In Asia, frescos also adorn the interior walls of Buddhist temples. The fresco technique was a predominant medium throughout the Renaissance; the most famous example from this

Figure 5–7 Mark Lavatelli, *Red Pine,* 1996. Collection of the artist. Encaustic on panel. © Mark Lavatelli 1996. This contemporary use of encaustic paint illustrates the brilliance of the color enhanced by the medium, which is pigment in a wax binder.

Figure 5–8 Catherine Catanzaro Koenig, *Pendulum,* 1992. Egg tempera on panel. Collection of Brian and Barbara Baird. © Catherine C. Koenig 1992. Egg tempera is characterized by a pale value key and translucency, as shown in this work.

period is the Sistine Chapel ceiling by Michelangelo. [12.2] Artists employing fresco were limited to mainly earth and mineral colors, because plant-derived pigments reacted badly with the alkaline plaster. The dried colors of a fresco painting are somewhat pale in value due to the pigment's reaction with lime.

EGG TEMPERA Egg tempera was another early Renaissance technique. In egg tempera, pigments are first ground in water then "tempered" with egg yolk, which serves as its binder. Egg yolk is a perfect natural binder, being an emulsion of water, a nondrying oil, and lecithin. The oil in egg yolk binds the pigment to a primed wood panel support. The yellow of the egg yolk bleaches, not affecting the colors of the pigments. The gesso ground (primer) is a mixture of chalk whiting and sizing, which has a bright white, absorbent surface. As egg tempera dries, the water in the emulsion is replaced by air. This causes more light to be reflected from the bright white gesso surface, lending the paintings a special luminosity of color. The proteins in the egg also harden to create a satiny, durable surface. The disadvantage of this medium is the necessity to continually remix fresh paint with fresh egg and the time-consuming application technique, which employs multiple paint layers. Egg tempera was a primary painting medium of the early Renaissance before the development of oil. Although it is not widely used today, several contemporary artists favor it as their primary medium. [5.8]

OIL Oil painting was a direct offshoot of egg tempera painting. Early Renaissance artists began to add small amounts of drying oils to the egg yolk binder for more painting flexibility. Oil was also used as a final varnish over egg tempera paintings. Soon artists discovered

that pigments could be ground solely into oil to make a new type of a more flexible paint. The principal type of oil used for oil paint is linseed oil, a natural drying oil extracted from the seed of the flax plant. Oil paint is soluble in gum spirits of turpentine or mineral spirits. The dried oil film serves as a vehicle for the pigment, protecting the particles and binding it to a gesso surface. Other oils, such as walnut oil, poppyseed oil, lavender oil, and hempseed oil, have been used in the manufacture of oil paints and oil medium (a paint additive).

The artist who is commonly credited with the development of oil painting technique is Jan Van Eyck (1390–1441), a Flemish artist, who made major contributions to Northern Renaissance painting. The advantages of oil paint are numerous. Oils have an ease of manipulation due to their slow drying time. Many paint consistencies can be manipulated with oil, from thin glazes to heavy impasto. Oil is painted on primed canvas, a light, movable support, as well as on a wood gesso panel. In most painting media, the colors change in value from wet to dry, but oil colors retain a similar appearance from wet to dry. Oil colors also have an innate richness. Some of the disadvantages of oil are the slow drying time and the need for harsh, toxic solvents. The handling and surface quality of oil paint can be enhanced or changed with the additions of varying types of oils, resins, and waxes.

WATERCOLOR Watercolor is the only truly transparent painting medium, making it unique among the scope of primarily opaque painting materials. Watercolor came into common use in Western art in the nineteenth century, popularized in England. Optimal pigments for watercolor are those that are transparent by nature, such as Ultramarine Blue and Alizarin Crimson. However, even those pigments with characteristic opacity are used for watercolor, such as the cadmium pigments. The watercolor pigments are ground very finely in a gum arabic (glue) solution. Watercolor is available in both tubes or in small color pan sets. The proper support for watercolor is watercolor paper, which is lightly sized with gelatin to prevent washes from absorbing into the surface too quickly. Pale value tints are made with thin layers: washes of color diluted with water that allow the white of the paper to show through. [5.9] Watercolor actually stains the surface of the paper as it dries. Since pigments are adhered to the paper surface with a delicate binder, watercolors are matted and protected by glass when professionally presented. This keeps the paint surface clean, protecting it from the ultraviolet rays of daylight. Watercolor is a popular painting medium because it is highly transportable, has water as a solvent, and cleans up quickly. Although watercolor is a medium associated with beginners and children, in reality, working with watercolor is quite complex, requiring both a delicate touch and knowledge of color transparency. Inexpensive children's pan sets of watercolors should be avoided by artists and designers, as they are low in quality and impermanent. Fine brushes and paper are also extremely important for success in watercolor.

GOUACHE Gouache, or tempera, is an opaque form of watercolor. Gouache has a gum arabic as a binder like watercolor, but also has a larger ratio of binder to pigment than found in ordinary watercolor. The paint is also applied more heavily and with less water than watercolor. [5.10] Either watercolor paper or illustration board serves as a painting support for gouache. The addition of various amounts of chalk or white to the pigments give gouache both body and opacity. Gouache is more intense in color than watercolor since it is opaque and contains more pigment. Tempera painting was used for book illumination in the Middle Ages, for Persian miniatures, and for Asian painting on paper and silk.

Figure 5–9 Transparent watercolor washes allow the white paper surface to show through the paint film to create tints.

Figure 5–10 A comparison of the transparency of watercolor (top) to the opacity of gouache (bottom).

Gouache is commonly used today for fine art or as designer's color. A lower grade of gouache is called poster paint.

ACRYLIC Two Americans, Leonard Bocour and Sam Golden, developed acrylic paint in the 1940s, but this paint did not come into common use until the 1960s. Acrylics are an emulsion of water, pigment, and a polymer resin. The water component of the emulsion allows the paint to be water soluble, one of its main advantages. When acrylic dries, the water evaporates; leaving an extremely strong polymer film that binds the pigment into the paint film and onto the painting support.

Acrylic paint has many advantages; it can be thinned with water, thus eliminating the need for solvents. It can be applied in an opaque, transparent, or translucent fashion, and fluctuates in application from impasto to watercolor-like washes. [5.11] Acrylic paint dries

Figure 5–11 Acrylic is the first paint using a synthetic binder, polymer resin. A versatile medium, acrylic is capable of a wide variety of effects. Clockwise from top left: a tint, body color, a transparent wash, and a texture made with acrylic gel, all with Dioxizine Purple pigment.

quickly, allowing overpainting almost immediately. It can be painted onto many surfaces, primed or unprimed, including canvas, paper, board, wood panel, and plastics. Additives for acrylic paint can produce numerous paint surfaces: gloss and matte mediums, gels, and modeling pastes. The disadvantages of acrylics are changes in color and paint quality that occur when the paint dries. Acrylic dries too quickly for some artists, not allowing enough time for paint manipulation.

DRY COLOR-DRAWING MEDIA To work in color with drawing media there are a wide selection of dry color-drawing materials, including colored pencils, chalk pastels, pastel pencils, oil pastels, oil sticks, and wax crayons. Color-drawing media all use a paper surface as a support. [5.12]

Colored pencils are colored sticks encased in wood casings. They are made from pigments mixed with clay, a synthetic resin, and wax. They are also available in a water-soluble composition and are called watercolor pencils. The lightfastness of colored pencils is questionable, since some pencils have dyes rather than permanent pigments, so good artist's grade of colored pencils should be used for finished fine art or illustration. Colored pencils can be translucent or opaque depending on the application onto the drawing paper support. The colors may be built up in layers or applied lightly, letting the grain and whiteness of the paper show through. They are a convenient way to make both quick color plans and finished drawings.

Wax crayons have the same binder as encaustic paint, but they are used as a dry media on paper. They are essentially pigments or dyes mixed with paraffin wax to make colored sticks. We usually think of crayons as a child's art material, but there are also wax-based colored drawing sticks for artists on the market.

Chalk pastels are dry pigments with a very minimal glue binder called gum tragacanth. The chalk pastels are made of a glue solution of precipitated chalk and pigment. These ingredients are mixed together then formed into sticks and dried. Since this is an opaque medium, tints are made in premixed color sticks with gradated additions of white pigment, and shades are made with the gradients of black pigment. Pastels are best used on a medium-textured paper surface. Pastels can be drawn onto toned papers (for example, a sepia-colored paper), which bring out the sparkling quality of the colors. Pastels are easily blended with the hand or a with a paper blending stomp. Their portability makes them an ideal painting medium for working outside. Pastels may be lightly sprayed and fixed, but have a delicate surface and should be always professionally displayed under glass.

Oil pastels are colored sticks that are made of pigments or dyes in an oil/wax binder. Oil pastels do not dry, but retain a somewhat sticky surface. They can be drawn onto paper and blend easily into each other or can be blended with mineral spirits or turpentine. Be

Figure 5–12 Oil sticks, pastels, and colored pencils are dry pigmented colored drawing materials. From the top: chalk pastel, colored pencil stick, and oil pastel.

aware that there are many inferior grades of this material on the market. For permanent work, only use those graded as artist quality.

Oil sticks are actually oil paint in stick form. The sticks form a skin but stay wet inside. They should be used on a primed ground as oil paint and can be blended with turpentine and oil paints. See Table 5–2 for a comparative chart of pigmented materials.

Inks and Dyes

DYES Dyes are soluble colorants. Dyes transfer color by being dissolved in liquid and then staining or absorbing into a given material or surface. The lightfastness of dyes is variable—they are not all as lightfast and stable as artist's pigments. There are two major sources for dyes: natural (animal or vegetable extracts) or synthetic. Some fiber artists prefer natural dye agents such as indigo, cochineal, and madder, which are older organic pigments no longer in use in paints.

The number of dyes used for textiles is enormous—over 10,000. Synthetic fabric dyes are fiber-reactive dye, disperse dye, vat dye, and procian dyes. Natural dyestuffs will only adhere to natural fabrics, so synthetics are widely used on commercially produced fabric. Procian dyes, while offering a large range of bright and permanent color for textiles, are highly toxic.

DYES IN ART MATERIALS Dyes are also used in various art materials. Most felt-tipped markers, for example, are filled with dyes rather than pigmented material. In order for colors to flow properly through a fiber point, they must be a liquid dye. Markers are convenient when used for execution of architectural renderings and quick compositions for graphic design; they are available in a wide assortment of colors for these purposes. Markers are a transparent medium and are layered for a wide range of effects. Alcohol-based markers blend into each other easily. Water-based markers can be layered with less blending. Both types of markers bleed and absorb into the paper surface to stain the paper with their dyes. Markers should not be regarded as permanent art materials for fine art or design. There are a few markers that use pigmented ink, mostly black, which should make

Table 5–2
CHART OF PIGMENTED MATERIALS

Media	Binder	Additive	Solvent	Support	Opacity	Property
Encaustic	Wax	Gum		Wood panel	Translucent	Must be heated to paint with
Fresco	Lime plaster	None	Water	Lime plaster on wall	Translucent	Must be painted on wet plaster
Egg tempera	Egg yolk	Oil	Water	Panel with gesso	Translucent	Must be painted in thin layers
Oil	Linseed oil	Resins, oils, or waxes	Gum turpentine or mineral spirits	Primed wood or canvas	Opaque or transparent	Slow drying glazes to impasto
Watercolor	Gum arabic	Gum arabic	Water	Watercolor paper	Transparent	Thins with water
Gouache	Gum arabic		Water	Watercolor paper	Watercolor	Opaque watercolor
Acrylic	Polymer resin	Polymer medium or gel	Water	Almost any	Opaque or transparent	Fast drying any thickness
Chalk pastel	Gum tragacanth		Dry medium	Paper	Opaque	Dry blends easily
Colored pencil	Wax and clay		Dry medium	Paper	Translucent	Smooth or textured
Oil pastel	Wax and oil		Turpentine	Paper	Translucent	Blends easily
Oil stick	Linseed oil		Turpentine	Paper or canvas	Opaque	Like oil paint

Figure 5–13 India ink is a combination of carbon black and a shellac binder.

them more lightfast. There are also "paint" markers, which contain an enamel paint that is released to flow by a pump mechanism. All markers are questionable as to permanence and should be subjected to informal light testing before use for permanent work. Dyes are also used as coloring agents for both ink jet printers and photography.

INKS Ink is a term for a large variety of art materials. Inks refer to both physical materials and process materials. There are drawing inks, printing inks, process inks for commercial printing, and printing inks for fine art printing.

India ink is a pigmented black ink that has been in use for several hundred years. [5.13] India or China ink was originally available in a stick form that was subsequently ground and mixed with water to make a black, permanent ink. India ink now refers to a black waterproof drawing ink made with carbon black combined with a shellac binder and to be used on paper. India ink is different in composition from writing ink for fountain-type pens. Writing ink is dye-based and water-soluble. There are also colored inks that can be brushed on or applied with dip pens. Colored inks that are dye-based are of questionable permanence. Other dye-based materials that are subject to fading are the liquid "watercolors" in dropper jars. These are appropriate for graphic design, but because they are dye-based, they may fade or change color. Pigmented colored inks can be applied by a brush, pen, or airbrush (a spray-painting device). Pigmented inks are higher in colorfastness than dye-based inks.

The permanence of some questionable materials can be tested at home for color- and lightfastness. Swatches of all the questionable materials can be put on a paper or board, complete with labels. Half of the board should be covered with a heavy black paper. Placement in a south-facing window for a month or more should indicate any fading that will occur. The black paper is then removed to compare exposed with unexposed areas.

PROCESS MATERIALS

Color Photography

Color photography applies principles of the tricolor theory and the interplay between the additive and subtractive color systems. Color photography was first introduced in 1907. The color image was created by a series of films exposed with separate color filters to make three color images. Color film today is made of three light-sensitive layers. Each of these layers records one of the primaries of additive light: red, green, and blue. Each image is actually recorded as a black and white using silver halide, which is subsequently washed away in processing. This leaves three dye colors: the three subtractive process primaries of cyan, magenta, and yellow, one color on each layer of the three-layer film emulsion. Dye couplers, color formers that are activated in the film development process, form the dyes.

The photographic process involves the additive color system, with an additive color circle as its reference. [5.14] The secondary colors of light are the three subtractive process primaries, cyan, magenta, and yellow, which are the complements to the additive primary colors. When color film is exposed to a subject, the light hits each layer of film, and the additive primaries of red, green, and blue change in color to their complements. The complements of additive colors are cyan (from red), magenta (from green), and yellow (from

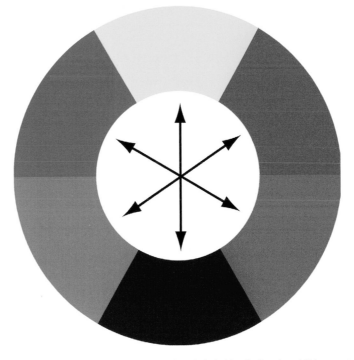

Figure 5–14 The photographic color circle is identical to the additive color circle. The complements determine how each color filters another in photography.

blue). In film, the red sensitive layer records as cyan, the green layer as magenta, and the blue layer as yellow on the developed negative. [5.15] The color black in an image does not expose any emulsion and white exposes all three. Black is open on the negative, thus it is a combination of cyan, magenta, and yellow. White is black on the negative, thus blocking all color development in these areas on the positive print.

The photographic positive is made on special color print paper that also has three layers of light-sensitive emulsions. These are in reverse order when compared to the film. The top layer is cyan; the middle, magenta; and the bottom layer is yellow. To make the print, the negative is projected through an enlarger either sequentially to red, green, and then blue light or to a balanced white light. Since both the negative and the positive print

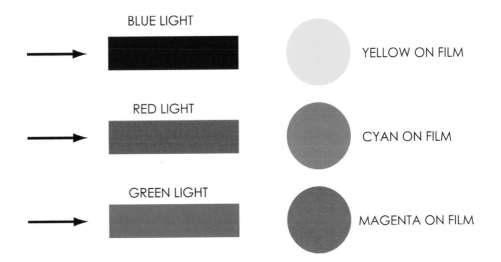

Figure 5–15 How light is filtered to produce a color on a photographic negative.

are formed from dyes, color photography is subject to fading. Care must be used in protecting framed images with glass, especially glass that controls ultraviolet rays.

Digital Photography

Within the last few years there has been a shift from color film usage to digital photography. The advantages of digital cameras are numerous: The images can be viewed on a small LCD screen on the outside of the camera before taking them and photographs can also be scrolled through on this screen after they are taken. Images can be viewed, deleted, and loaded onto a computer for cropping, editing, making color adjustments, and balancing. All of these options give the casual and professional photographer much more control over the final images, the type of control that only professional photographers had when using film.

Digital cameras operate and collect visual information in a different manner than traditional analog cameras. Digital cameras use millions of pixels to produce a photographic image. When the shutter is pressed on a digital camera during the exposure time of each picture, each pixel has a *photosite* that is uncovered to collect and store photons. A *photon* is the smallest measurable particle of light. When the exposure is finished, the camera closes the photosites and then assesses the number of photons in each cavity. The number of photons in each cavity are then sorted into varied intensity levels that are determined by bit depth (see Chapter 6).

Each cavity has a filter that lets in only one of the RGB components of light in each exposure, thus two-thirds of the incoming light is discarded. A common color filter system is called *Bayer array,* which has alternating rows of RG and BG filters. In this system, there are twice as many green filters as red or blue, because the human eye is more sensitive to green light. To translate the Bayer array of RGB light into a complete image, a process called *demosaicking* completes the digital image. This proportion of RGB forms a finely detailed image. Some cameras have alternate systems for capturing RGB light during exposures by which each pixel is able to capture R, G, and B in each pixel.

A *histogram* is a chart that is useful for understanding the values and RGB components of each image. There are RGB histograms for color analysis and luminosity charts for evaluation of image values. This chart is a way in which the computer analyzes each image in graph form by mapping shadows, midtones, and highlights. The tonal range of each histogram represents the characteristics of each image. If the image is high contrast, the tonal range's peaks will be broadly separated; if heavy in midtones, the graph for an image will peak in the center, and so on. Understanding histograms helps the photographer choose cameras settings as well as edit the photos on the computer.

Color Printing

Color printing refers to two types of printing processes: first, processes used for commercial reproduction of type, text, and image; and second, processes used by artists for fine art printing. Printing always refers to the transfer of image from a special surface (a plate, block, or stencil) by ink onto paper. Print processes can be roughly divided into four major areas: relief printing, intaglio, screen printing, and lithography. There are fine art and commercial processes within each area.

RELIEF PRINTING Relief printing utilizes the raised and recessed areas of metal plates or wood blocks to form a printed image. Types of relief printing include woodcuts, wood engravings, and letterpress for commercial work. To make a relief print, ink is rolled onto the raised areas and a lightweight paper picks up the inked areas by the pressure of a press or hand. [5.16] Raised areas of the block or plate are printed and recessed areas remain white as unprinted areas. Any number of colors can be used, but each color is a separate print run from different block surfaces. For wood relief printing, either oil-based or water-based inks are applied to the block with a rubber roller. Among the finest examples of wood block printing are the Japanese woodcuts, which have been refined to a high art form. [12.6]

Letterpress is a form of relief printing that uses a photosensitizing process to etch a metal plate. After etching, raised areas remain, which are alternately inked and printed by machine. Letterpress was in use until the 1960s, when other more efficient printing pro-

Figure 5–16 A cross section of a relief-printing block. The raised areas (red) print, and the recessed areas do not.

cedures replaced it. It is still used primarily by small printing companies for high-quality bookwork.

INTAGLIO PRINTING In intaglio printing, metal plates made of steel, zinc, or copper are used. These plates are etched by acid or hand engraved to form recessed areas. The plate is fully inked, and then wiped by hand or scraped by machine to force the ink into the recessed areas of the plate. The inked plate is then run through an etching press equipped with heavy rollers, and the image is transferred onto a dampened sheet of paper. The recesses can be either line or textured areas. In fine art processes, such as etching, the heavy oil-based pigmented ink is applied to the plate by hand and then wiped. Intaglio processes include dry point, etching, metal engraving, aquatint, photo etching, and the commercial process of gravure. Gravure printing is often used for large printing jobs, the costs being too high for smaller jobs. In the gravure process, ink is rolled onto the plates and then scraped by a thin steel blade to force ink into the recessed areas. Gravure printing of photographs is considered a superior method due to the higher contrast that it provides.

LITHOGRAPHY Lithography was developed in the nineteenth century. Lithography was used for art printing, as its process was quicker than that of either etching or engraving. In lithography, an image is drawn with a grease-based material on a specially ground stone or metal surface. The printing process involves oil and water, which resist mixing. A thin film of water keeps the ink on the oil-sensitized areas of the surface and away from other surfaces. Offset lithography is a primary means of commercial printing for books, magazines, and art reproductions. The offset process uses a thin metal plate to offset the image onto a rubber mat, which is then printed onto paper. Both etching and lithography use heavy oil-based pigmented inks that have a sticky consistency.

SCREEN PRINTING Silkscreen or screen-printing involves a special fabric screen that employs a handmade or a photosensitized stencil method to produce prints on paper or fabric. The screen is a fabric that is stretched over a simple wooden frame. [5.17] The prints are made by using a squeegee to force ink through the screen. To produce a print, open areas of stencils allow the ink to pass through the screen to a sheet of paper underneath. Silkscreen

Figure 5–17 In a silkscreen print, a stencil on the screen controls the areas to be printed.

is manually produced both for artists' prints and for larger commercial production. There are also semiautomatic presses, which are hand-fed with paper. Fully automatic machines print large editions of posters. Screen-printing ink adheres to many surfaces, including plastic, paper, metal, glass, and fabric.

Andy Warhol, the U.S. twentieth-century "pop" artist, integrated silkscreen process as a primary part of his painting process. Using the screen print process allowed Warhol to use photo-based imagery in his paintings, screened onto canvas as one of the final layers of each painting. He also produced many portfolios of screen prints with color variations on the same images. Silkscreen inks provided Warhol with a commercial type of color palette that freed him from historical color constraints. [5.18]

Color Reproduction

Commercial color printing has two principal processes to reproduce color, namely, color separation and flat color.

COLOR SEPARATION The first photomechanical color separation was produced in 1893. Color separation is a process of isolating the component colors of a full-color photo, painting, or illustration for reproduction purposes. Three photographs of an artwork are shot, each through a separate color filter. The filters are meant to calibrate exactly to each wavelength of the three light primaries. Reproduction quality is dependent on the quality of the filters used. Each photo records one-third of the color information, which is similar to the color photographic process discussed previously.

- The red filter removes red and leaves green and blue, making cyan.
- The green filter removes green and leaves red and blue, making magenta.
- The blue filter removes blue and leaves red and green, making yellow.

Each photo thus results in the process complement of each additive color. [5.19]

Figure 5–18 A silkscreen print by Andy Warhol shows his innovative use of color combinations produced in a series of prints. Andy Warhol, *Marilyn Monroe,* 1967. One from a portfolio of ten screenprints, 36″ × 36″. Publisher: Factory Additions, NY. Printer: Aetna Screenprint Products Inc./Du-Art Displays, NY Edition 250. The Museum of Modern Art, New York. Gift of Mr. David Whitney. © 2001 Andy Warhol Foundation for the Visual Arts/Artists Rights Society (ARS), Art Resource, NY.

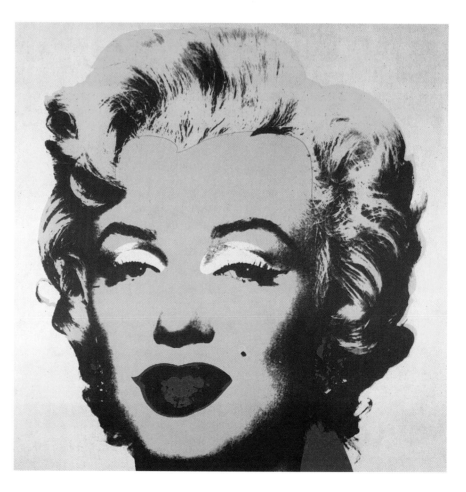

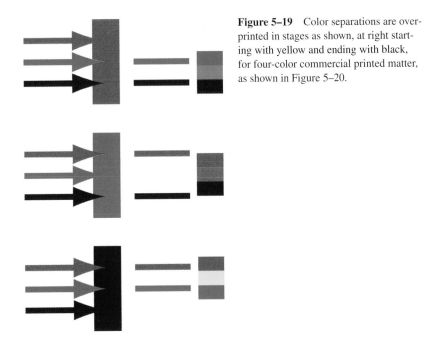

Figure 5–19 Color separations are overprinted in stages as shown, at right starting with yellow and ending with black, for four-color commercial printed matter, as shown in Figure 5–20.

In the four-color process, printing inks are transparent, which means that color mixing occurs by color layering and open white paper represents white. Cyan, magenta, and yellow mix in various intensities to produce most colors; C and Y forming greens, M and Y making oranges and reds, and C and M producing violets and blues. Unlike photography, in commercial printing, cyan, magenta, and yellow alone are not adequate to reproduce a full-color continuous tone image. A fourth photo with a neutral filter allows black to be added to sharpen, darken, and define the image. [5.20] Thus the four-color process is called CMYK, standing for cyan, magenta, yellow, and black or "key."

FOUR-COLOR PROCESS The four-color process of printing is actually a pattern of tiny dots, which are round, elliptical, or square. By their density, these dots produce disparity of both value and color saturation for the final image. Screens that generate these dots vary according to the desired resolution of the printed image and the type of paper onto which it is printed. Halftones are a pattern of dots used for reproduction of a continuous tone image. These dots are called Benday dots after their inventor, a New York printer named Benjamin Day. Benday dots gradate in size to suggest light or dark areas of the image by optical mixtures. While the dot pattern remains consistent, dots in dark areas are larger to cover more white paper. Dots are smaller in light value areas so that the white paper optically mixes with a small amount of color to produce tints. Gradation of the size and overlapping of dots produces the illusion of a smooth value, hue, or tonal gradations. The screen pattern of dots or dpi (dots per inch) can be finer or coarser depending on the desired resolution of each printing job. [5.21] The combination of CMYK dots in various sizes and overprinting colors forms optical mixtures that give the illusion of a wide array of colors. The first step in this process is a photographic or digital color separation. Each separate color of CMYK is screened to create a dot pattern.

The dots are graded in lines per inch. [5.22] These can be roughly sorted in quality as follows:

- Newspapers: 85 lines per inch
- Magazines: 133–150 lines per inch
- High-quality art reproductions: 300 lines per inch

The four-color process is printed in layers in this order: first yellow, then magenta, then cyan, and then black. [5.20] The screens are placed at different angles to avoid a wavy

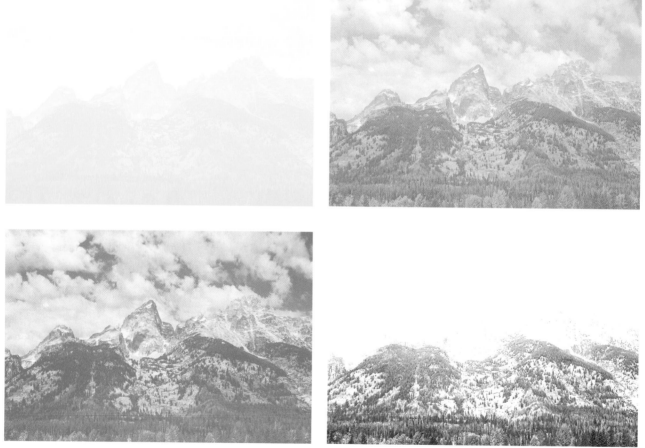

Figure 5–20 How colored filters separate colors for the four-color printing process (CMYK).

Figure 5–21 Large-scale halftone dots shown here indicate the changes in pattern structure that occur to produce values.

effect called a moiré pattern that can occur in the final reproduction. When more color accuracy is desired, up to eight colors can be used for process printing.

To ensure color consistency, printers use color control bars called SWOP, which stands for "specifications web offset productions." Variations in the colors of CMYK inks are dependent on the manufacturer, which is important to know at the outset of a job. Today, computer scanners are used to produce most color separations. Original art is put through a scanner that uses a high intensity light or laser to separate the colors. Color filters are built into the scanner, which then converts the image into a four-color separation. The resolution of the scanner can be set according to the resolution and paper that are desired for the final print of the image.

FLAT COLOR Flat or spot color is a solid printed color area selected for some one- to three-color printing jobs. The colors are chosen from a PANTONE MATCHING SYSTEM ® or process color chart. The PANTONE MATCHING SYSTEM ® system has upwards of 1,000 spot colors. Choosing colors from the PANTONE ® chart allows the printer to exactly duplicate a particular color choice.

The materials of color range from the traditional pigmented materials that artists have always used to sophisticated process tools of ever-increasing complexity. These tools allow the artist and designer to communicate more widely with color than ever before.

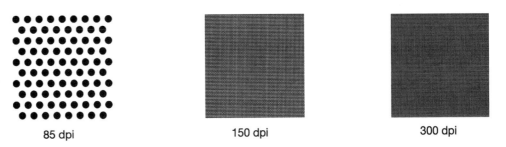

85 dpi 150 dpi 300 dpi

Figure 5–22 An example of 85, 150, and 300 dpi clarity of printed matter.

ACTIVITY

COLOR TESTING

Objective: To learn about the permanence and paint quality of a variety of colored art materials.

A. Lightfastness Tests
- Make color test strip on a small piece of board. Make marks of colored markers, colored inks, computer printed color, writing pens, paint markers, or colored pencils on the board. Use colors that are both pigmented and made from dyes. Try many different colors and coloring materials.
- Make sure that each item is labeled. Cover half of each mark with black paper.
- Put the test strip in a sunny, south-facing window for at least one month.
- Remove black paper and note any fading or color changes.

B. Paint Tests
- Using acrylic, gouache, and watercolors test the paints for opacity by painting a strip of each color on black paper or on a black strip of paint.
- Paint out a thick swatch of each color and then test the undertone of some of the colors by spreading each pigment out thinly next to each thick swatch. [5.5]
- Try adding the same amount of white to two or three different pigments. Be careful to use the same amount of white for each color. How do the tinting strengths of each one of the pigments compare?

Chapter 6
Computer Color

INTRODUCTION

The advent of computer design has produced a rapid development in electronic color. Computer graphics are ever-changing due to simultaneous advances in computer hardware and software. This chapter provides generalized information about computer color modes and the characteristics of graphic software programs. In addition to this, a manufacturer's manual and tutorials are essential references for the operating specifics of any type of computer graphic software. This chapter provides a broad guide to common color modes that exist within a number of graphic programs. Graphic software is advantageous to color-study students because computer programs demonstrate many of the color theory concepts discussed in preceding chapters.

Computer color opens a vast new territory of color to the artist and designer. The computer is capable of producing 16 million colors. Despite this number, a computer still cannot generate all the colors that we perceive in reality. A click of the mouse provides us with a staggering number of color selections. A basic knowledge of computer color is indispensable to take full advantage of all of the computer's color modes.

COMPUTER COLOR BASICS

The computer is the primary tool to create graphic communication design, drafting, animation, illustration, typesetting, page layout, photo enhancement, and web design. It also can be used to edit video and even formulate paintings and drawings. The emphasis of this chapter is on the basics of color both viewed on a display monitor and in print.

Graphic design is accessible to a wide range of people due to the advent of personal computers, which can generate printed matter and web design. Web design is as vital a form of visual communication to companies and organizations as printed publications. Computers have revolutionized the design process by their ease, speed of use, and are readily available tools for in-house design and publications. Layout programs, inexpensive printers, and photocopying machines have revolutionized the graphic design process, together with making color publication less expensive. Color is used in both small-run and large-run publishing by the use of inexpensive ink jet printers, graphic software, and color photocopies.

A home computer studio consists of a standard computer setup: computer, scanner, monitor, printer, and design software. The computer should have adequate RAM because graphic files need a lot of memory. With this equipment, a designer can do virtually all pre-press work for publication.

THE COLOR MONITOR

The computer display monitor has an illuminated screen, the surface of which is a grid, and each unit of the grid is called a pixel. The word *pixel* is a combination of the words picture and element; hence a pixel is a "picture element." On a traditional monitor, each pixel has tiny spots of phosphor, a chemical that can emit light. Pixels are arranged in rows called *rasters*. The number of pixels or the fineness of the pixel grid is measured in *ppi* (pixels per inch). Ppi determines the resolution of the monitor screen. At the rear of traditional cathode ray tube monitor (CRT) screen is a device called an electron gun, similar to that used in a video screen on a TV. The electron gun fires beams of electrons at each pixel in a particular order. Each dot is either illuminated on or off during this process. In color monitors, each pixel contains at least three separate spots of phosphor, one for red, one for green, and one for blue. Three electron beams can activate these spots individually or simultaneously, one corresponding to each color (RGB). While computer screens have higher color saturation than TV screens, the RGB range in a CRT monitor is smaller than the true range of spectral colors (RGB from light) in reality. A color limitation occurs on CRT display monitors because colors formed by phosphor are not as pure as true spectral hues. A CRT display screen's limited color range (in relationship to the color range of what we actually perceive in reality) is called a color *gamut.*

Flat-screen monitors are called liquid crystal display monitors or LCDs. LCD monitors are used on laptop computers and in a larger format for personal computers. The LCD flat monitors are attractive, compact, and are significantly different from CRTs. LCDs display in one optimal resolution, have a smaller viewing angle and a lower radiation emission, have no flicker or distortion, and use less energy. In LCD monitors a light source filters through the liquid crystal, bending and twisting light to display colors and images. LCDs use pure RGB filters so the color distortion of phosphors does not occur, exhibiting true RGB colors with more saturation and brightness.

All computer monitors display colors by actual additive colored light. Essentially a color monitor paints and draws with light.

BIT DEPTH

To grasp the concept of pixel or *bit depth* in reference to computer color, we need a basic understanding of the operation of a computer. A *bit* is the smallest unit of information utilized by a computer. A bit is equivalent to a single electronic pulse, which can be either on or off. One (1) is the numerical code for on, and zero (0) is the number code for off. This is the basis of the *binary system,* a two-number system that is the code for all the information contained in a computer. Pixels either turn on or off contingent upon the coded information sent by the computer to the monitor. Older computer monitors had one-bit pixels, which meant that a pixel was either on (illuminated) or off (darkened). The illuminated areas of the screen were either white or green and could display text, line art, or simple shapes. Two-bit screens were subsequently developed, which meant that each pixel was capable of holding two bits of color information. Two bits per pixel means that a monitor has four colors: black, white, and two gray values. Thus, the higher the bit number, the more colors that can be displayed on the screen. An 8-bit pixel displays 256 colors or grays, since 2 to the eighth power mathematically forms 256 distinct combinations of color information. Each bit also has "depth" or different levels. For example, on a 4-bit monitor, the four on and off signals can be arranged in 16 different ways. The colors that we see due to bit depth depend on the arrangement of the bits in various layers. [6.1] Bit numbers correlate to the number of colors displayed on the screen as follows:

 1-bit 2 colors, black and white

 2-bit 4 colors, black and white and 2 grays

 4-bit 16 colors

 6-bit 64 colors

 8-bit 256 colors

 24-bit 16 million colors

R G B

Figure 6–1 Bit or pixel depth determines the number of colors that can be displayed on the computer screen. Each bit is either on or off in combinations that determine the overall color of each pixel. Shown here are an 8-bit depth that makes 256 colors and a 24-bit depth that can form 16 million colors.

Most computer screens have 24-bit color or "true color," which is photographic quality color on the screen display. Twenty-four-bit color has 8 bits of memory for each hue, red, green, and blue, and results in over 16 million colors that, when exponentially calculated, are all the numerically possible combinations of color information. A lot of code goes into 24-bit color, and this information takes a large amount of memory file space on the computer's hard drive or disc.

BITMAP AND VECTOR-BASED PROGRAMS

There are two major methods to fashion and manipulate images on a computer. These are referred to as either bitmap or vector-based modes.

Bitmap

Bitmap images employ pixels to generate areas of color on the computer screen; they are also called *raster* images. Bitmap images are built from pixels to fill the computer screen in horizontal and vertical rows. Painting programs and photo editing software are established on bitmap images. Bitmap software is effective for photo images because of the need for continuous tones. Painting programs are also bitmap-based because computer painting is characterized by blended colors and gradations. In bitmap software, pixels define image areas; when images are enlarged, they lose definition and the jagged edges of the pixels become visible. Bitmap programs have a fine mosaic of pixels. A bitmap program controls pixels rather than lines or shapes. [6.2] Gradations are formed by optical mixture of the colors in the pixel mosaic to create tones that then form images. Bitmap images are *resolution dependent,* signifying that image resolution depends on the display monitor and the scale of the pixels themselves. Resolution refers to the number of dots or pixels per unit used to reproduce or create artwork. Although the computer itself controls pixel resolution, on a larger screen the individual pixels may become more evident. This is called pixelation. Higher resolution uses a grid with a greater number of pixels, which gives an image a smoother, finer grained appearance.

Vector

Vector-based programs are based on line drawing. Defined by math objects called *vectors,* vector images portray shapes according to their geometric plan. Vector programs use mathematical locations or points to form lines and shapes, which then formulate images. The advantage of a vector-based graphic program is that the images are *resolution independent;*

Figure 6–2 Above, pixels or rasters can become evident when a bitmap image is increased in size, compared to the crisp edges of the vector image below.

Figure 6–3 A vector image maintains a crisp outline despite its size since it is based on a computer line drawing.

that is, the images can be enlarged or reshaped without losing their clarity. [6.3] A vector-based program is more precise than a bitmap program and allows more flexibility for change. The file sizes of vector art tend to be smaller than bitmap or raster-image files. Vector programs are a good choice for type, logos, and clean-edged work drawn with straight lines, freehand lines, and Bezier curves (curves plotted by anchor points). Vector programs also include a limited amount of painting capability to create softer effects. Vector images cannot be seen with complete accuracy on a monitor because images are displayed in a pixel format. A good printer converts vector lines into dots through a process called rasterizing. A low-end ink-jet printer cannot rasterize so it will print the image as seen on the screen display. A high-quality printer improves the printed final product.

TYPES OF GRAPHIC SOFTWARE

Several principal types of graphic software are obtainable for drawing, painting, image editing (for photography), page layout, and drafting. These programs are designed for static art, but software programs are also designed for time and space media, such as video editing and computer animation. Drawing software is vector-based and has drawing, limited painting, and typesetting capability for both graphic design and illustration. Bitmap-based painting programs have the capability of simulating the effects of traditional drawing and painting media. Image-editing software is designed for manipulating photographic material, which is scanned in or loaded from a digital camera. Photo software is bitmap based to supply the continuous tones needed for photographic imagery. Page layout programs assist the graphic designer in layout of print-ready materials, both illustration and type. Drafting programs are used for architectural drafting and perspective presentations.

TYPES OF IMAGE FILES

There are two principal types of image files for computer graphics. GIF (Graphic Interchange Format) files are used to compress illustrations and graphic files with either solid color or animation. JPEG (Joint Photographic Experts Group) files were specially developed for continuous tone photographic files; they do not compress solid color files well. Progressive JPEG files appear on screen initially in a chunky, mapped format gradually taking on the focus and definition of a photographic image. TIFF (Tagged Image Format) files are widely used in desktop publishing and can be raster-based RGB, CMYK, Grayscale, LAB, or indexed color; compression in these files is considered to be *lossless,* meaning that they compress data well without losing color information.

COMPUTER TOOLS

Toolbox

Graphic programs provide the artist with a workspace on the display screen (sometimes called the paper or art board), a toolbox, and a huge range of colors. Toolboxes of graphic programs have some tools in common, which are activated by clicking or dragging with a mouse. Some graphic tools are for image creation, and others have image-editing capability. Shown here are the toolboxes from Illustrator and Photoshop. [6.4]

 Tables 6–1 and 6–2 provide brief descriptions of some of the common image-making and editing tools found in graphic software; example of their use are also shown. [6.5] Graphic software is updated on an almost continual basis, making the tools ever more sophisticated and with added functions. [6.6]

 Image-making tools in either bitmap-based (Photoshop) or vector-based (Illustrator) software are tools that draw, paint, and create shapes or type. Image-editing tools affect or change given images (either made by the artist of photographic) in widely varied ways, changing the contour of an image by tools like blur, pucker, and bloat. [6.7] There are also effects that filter individual objects in designated ways such as extrude (a 3D effect), drop shadow, and pixelate. [6.8]

 When a computer object is selected it can be manipulated in a dizzying number of approaches. The student that uses computer tools needs to have a spirit of experimentation, time to grapple with the often steep learning curve of software and adequate instruction and reference materials.

 Graphic tools vary in their function dependent on vector, which is line based, or bitmap, which is a pixel-based method of drawing, painting or image modification. In photo image editing software, many of the functions apply to the modification of color, texture and contrasts of the image, as well as altering the image itself by cutting and pasting images together. Vector software is more suitable for making graphics that are line based with clean edges and solid color. Both of these types of software have functions of creating images by use of the drawing and painting tools such as pencil, pen tools, airbrush, which can be either picked from extensive palette choices or be customized to the artist's specifications.

 In addition to creating images, there are also palettes of premade textures, graphic styles, and symbols to pick and apply to areas or objects. [6.9]

Filters

Software can distort, change, and modify images with the use of *filters,* which automatically transform the appearance of a computer drawing or one based on a photographic source. Because each filter alters an image in a particular way, it is useful for the student to become familiar with filters and their use in the creation of visual effects, see [6.10] for some examples of filter effects.

Figure 6–4 Left: A sample toolbox from Adobe Photoshop® includes (clockwise from top left) marquee tool, move, magic wand, knife, brush, brush history, gradient, burn and dodge, type, rectangle, eyedropper, zoom, hand, notes, pen, path selection, blur, eraser, clone stamp, spot healing, crop, and lasso. Right: A sample toolbox from Adobe Illustrator®. Clockwise from top left: selection, direct selection, direct selection lasso, type, shape, pencil, scale, free transform, graph, gradient, blend, live paint selection, scissors, zoom, hand, knife, paint bucket, eye dropper, gradient mesh, symbol sprayer, blur, rotate, paintbrush, line, pen and magic wand. The bottom square indicates the fill (solid) color, and the open square is the stroke (outline) color. Screen captures from Adobe Illustrator® and Adobe Photoshop®, registered trademarks of Adobe Systems, Inc. in the United States and other countries.

Figure 6–5 Some examples of the use of drawing or painting tools. Clockwise from top left: pencil tool, brush tool, scatter brush, and pen tool. Screen capture from Adobe Illustrator® and Adobe Photoshop®, registered trademarks of Adobe Systems, Inc. in the United States and other countries.

Table 6–1

COMPUTER GRAPHIC TOOLS

Tool	Function
Selection	An arrow that allows selection of an item. An item must be selected in order to work on it. A selection box can be dragged around numerous items; shift/click or lasso will allow selection of more than one item.
Pencil	A pencil tool allows drawing of freehand lines or shapes. This requires some control with the mouse or stylus. Some programs can vary line texture and pressure. Line weight is easily adjusted. Some programs can simulate fine art media such as charcoal, ink, and pastel.
Brush	The brush tool is for freehand drawing and painting. Brush options can control brush size, texture, and shape. Some programs also have options of various transparencies, such as water or dry brush. A scatter brush can repeat a motif or pattern along a painted path. There is usually an airbrush or spray can link with the brush tool, which can spray a fine stipple of color. An art brush will bend an object along a path.
Shape	The shape tool has preset shapes that can be formed by dragging from a corner or the center of the shape. The set shapes include squares, rectangles, ellipses, circles, as well as a flare and others. Other polygons can be made with a polygon tool. Shapes can also be drawn with the pencil or pen tool.
Eraser	The eraser tool can erase areas down to white or to a previous color area. It can also change or modify an object.
Pen	The pen tool is used for precise straight lines and curves. The curves (Bezier curves) are built from anchor points, which indicate changes in direction. Straight lines can be bent at anchor points, which are clicked to set. The lines made by the pen tool are called paths. They can be open or closed to make shapes. Directional guidelines control the curve of each path.
Type	The type tool allows type to be placed anywhere in the design, inside and out of the object (area type), in a text box, on a path. The type can also be enlarged, distorted, rotated, as with any other object.
Column Graph	This tool is for making graphs, pie charts, etc.
Gradient Tool	Controls the placement of a gradient inside the shape of the object.
Blend	Creates a blend of characteristics in steps from one shape to another.
Scissors or Knife	Tools to trim or cut apart objects.
Gradient Mesh Tool	Inside a vector shape a mesh is created to generate a gradient that describes a more three-dimensional form.
Symbol Sprayer	Sprays out grouping of selected symbols from graphic objects palettes.
Line	Makes straight line segments as well as spiral, grid, and polar grid.
Fill	The fill tool can fill an area with color, texture, or a gradient. Its icon can be either a paint bucket or an eyedropper. An eyedropper selects a color from an object and applies it to another object.

Table 6–2
COMPUTER EDITING TOOLS

Tool	Effect
Zoom	Allows the view to be magnified or moved back from the object.
Lasso	Allows the selection of a group of objects to modify or move.
Blend	Makes shape or color blends between objects.
Scale	Enlarges or shrinks objects.
Transform	Allows geometric edits to selected objects, including rotation, reflection, shear, extruded, or applied perspectives.
Hand	Allows the art board to be moved around freely to change the viewing and work areas.
Feathering	Softens transitions between foreground and background objects.
Filters	Encompass a large range of effects that can be used on images. Artistic filters can give an image the effect of traditional art media such as pastel, impasto, brushstroke, etc. There are also larger arrays of textures that can be applied to objects. Various other effects can include distorting, blurring, sharpening, sketching, and pixelating.
Magic Wand	Allows the selection of attributes of an object.
Dodge, Burn Sponge	Effect the surface texture of color of an object by a subtractive process that is more delicate than the eraser tool.
Clone Stamp	Allows an object to be cloned and repeated by stamping it.
Spot Healing Tools	Edits flaws, red eye in photos.
Crop	Crops down images and photos.
Blur	Blurs objects as well as twirl, pucker, bloat, scallop, crystallize, and wrinkle. This tool acts like a filter effect for individual objects but is more hand controlled.

Figure 6–6 Some painting effects that are available. Clockwise from top left: blur, hatch/scribble, stipple, and extrude.

Figure 6–7 Images can be distorted or changed with the warp tool in the toolbox. Clockwise from top left: crystal, bloat, tweak, and twirl.

Figure 6–8 Object Effects.
Shapes or other objects can be affected by effects tools: (clockwise from top left), original shape, glow, pixelate, twirl, stretch, twist, noise, and drop shadow.

Figure 6–9 A sample array of palettes commonly used in Adobe Illustrator®: from top, brush palette, swatch palette, CMYK palette for mixing colors, symbol palette, and graphic effects palette. Screen capture from Adobe Illustrator® and Adobe Photoshop®, registered trademarks of Adobe Systems, Inc. in the United States and other countries.

Figure 6–10 Filters can be used on entire images to change the character or surface texture of an image. Some filters simulate actual media, while others create more technical effects, such as (clockwise from top left) original image, ink outline, notepaper, liquefy, solarize, and glowing.

Layers

Graphic software functions in layers that can be thought of as clear layers of acetate, each containing a part of the final design. One or more layers are used to create any given artwork; each layer has objects "stacked" in order of their creation. Objects can be moved forward or back in this stacking process or moved from one layer to another by cutting and pasting. For most of the computer activities in this book, a single layer is adequate.

Computer Color

There are several color modes available within each graphic program. Each color mode should be understood in relationship to its color range, mode of operation, and function. Otherwise, the color selection process can be overwhelming. In any case, having 16 million colors at our disposal is true color power. The major color modes are RGB, CMYK, HSB or HSV, Web-safe color, and sometimes a mode called LAB color, which is the computer version of CIE color.

RGB COLOR Both the computer monitor and scanner utilize the RGB color mode. Since the computer monitor displays color information with light, it operates in the additive RGB light color mode. Each set of color information, red, green, and blue, is called a channel. Each channel of RGB color is 8-bit. Since there are three colors (RGB), this makes a total of 24-bit color. Each channel is capable of making 255 variations on each color (red, green, and blue). The possible combinations of three sets of 255 provide us with the choice of 16 million colors in the RGB mode.

Figure 6–11 RGB Band and Sliders. The RGB slider and spectrum represent the additive color mode of light mixtures seen on the computer screen or from any light-based medium. Screen capture from Adobe Illustrator®, a registered trademark of Adobe Systems, Inc. in the United States and other countries.

The RGB color can be selected in several ways. We can select hues from a spectral band or color circle that is displayed in this mode. A hue band has higher saturation colors in the center, which blend gradually to lighter values of hues on one edge and darker values on the opposite edge. The spectral band allows us to choose colors instinctively. The option of red, green, and blue sliders is also available in the RGB mode. [6.11] Since RGB color represents light, the sliders display RGB color mixtures in an additive fashion, which may be surprising at first. When all the sliders are pushed up to 100 percent, the RGB colors mix to white; when all the sliders are set at 0 percent, the mixture is black.

RGB colors can be chosen and coded in several ways. Any RGB color can be represented by a combination of three numbers for each of the three primaries of R, G, and B. Assigning a numerical value between 0–255 (0 for none and 255 for 100 percent on the sliders) for each of R, G, and B in combination. For example, R 255 G 255 B 255 (all the primaries at 100 percent) which, as we know, is white in an additive light mixture. The RGB code for yellow is R 255 G255 B0, which is consistent with the additive color circle.

HEXADECIMAL COLOR Another method of coding RGB for HTML for the web is called *hexadecimal color* coding, a complex base 16 mathematical combination. HTML uses this six-digit numerical (0–9) and letter code (A–F) to identify specific colors that a designer has chosen; RGB conversion charts to hexadecimal code are readily available. In hexadecimal code each RGB channel is represented by two letters or numbers: White, for example, would be FFFFFF standing for FF = R 255 FF = G255 FF = B255. Yellow in hexadecimal code is FFFF00, meaning FF = Red 255, FF = Green 255 and 00 = Blue 0. Alternately, some programs request that RGB values be represented as percentages as they appear on the sliders.

The RGB mode is used for web graphics, art that will be viewed exclusively on the monitor, or for any light-based medium. Scanners use the RGB mode like a camera, capturing the red, green, and blue color information from the scanned image. The RGB mode should not be used for the creation of printed material because it forces the computer to convert the RGB color to CMYK mode and color information can thereby be lost. The gamut or range of RGB color is larger than the range of CMYK. When a conversion from RGB to CMYK occurs and a color is out of gamut (range) for printing, the computer warns us that the selected color is not printable. RGB color can also be selected from a color picker box, which shows a chromatic gradation between additive colors.

WEB-SAFE COLOR Web-safe color, also called a web-safe palette or browser-safe palette, is a selection of 216 red, green, and blue additive colors that are common to 8-bit color palettes. The web-safe palette is mainly useful for flat color; browsers are better at processing photographic tonal images. [6.12] The browser-safe palette is laid out in a mathematical rather than a hue or value system; however, one may download or buy software with more sensible layouts of the 216 colors. When art is viewed on some monitors, colors that are outside of the web palette for flat color may cause colors to "dither" (distort the color into a line pattern, due to the computer's trying to simulate a color outside of its range). Using the web palette allows web images to be viewed on 8-bit or higher monitor

Figure 6–12 Web Colors are a selected palette of 216 colors that can be displayed on older monitors as well as new ones. Screen capture from Adobe Illustrator® and Adobe Photoshop®, registered trademarks of Adobe Systems, Inc in the United States and other countries.

display screens. Use of web- or browser-safe color is slowly going out of use as fewer display screens have a low bit depth.

CMYK COLOR MODE CMYK color mode on the computer correlates with subtractive process printing colors. On the display screen, CMYK has sliders that represent percentages of cyan, magenta, yellow, and black, used either singly or in combinations. [6.13] Not every color monitor is able to display pure CMY colors exactly, but using this mode translates perfectly for printed color artwork. The CMYK mode should be used for art that is to be sent out to a printer for publication. A process color swatch book is a vital reference, because colors seen on screen are different from the final colors printed at the printer. The monitor displays color in an additive mode, forming brilliant luminous color that cannot be exactly emulated in print with the process colors. Also, due to unavoidable changes between types of monitor screens, the quality of color varies on screen. Tints in the CMYK mode are formed by low percentages of colors; for example, a 10 percent magenta is a light tint of magenta. [6.14] To generate shades, percentages of K (black) can be added to a color. [6.15] Secondary and tertiary colors are mixed by the combinations of CMY, cyan and yellow for green, magenta and yellow for orange, and cyan and magenta for violet. Various percentages of CMY combinations can control both the value and hue cast of a color. [6.16] Neutrals can be formulated from varied percentages of black to make grays: For example, a light gray is 10 percent black or K, and a dark gray is 80 percent K. Complements can also be mixed together by manipulation of the sliders. For instance, an orange can be first mixed from yellow and magenta, and then a percentage of cyan may be added to the orange to make lower saturation oranges or blues or chromatic neutrals between the two hues.

Figure 6–13 CMYK sliders set at 100 percent magenta. The color appears on the left in the fill color indicator box. The open square is the stroke or outline color, which can also be set to any color. Screen capture from Adobe Illustrator®, a registered trademark of Adobe Systems, Inc. in the United States and other countries.

Figure 6–14 CMYK sliders form a tint of magenta by lowering the magenta percentage. Screen capture from Adobe Illustrator®, a registered trademark of Adobe Systems, Inc. in the United States and other countries.

Figure 6–15 To make shades of a color with the CMYK mode, a color (magenta) is mixed or chosen, then a percentage of black (abbreviated as K for "key") from the bottom slider is added to darken the value of a color. Screen capture from Adobe Illustrator®, a registered trademark of Adobe Systems, Inc. in the United States and other countries.

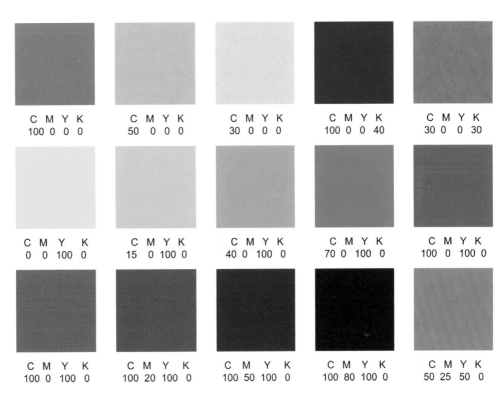

Figure 6–16 CMYK Percentages. The top row shows pure cyan, on the left, with lower percentages to create tints and black added to create shades. The second row shows a chromic gradation from yellow into green by the addition of cyan. The bottom row shows a green with magenta (green's complement) added in increments to mute the green. The last color on the right shows a lower saturation of the muted color by lowering all the CMY percentages.

HSB OR HSV COLOR MODE A third principal color mode is HSB or HSV color. H regulates hue selection, S controls saturation, and V or B varies value or brightness. HSB is operated by manipulating sliders, a hue box, or a spectral band display. The HSB color mode directly correlates with the three attributes of color, so it can be a device for insight into color notation systems. Sliders regulate hue selection, value, and saturation, but all three attributes also operate as a unit. [6.17] For instance, if saturation is set at a low percentage, the whole spectral band in the hue selector appears to be low in saturation. Subtle differences between colors can be chosen from either an enlarged spectral band or a Color Picker box that displays a gradation between a hue, gray, black, and white. [6.18] HSB color mode is the most instinctive for people who are comfortable with traditional subtractive materials such as paint. However, HSB is not a standardized system; therefore, for printed work, the computer must convert color information into CMYK and some color information can be lost in this process.

Figure 6–17 HSB sliders mix a light value, a low saturation green. H controls hue, S controls saturation level, and V or B controls the value or brilliance of a color. Screen capture from Adobe Illustrator®, a registered trademark of Adobe Systems, Inc. in the United States and other countries.

Figure 6–18 HSB color picker can also show many saturations and values of a single hue. A color may be selected from any part of this gradated box. Screen capture from Adobe Illustrator®, a registered trademark of Adobe Systems, Inc. in the United States and other countries.

COLOR LIBRARIES Color libraries further expand the color selections enclosed within graphic programs. Color libraries are large groups of preset colors for color reproduction. Spot colors are used for an exact color match or for color reproductive processes when only one to three colors are desired in addition to black. A printed swatch book is an accurate reference for visualization of how the colors will print (they will appear differently on the monitor). Several color libraries may be contained in a single graphic software program, which displays the color swatches on the screen. Most of these color libraries have upwards of 1,000 colors from which to choose. The PANTONE MATCHING SYSTEM® is the best known of these libraries and is the most commonly used color library in the United States. [6.19] Commercial swatch books can be purchased from each color library company. Swatch books are used either to choose spot colors or to find equivalent CMYK percentages to match each color if the colors are to be printed in four-color process. Even when colors look different on the screen display than on the swatch books, they should match perfectly to the swatches when printed. Swatch books present color samples printed on either coated or uncoated paper stock.

Other color libraries are part of any given software. Many of these libraries are organized into laymen's color terminology such as pastels, desert colors, sky colors, etc. These color palettes are more user friendly and not as technical as CMYK percentages. [6.20]

Figure 6–19 Many color libraries are part of graphic software such as the Pantone® library, shown here in swatches, one of the best known color systems for design. Screen capture from Adobe Illustrator® and Adobe Photoshop®, registered trademarks of Adobe Systems, Inc. in the United States and other countries.

Figure 6–20 Other color libraries are integrated into software, such as groups of colors classified into descriptive categories like desert and tropical colors. Screen capture from Adobe Illustrator® and Adobe Photoshop®, registered trademarks of Adobe Systems, Inc. in the United States and other countries.

Swatch Palette

Most graphic programs have a standard swatch palette that consists of commonly used colors, textures, and gradients. Colors selected from a color library or mixed from any color mode can be dragged and added to the swatch palette to maintain a group of colors while designing. [6.21] Swatch options can be selected to visualize any specific chosen color in a gradient form.

USING COMPUTER COLOR

Although graphic software can be intimidating because of its many options and sophisticated applications, it can be fairly simple to use if some time is spent reading the manual and following tutorials. Simple design/color-studies applications of graphic software need not be difficult. Basic exercises are a quick way to execute color studies and to familiarize us with graphic software.

Color Theory and Computer Design

It is important to remember that the main concepts of color theory are extremely important in any type of computer graphics, especially in web design. Color contrasts are the most effective way of differentiating sections of a web page, graphics, or type against ground. Often we see art on the web with inadequate color or value contrasts, which makes reading

Figure 6–21 The standard color swatch box can be used both for color selections and storing any other colors that are in use. Screen capture from Adobe Illustrator®, a registered trademark of Adobe Systems, Inc. in the United States and other countries.

Figure 6–22 To understand how color theory and color contrasts operate on the web, type studies can be implemented in various color combinations and textures.

type and processing information quite difficult. The principal types of color contrast that can be utilized for type and ground are value contrast, hue contrast, saturation contrast, and/or cool/warm contrast. Of this list, the most important tool to contrast type and graphic images with a background is value contrast. Since the web palette is so limited, it is useful to establish effective color contrast groupings for maximum visibility. [6.22] Contrast can be evaluated by viewing prospective art in the grayscale on the display screen. When texture (noise) is used for backgrounds, low color contrasts within the textured area will keep the textures from overwhelming the images or type placed upon them. Examples of low color contrasts are value matches, analogous hues, all low saturation colors, and all cool colors.

To Pick and Apply Color

Colors can be chosen from any of the aforementioned color models and/or libraries. Bear in mind that a color mode is selected dependent on whether the work is to be printed or viewed on the display monitor. Studies made for a color class can be either printed out or saved on a disc to be viewed on a monitor.

Computer color may be selected either by numerical percentages or by using sliders to choose a color visually. Colors to be used multiple times in a design should be dragged and saved to the swatch palette. Any closed form (fill) or line (stroke) can be easily filled with color by choosing a color and filling the selected object with the paint bucket or eyedropper icon or by simply dragging to or clicking on a color for a selected object. Colors

Figure 6–23 Gradients can be customized by dragging any colors to the small squares below the gradient strip. The squares also operate as sliders to modify the gradient. Screen capture from Adobe Illustrator®, a registered trademark of Adobe Systems, Inc. in the United States and other countries.

Figure 6–24 Various Gradients. From top to bottom: yellow to black, complementary blend from green to magenta, a chromatic gradation from red to yellow, a tint gradation of white to blue, a tone gradation from cyan to gray.

may be changed quickly as a study is produced, since colors may be immediately reselected and refilled into selected areas. If the stroke (outline) option is set to zero or off, the color will fill a selected shape completely to its edges. There is an enormous advantage to creating color studies onscreen because we can view alternate color options and combinations with ease. Working electronically is an effective and efficient tool for conceptualizing color harmonies.

GRADIENTS Gradients are gradual blends of one color to another, or a color to a neutral. Gradations blend from left to right, top to bottom, diagonally, or from the center of an object. There are some preset gradients on the swatches palette, but gradients can also be customized. [6.23] A gradient fill is created with the gradient palette or tool by dragging colors from the swatch palette to the gradient bar, then manipulating the gradation itself with the sliders on the bar. Gradations can be customized by color, direction, and amount of gradation. [6.24] Gradients are useful in being able to visualize color blends between two hues or colors.

BRUSHES Computer brush options are numerous and easy to use and customize. Brushes can be chosen from an extensive list of preset types, such watercolor, ink, charcoal, stipple, airbrush, and others. [6.25] Brushes can also spray a group of textures or symbols along a path or be made transparent to any degree. Filters can be applied to brushstrokes to change their character, textures, or other attributes. In a bitmap program such as Photoshop, using brushes is extremely flexible and variable, and there are more filters available because objects are already in raster format, which makes it easier to apply filters.

TRANSPARENCY The transparency option palette allows the use of an opacity slider to control the transparency of a color from 0 percent opacity (completely clear) to 100 percent opacity (completely opaque). When using transparent color, new colors are formed when shapes overlap. A transparency mode can also allow overlapping color areas to mix in a number of different manners. Individual objects or groups of objects can be set for transparencies with varying results.

Figure 6–25 Brushes on graphic software have a wide range of functions and visual effects; note the many variables for customizing brushes. Screen capture from Adobe Illustrator® and Adobe Photoshop®, registered trademarks of Adobe Systems, Inc. in the United States and other countries.

Computer Color Printing

INK JET PRINTERS Computers used for artwork at home use a color printer, which is usually an inexpensive ink jet printer. Ink jet printers use the CMYK process colors in cartridges that are applied to the paper by high pressure or heat. Color quality can be improved by printing on glossy photo paper. A dot pattern creates color blends and gradations. High-end ink jet printers can also have pigmented ink, which is much less susceptible to fading over time.

A giclée (French for *spray*) printer is a high-end ink jet color printer. It sprays CMYK process inks onto paper in a much slower process that yields richly colored printed materials.

LASER PRINTERS Laser printers are high-resolution printers that use laser technology to define an image. A heat process melts toner powder onto the paper. Laser printers utilize CMYK process color to create colors images either in layers or all at once.

DYE SUBLIMATION PRINTERS Dye sublimation printers convert solid dyes into gases that are then applied as colors onto paper. This process does not use dots as laser and ink jet printers do, but forms continuous tones. Dye sublimation printers are a good way to print out high-quality photo images directly from the computer.

Computer processes uniformly use dyes as their colorants, meaning that the lightfastness of the printed products are dependent on the quality and permanence of the dyes. Some printers are capable of using pigmented inks for permanent art.

COLOR MANAGEMENT

Two major drawbacks to using computer color are that color gamut ranges vary from one color mode to another, and inconsistencies may occur between colors on a screen display and the actual colors as printed on paper. Color management is a way of stabilizing color variation between devices in order to provide more consistent color. The limitations of color gamuts may affect such things as RGB and CYMK modes because each mode may have a number of colors that cannot be reproduced by the other system. [6.26] Color variations also occur among different monitors, printers, scanners, and papers.

Color matching problems arise from all of these variables. A color management system or CMS translates color in a precise way between the computer devices. Color man-

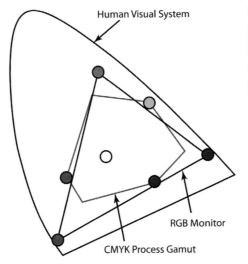

Human Visual System

CMYK Process Gamut

RGB Monitor

Figure 6–26 Comparative gamuts of RGB and CMYK superimposed upon each other. Note the colors that can be made with CMYK and colors that are not available to RGB. The overlapped areas indicate colors that are common to both modes.

agement employs an objective manner of defining colors, namely CIE color. CIE color is based on a perceptual color model. Color information is translated by a color management system into the appropriate color selections in each color mode. Color monitors can also be calibrated with special software to standardize color settings and make screen display colors more accurate. Some graphic programs have color management settings for web graphics and U.S., Japanese, or European prepress.

Another tool for color consistency is viewing printed color under consistent lighting. Graphic design light booths can be set up for viewing color in balanced light. Adequate and consistent lighting is also helpful in areas where monitors are used in a design studio.

Computer color gives the artist more color choices than ever. A working knowledge of the color options contained in each graphic program is the foundation for successful manipulation of computer color.

ACTIVITIES

Objective: For the student to use and become familiar with the various computer color modes: RGB, CMYK, and HSB. The student will also learn some computer operations by making some simple color studies using fills, blends, and gradients.

1. RGB, CYMK, AND HSB EXPERIMENTS

- Use RGB sliders to create white, black, gray, cyan, magenta, and yellow.
- Use the CYMK mode to make red, blue, and green. Use the sliders to make at least five light tints and five shades of different colors. Low percentages make tints and colors with percentages of black added create shades. Mix complementary colors to make some neutrals.
- From the HSB mode, pick at least two different hues. Manipulate value and intensity to make ten to twelve variations on each hue. Place the colors on the swatches palette. Use the colors in a grid study. The grid may have 4×4 square units, making 16 squares or 5×5 units making 25 squares. Repeat colors as desired. Use the rectangle tool and duplicate to make squares. Use the grid on your art board as a guideline for placement. [6.27]

2. COLOR BLENDS

- Make various hue-to-hue or color-to-color blends using the gradient tool. By dragging pure colors to the gradient bar, you may form a gradient between two colors. Using the following color criteria make the following gradients:
- Complementary blends.
- Hue-to-hue blends (use two hues that are difficult to imagine mixed together).
- Make colors with the CMYK palette and make mixtures between them, such as an orange from magenta and yellow with a violet added (try to conceptualize the percentages to do this).
- Mixtures between light value and dark value colors.

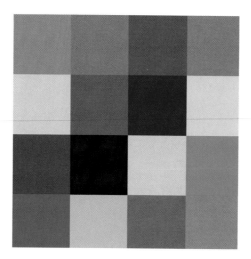

Figure 6–27 HSB Study. Variations on any two hues are mixed in HSB mode, saved as swatches, and then placed into a grid.

- Gray and hues to make tonal bars.
- Blends of colors or hues with white or black. [6.24]

3. BEZOLD STUDIES

- Make a simple pattern with at least five colors. Use shape tools: a pencil tool for freeform shapes or a pen tool for structured shapes (either rectilinear or curvilinear) for parts of your design. The whole study should be filled with color. Make sure that you save your colors on the swatch palette.
- Duplicate the study on the same art board. Using the same group of colors, change only one color in the design to revise the appearance of all the colors in the study. Make a third design, this time changing one of the colors in the design to a gradient of any color(s). [6.28]

Figure 6–28 Bezold effect studies are fast and simple when made with the computer. Copy and paste an original study and simply change colors and/or gradations to modify the overall appearance of color interaction.

Figure 6–29 A transparency study makes use of varied transparency percentages to create the proper color mixes in the overlapped areas.

4. TRANSPARENCY STUDY

- A study can be made of transparent colors in either a vector or bitmap program, with selected shapes using the shape tool or created shapes using the pencil or pen tool. Shapes can be copied and pasted, scaled to different sizes, and composed with overlapping areas.
- The colors in each shape can be set at approximately 50 percent transparency, depending on the intensity of each color. Darker hues or colors may not seem to be transparent at 50 percent, and lighter hues or colors may need to be set to a higher percentage to equalize the colors for a transparent appearance.
- The background color can be set to a neutral color or white, similar to the study in Chapter 4. This will enhance the transparency.
- This study is an easy way to help visualize transparencies and will assist in understanding concepts set forth in Chapter 4. [6.29]

5. WEB COLOR TYPE STUDY

- Using a phrase, make several design layouts of type on a ground. The phase can be laid out horizontally, vertically, or diagonally or in a combination of these positions.
- The background should have some type of simple tile motif or texture, all or in part.
- Using either the web palette or RGB color, make at least four different color combinations, using some standard harmonies from Chapter 9, or simply concentrate on color contrasts for readability.
- Colors should be also chosen because they are expressive of and sympathetic in relationship to the textual meaning of the phrase.
- This piece may be viewed in grayscale to verify whether value contrasts are adequate to make the text visible. [6.22]

Figure 6–30 A computer painting made with vector or bitmap program is an experiment with drawing and painting tools, effects, and filters.

6. COMPUTER PAINTING

- Make a study using the paint options on your drawing program or painting program.
- Pick five colors for your study and place them on the swatches palette. Use paint effects exclusively to make this study. Vary the brushes; use the airbrush, the blur, and the eraser tools.
- You should also try to apply filters to change the appearance of the piece; however, try to use filters that create painting effects and not ones that look artificial.
- Make a study that is textural, painterly, and does not look like it was made on the computer. [6.30]

Chapter 7
The Elements of Design

INTRODUCTION

Design elements, which are also referred to as art elements, are the basic visual building blocks of art. *Form* is defined as the purely visual component of art. Within the form realm of art, design elements offer a series of alternatives. *Design elements* are visual tools that are utilized to generate two-dimensional and three-dimensional art. Each design element has its own distinct visual characteristics. The design elements are line, shape, form/volume, space, value, scale, texture, and color. Color is by far the most complex and variable of all the design elements. The artist makes suitable choices from this design element "toolbox" to convey the subject, theme, and function of an artwork.

THE ABSTRACT CONCEPTS OF DESIGN

Wassily Kandinsky, in his book on art and design entitled *Point and Line to Plane* (1947), compiled a working list of the abstract components of art that are the basis for all design elements. Kandinsky identified the four major ingredients of art as point, line, plane, and volume. [7.1] A *point* is defined as either a dot or simply a location in space. A point may also be visible or invisible, of any size; it refers to a specific position in a composition. A *line* is a connection between two points and can be thought of as a point's or dot's movement through space. A plane is a shape with height and width, but no breadth or depth. A *plane* is two-dimensional and flat, but may have any configuration of outer edge or contour.

Figure 7–1 The abstract components of design: point, line plane, and volume.

A volume is a plane that has been pushed back into or advances forward in space. A *volume* has three dimensions, height, width, and depth. Parallel concepts to point, line, plane, and volume will emerge in the following discussion of design elements.

THE PICTURE PLANE

The *picture plane* is a formal rectangular or square unit that contains a two-dimensional composition. The format of the picture plane is a given entity of art and design, even though there are many pieces of art that do not use this format. In the understanding of two-dimensional design theory, the picture plane is a useful structure to aid our study of composition. By working within the confines of a picture plane, we learn to master compositional forces. A picture plane is the compositional window through which we see an artist's vision.

DESIGN ELEMENTS

Line

A *line* is a pathway, the closest distance between two points, the elemental mark, and a moving point. Lines and edges define our visual sense, because we identify an object by innately scanning its contour. Line represents the edge of a form, distance, a continuum, and a connector. Line is the trail left by pulling the point of a pencil or pen. Line is strictly defined as a mark whose length is greater than its width. The term *linear* refers to line or line quality.

 The variables of line are its width, direction, quality, position, and expression. As defined, a line's length must be greater than its width, but its width can range anywhere from slight to massive. The direction of a line is an infinite and ever-changing path. We tend to think of line as straight, so special attention must be put into variety of line directions. Descriptive words for a line's direction include straight, curved, zigzag, meandering, squiggled, angular, massed, spiraling, and overlapping. Line quality refers to the texture, media, weight, hand pressure, personality, and speed of a line. [7.2] An exploration of line quality can originate in simple word associations. The following list includes linear objects paired with descriptive adjectives for the character of each line:

Object	Adjective
Tree branches	gnarled
Wire	taut
Leaf veins	branching
Highway lines	straight, curved, dotted
Circuitry	angular
Facial lines	fine, spreading
Wrinkles in fabric	undulating, smooth
Yarn	fuzzy
Barbed wire	jagged

A similar descriptive list suggests media that will produce a large range of distinctive line marks:

 Tight and delicate—ink

 Bold and heavy—charcoal

 Fast and blended—charcoal and graphite

 High contrast—black ink with white chalk

 Blurred and bled—ink into water wash

 Personal lines—made from words, letters, shapes, images

Figure 7–2 Line Direction. Line can vary in any directional path: straight, curved, squiggle, zigzag, scribble, etc. Line quality varies with hand pressure and media handling.

Line position refers to a line's direction in relationship to the picture plane. Horizontal, vertical, and diagonal are the three major line positions. [7.3] *Vertical* direction suggests height, up and down, north and south. *Horizontal* direction suggests flatness, east and west, the ground, and the horizon. *Diagonal* lines can be in any direction, varying by 360 degrees. A diagonal can be an angle of any degree, radiating any direction, or be a stationary 45° angle. Diagonals form a compositional dynamic that suggests movement, speed, rotation, and convergence.

A line can also move through space three-dimensionally, either receding or advancing into the picture space, by convergence or gradation of width. An *actual line* is a physical line in three-dimensional space, for example, a wire or thin piece of wood in a sculpture. An implied line points to another line as its logical continuum, creating an invisible connection. [7.4] An implied line is a conceptual line that forms bonds between the parts of a composition.

Shape

When a line closes upon itself, it produces a shape. A shape is a two-dimensional closed form or plane. [7.1] A shape can have any contour, height, and width, but no depth. A shape has mass or area defined by its edges. It can be outlined or solidified by filling it with a value, a texture, or a color. Shape is almost infinite in its variations.

There are several categories of shape. Geometric shapes are our standard shape vocabulary: circle, square, rectangle, ellipse, triangle, diamond, and pentagon. [7.5] Geometric

Figure 7–3 Line position refers to its direction in relationship to the picture plane. The main line positions are vertical, horizontal, and diagonal (also shown as "radiating" diagonals).

Figure 7–4 Line Continuity Study, student work by Alicia King. Implied line forms a mental and visual connection between the parts of the composition.

Figure 7–5 Geometric shapes are the standard shape vocabulary: circle, square, triangle, rectangle, oval, diamond, and trapezoid.

shapes form the archetypal shape language and serve as building blocks for other categories of shapes.

A *rectilinear shape* is made up of straight edges. Rectilinear shapes are angular in structure, and may be based on sections of squares, rectangles, triangles, or a combination of ruled lines. [7.6] A *curvilinear shape* is built primarily from curved edges. The contours of a curvilinear shape are derived from circles, ellipses, or freehand curves. [7.7] Curvilinear shapes indicate a sense of movement or continuity.

Art and design cannot be created in a vacuum. Art is always derived from and inspired by our surroundings. Some shapes are reality based: namely organic (nature made) and mechanical (man-made). *Organic shapes* are those that are inspired by—but not a direct depiction of—nature. [7.8] For example, an organic shape could be derived and synthesized into a simplified shape from a flower, shell, or leaf. *Mechanical or man-made shapes* are inspired by man-made objects, technology, architecture, tools, and so forth. [7.9] Everyday objects can be compelling sources for the invention of shapes.

Symbols are shapes with cultural associations. A *symbolic shape* stands for an idea, such as a cross, a heart, a stop sign. [7.10] Symbols should be used with the awareness of

Figure 7–6 A rectilinear shape is formed from straight edges or contours.

Figure 7–7 Curvilinear shapes are formed from curved edges.

Figure 7–8 Organic shapes are those reminiscent of natural forms.

Figure 7–9 Man-made or mechanical shapes are those inspired by man-made objects.

Figure 7–10 Symbolic shapes are associated with cultural meanings.

their strong associations with specific ideas. The viewer can often perceive a thematic message when symbolic shapes are presented in an artwork.

Shapes can be invented and individualized with infinite variety. An *invented shape* is a unique shape formulated by an artist. [7.11] Any category of shapes can be an inspiration for shape invention. Some students easily develop invented shapes, but others have problems with shape invention. Several strategies facilitate the process of shape invention. *Addition* is a process of overlapping multiple shapes in order to synthesize composite shapes. [7.12] The process of *subtraction* also utilizes overlapping shapes, which are then sheared or subtracted in order to make new shapes. [7.13] In the process of *intersection,* shapes are overlapped, and a common residual area is extracted to produce a shape. [7.14]

When a shape is positioned in a picture space, it occupies a larger physical area than a line. The innate mass of shapes gives them an interdependent relationship with the space of the picture plane. The area that a shape occupies is called the *positive space* or *figure* in a composition. The area that surrounds the shape is called the *negative space* or *ground.* [7.15] When designing with shape, we need to be sensitive to both positive and negative spaces. The negative space, in some instances, can itself become a shape. When we are uncertain which compositional areas are positive and which are negative, this is called *positive/negative ambiguity.* [7.16] Positive/negative ambiguity is sometimes also referred to as *figure/ground reversal.* As shown, in figure/ground reversal, our eye shifts between the black shapes as a positive space, then to the white areas as the positive space, and back again. Comprehension of positive and negative ambiguity serves to sensitize us to the manipulation of space in a picture plane.

Figure 7–11 Invented shapes can be made from any of the shape creation processes or simply by instinct.

Figure 7–12 The additive process forms new invented shapes by overlapping and combining a group of shapes.

Figure 7–13 The subtractive process uses overlapping to create new shapes. In this case, the overlaps cut away to form a new shape.

Figure 7–14 The process of intersection uses only the area where two or more shapes intersect, which is sometimes called a residual shape.

Figure 7–15 The relationship of shape to background. The shape is referred to as the positive space or figure and the background is called the negative space or ground. When this relationship is unclear, this creates positive/negative ambiguity or figure ground reversal.

Figure 7–16 Figure ground reversal occurs in this pattern. Student work by Amberly Strykza.

Space and Form

Two main formats of art are two-dimensional and three-dimensional structures. Three-dimensional work, such as sculpture or relief, is comprised of *actual* space and form. On a two-dimensional plane, however, space and form are created as *illusions*. Space in two-dimensional art hearkens back to the Renaissance notion of the picture plane as a window that represents a three-dimensional world. Our visual experience of the world forms guidelines for generating illusionary space. Gravity, weight, scale, value, perspective, and color all factor into the illusion of three-dimensionality.

FORM A shape realized in three dimensions is called a *form* or a *volume*. To represent a convincing spatial illusion on a two-dimensional plane, flat shapes must first be transformed into volumes or forms. A plane or flat shape is changed into a three-dimensional form or volume by the addition of the third dimension of *depth*. A flat rectangular shape can be made into a planar form by adding breadth or thickness. A curved or irregular shape acquires volume by gradated values called *modeling*. [7.17]

Figure 7–17 A shape is a plane with only two dimensions; a form is a volume with three dimensions or the illusion of three dimensions.

Figure 7–18 The three levels of space can be conceptualized as three parallel planes.

BACKGROUND

MIDDLE GROUND

FOREGROUND

Figure 7–18 The three levels of space can be conceptualized as three parallel planes.

SPACE Actual or true space is used only in three-dimensional art such as sculpture and architecture. It is quite complex to create an illusion of space on a two-dimensional plane. By application of the distortions that the human eye sees in depth perception, we can create an illusion of space. Methods to create illusionary space range from the simplest to the most complex as follows: overlapping, diminishing size, vertical location, form and modeling, linear perspective, and atmospheric perspective.

The three levels of space are identified as foreground, middle ground, and background. The *foreground* includes the objects and space closest to the viewer. The *middle ground* is comprised of objects and space that are a medium distance away from the viewer. The *background* consists of the objects that are farthest away in space along with the distant space itself. These spatial levels can be thought of as three parallel planes of glass in layers successively receding from the viewer. [7.18]

Ways to Create Space

The simplest method to create space on a two-dimensional plane is *overlapping,* which is the visual placement of one object in front of another. Overlapping or superimposition is a simple but extremely effective mode of constructing spatial depth. [7.19]

Objects that are further away from us in space seem to recede in size/scale. Because of our sense of size permanence, we instinctively recognize that objects are not actually smaller and that the perception of scale change is an illusion. The illusion of depth in a picture plane can be produced by *diminishing size;* objects becoming sequentially smaller as they recede into a larger surrounding space. When overlapping is combined with diminishing size, a stronger spatial illusion occurs. [7.20]

Figure 7–19 Overlapping is the simplest way to imply a three-dimensional space.

Figure 7–20 Overlapping combined with diminishing scale or size creates a stronger spatial illusion.

Figure 7–21 Vertical location refers to the placement of objects in a life-like spatial situation. The objects in the foreground are lower in our field of vision; their base lines are lower in the picture plane. Note that this placement is mirrored in the sky area.

An open space that is defined by a horizon line instantly implies a space with both gravity and depth. By adding a horizon line to a picture plane, the bottom section of the composition implies a ground plane and the area above the horizon line suggests sky. Objects placed in the "ground" area of the imaginary space in the picture plane give it a sense of gravity and location in space. Higher or lower vertical placement that determines spatial depth is called *vertical location.* [7.21] In vertical location each object has a *base line,* which is the base of each object in an illusionary space in relationship to the horizon line. Vertical location emulates what we see in reality; the base lines of objects closer to us are lower in our field of vision. Objects in the middle ground are positioned successively closer to the horizon line as they recede. Objects in the background are located highest in the picture plane and closest to the horizon line, the farthest point in illusionary space. Objects in the sky plane also must be correctly placed to enhance a spatial illusion. Objects in the sky area of the picture plane are larger at the top of the sky, becoming systematically smaller in scale as they are situated lower toward the horizon line. An identical vertical location strategy is used in either the ground or sky plane. This strategy is mirrored above and below the horizon line, which represents the farthest point in space. Objects meant to be weightless or floating are not subject to vertical location and can be located anywhere in the picture plane.

Linear Perspective

Linear perspective is a system devised during the Renaissance for accurate depiction of space. Perspective constructs the mode in which volumes seem to become smaller as they recede spatially, emulating a visual illusion formed by our eye. Linear perspective employs lines and vanishing points to demonstrate diminishing sizes and recession of objects in space. Linear perspective defies logic. Logically, we know that a box's dimensions are consistent in height, width, and depth, independent of its location in space. The scale of objects *seems* to reduce in dimension toward points, which are called *vanishing points.* In one- and two-point perspective, a vanishing point is placed on the horizon or eye-level line. The eye-level line represents the viewer's height in reference to the objects and the farthest point in space. As objects recede into the background, their edges appear to become closer together and diminish in width. Guidelines for each object converge at vanishing points. One-point perspective is the system used for objects that are located perpendicular to our viewpoint, meaning that a flat surface of the object faces us. [7.22] In one-point perspective, each object's guidelines recede to a single vanishing point, to make, for instance, the front dimension of a box larger than its rear dimension.

Figure 7–22 In one-point perspective, each object recedes to a single vanishing point that is always located on the horizon/eye level line.

Two-point perspective represents a view of objects or interiors that are located at an angle to our vision. For example, a box or building with its corner closest to us is depicted by two-point perspective. [7.23] An interior viewed diagonally is also represented by two-point perspective. Objects in two-point perspective are delineated as two sets of lines receding toward two vanishing points, which are located on the eye-level or horizon line.

Linear perspective can be generalized into two concepts, exterior and interior perspective. Exterior perspective guides the depiction of objects in an open space. Exterior views depict either objects seen in a landscape setting or the outside surfaces of architectural objects. Interior perspective guides the depiction of interior spaces. Inside or interior perspective depicts an interior view of buildings or rooms in an architectural space.

ATMOSPHERIC PERSPECTIVE An alternate means of creating space on a two-dimensional plane is atmospheric perspective. The concept of *atmospheric* or *aerial perspective* differentiates distinct characteristics between foreground, middle ground, and background objects in space. In our observation of real space, objects in the foreground have more detail, stronger light/dark value contrast, and brighter colors than distant objects. As objects

Figure 7–23 In two-point perspective, each object recedes to two vanishing points located on the horizon line.

Figure 7–24 Objects in the extreme foreground enhance a spatial illusion. Student work by Donna Briceland.

recede spatially, they lose detail and become less distinct. Objects also tend to lose value contrast and color saturation as they recede into space. [10.16] When we view distant mountain ranges, for example, they tend to be lighter, grayer, or bluer than closer mountains. The amount of atmosphere between the distant object and the viewer causes this illusion. For the artist, contrasting color, value, and detail are effective tools for the depiction of space.

The artist may enhance a three-dimensional illusion by "placing" objects in the extreme foreground. Large-scale objects in the foreground, which seem to obstruct our view, dramatize a spatial illusion. [7.24]

Value

Value is the series of gradual light to dark steps in achromatic or chromatic colors. The compositional depiction of space, light, and form is powerfully expressed by value. Contrasting values can be controlled to impart a flat shape with volume by light and dark areas or gradations. A round, curved, nonplanar form is given volume by an evenly stepped value change, called a gradation. By gradation, a curved object seems to be a volume with a play of light across it. In contrast, an illuminated planar, flat-sided form has abrupt value changes, with light and dark areas defined by the edges of planes. [7.17]

An illusion of spatial depth is most effectual when depicted by volumetric, modeled forms. Spatial illusion can be further enhanced by a systematic value gradation. A value system that suggests space is straightforward, operating in two strategies: dark to light or light to dark. For the dark-to-light strategy, a background space is predominantly light (like daylight) the foreground objects should be dark in value, gradually becoming lighter as they recede into space. [7.25] An alternate practice of this strategy is to supply foreground elements with strong value contrast, which gradually become lighter and have less contrast as they recede into space. An equally powerful spatial illusion can be established in the opposite light-to-dark value system. If the background is very dark (like nighttime), foreground objects should be light and gradually become darker as they recede into space. [7.26] The alternate method for light to dark is to give the foreground objects strong light/dark value contrast, gradually letting them become darker and less contrasting as they recede into space.

Value can also be placed in an arbitrary fashion for variety, balance, or to highlight an area of interest in a composition. Placing values arbitrarily will help us understand which values recede, advance, or draw our attention in a compositional context.

Figure 7–25 A spatial value study. Note that the objects seem to recede into space as their values become lighter and have less contrast. Student work by Mimi Fierle.

Figure 7–26 Texture experiments are ways to either depict or invent textures. Student work by Simone Theriault.

Texture

Texture is the characteristic surface quality of an object. Rough, fuzzy, gooey, and velvety are all words that describe texture. Texture is based on our tactile sense of touch, but we also experience texture visually. The everyday visual environment informs our sense of texture; we usually know how the surface of an object will feel solely by visual perception.

Actual or *physical texture* is real texture that is part of a work of art. Chiseled stone, polished metal, or sand added to paint are all examples of actual textures. *Simulated textures* are accurately portrayed textures that create an illusion of being real textured surfaces. Illusionary texture makes use of an artist's rendering skills to exactly duplicate a texture visually on a two-dimensional plane.

Like line and shape, textures can also be individually invented. Invented textures are derived from visual ideas or descriptive words. [7.27] Adjectives that describe textures can suggest creation of them: rough, smooth, fuzzy, glossy, and so forth.

Textures can also be invented by media experimentation, which is application of media in unexpected ways. Paints or dyes can be applied with sponges, toothbrushes, pieces of board, or by using drybrush, impasto, or imprinted objects. Combinations of media can be used. Scraping off or erasing can be used to make visual textures. Actual textures can be made by building up surfaces with crumpled paper, pieces of board, tape, or modeling paste. Additions can be made to paint, such as sand. Patterning also gives the illusion of texture because of the repeated images, marks and motifs. [7.26]

Transferred texture is texture that is rubbed and assimilated from a surface. A thin paper stock is laid over a textured surface, and then rubbed with a wax crayon, conte crayon, or graphite, which picks up the texture from underneath the paper. A similar effect can be obtained with paint by scraping; this method is called *frottage*. Textures are a wonderful tool for adding visual variety, physicality, and interest to a composition.

Figure 7–27 Student line continuity study by Priya Patel.

The design or art elements are the basic visual tools used to create art. Each visual element has its own characteristics and complexity. Art elements are part of formal study as well as a basis for the knowledge of compositional forces.

ACTIVITIES

Note: All these studies are executed in the achromatic colors of black, white, and gray, so the student can focus solely on the design elements.

1. LINE EXPERIMENTS AND CONTINUITY STUDY

Objective: The student will explore the design elements of line through experimentation with line direction, width, quality, and media.

Media: Black, white, and gray media. Cut papers on 15″ × 20″ illustration board. Leave 2″ to 3″ border and center the composition.

- Make various line experiments with black, white, and gray media (such as ink, graphite pencil, charcoal, gray and white chalks, and black markers) on white paper.
- The experiments should vary widely in direction, line quality, width, and media.
- Using the line experimentation examples that you have made, put together a variety of types of line into a collage.
- The lines should be connected, forming a collaged composition that has single or multiple pathways, using the principle of continuity (see Chapter 8) for unity.
- Try to connect all lines and make smooth transitions between thick and thin lines. The lines should seem to be drawn onto the board. Lines may go "off" the picture plane area. [7.28, 7.4]

2. INVENTED SHAPES

Objective: The student will make a variety of shapes: rectilinear, curvilinear, organic, and invented.

Media: Ink or marker on board.

- Make at least five examples of rectilinear and curvilinear shapes for a vocabulary of shapes to be used in subsequent studies.
- Next, make at least five shapes of your own invention. These shapes can be reminiscent of organic or man-made forms or simply individualized invented shapes. Fill the shapes in with black marker or ink. [7.11]

Figure 7–28 Sample pattern units for positive/negative reversal.

3. POSITIVE/NEGATIVE REVERSAL PATTERN

- Using the concept of positive/negative ambiguity, design about ten shapes in 2″ square units. Each unit should have a shape that easily reverses between figure and ground. To increase your success, design these units next to each other. [7.29].
- The shapes can be invented or be additive or subtractive combinations of several shapes. The units can have equal or unequal amounts of positive and negative space.
- Choose two units to make a pattern, alternating each unit in a grid system. The overall effect should be a unified repetitious structure.
- The pattern may use simple alternation of units, or the units may be mirrored, reversed, or changed in direction. Use tracing paper to aid in this process.
- Use a tracing of the pattern to transfer it onto a board. The final pattern should have figure/ground reversal. Overall image size should be 8″ × 10″ to 10″ × 12″ on a larger board, leaving at least a 2″ border. Choose size based on what works best for the pattern. [7.29] [7.16]

Figure 7–29 Positive/negative reversal pattern. Student work by Matthew Marin.

4. Computer Three-Dimensional Studies

- The student can learn some basics of shapes becoming forms on the computer in several ways.
- Invented shapes can be drawn with a pencil or pen tool on the computer.
- After brief vocabularies of these shapes are formed, the student can apply graphic 3D effects (in the graphic effects palette) to each specific shape, which will make them three-dimensional.
- Other shapes can be defined by using gradients, either standard ones from the swatch palette or a gradient that is customized by the student, using a gradient mesh or simply changing the layout of a gradient.
- Another useful tool for giving a flat shape a three-dimensional quality is the use of the extrude effect or filter. This can easily give an object a third dimension, whether it is a paintbrush line (stroke) or a shape. The individual object can be moved back and forth in space by using the arrange command, which determines the placement of an object in the foreground, middle ground, or background.
- The student can thus quickly understand the relationship of volumetric shape, positioning, and scale of objects by the use of flexible changes in a drawing or painting program.

5. Value Spatial Study

Objective: To sensitize the student to spatial issues. The student will use value and spatial rules to create a spatial illusion.

Media: Black and white and mixed gray acrylic paint on illustration board. Picture area: approx. 8″ × 11″ to 10″ × 14″, with 2″ border.

- Make an abstract design to demonstrate the illusion of depth, using linear perspective, overlapping, size contrast, value contrast, and/or atmosphere perspective.
- Use one of the shapes you have invented. Make it into a form by modeling, giving it depth, and making it appear to be a solid volume.
- Set your forms in an illusionary space: an imaginary interior, an open space with a ground and sky, or as floating shapes in space.
- Use several grays, black, and white to emphasize the volume of forms and depth. As forms recede into space, make the values gradually less contrasting and closer to the value of the background. Values may be light in foreground and dark in background or vice versa.
- Plan your composition with value drawings before executing. [7.24, 7.25]

Note: A ten-step gray scale must be completed previous to executing this painting. Use the gray scale as a reference for your final painting.

6. Texture Experiments

Objective: To experiment with media to make simulated, invented, physical, and transferred textures.

- Use black, white, and gray media to make invented textures. Make a list of descriptive words for textures, such as bumpy, jagged, or stippled, to inspire textural variety.
- Carefully make some of the textures into patterns. Make others by experimenting with media. Imprint some objects using various materials dipped into ink, such as string, wire, and sticks.
- Try painting and scraping away layers of acrylic paint. You can make frottage from objects by laying lightweight paper on a textured object, painting with heavy paint, and then immediately scraping away the paper to transfer texture.
- Build actual textures by gluing small objects to a surface and painting them. Physical surfaces can be built up with layers of paper, tape, modeling paste, impasto paint, self-drying clay, foam core that is carved, Styrofoam, and so forth.
- Use paper to make some transferred textures by placing the lightweight paper on a textured object, such as heavy wood grain, coins, and ridged vents, and rub the paper with a graphite stick or a wax crayon. [7.26]

7. Recovered Design (Project originated by Brian Duffy)

Objective: To develop the picture plane through the use of chance and intuition. To examine the effects of actual and implied texture.

Figure 7–30 Recovered Design, Texture study. Student work by Jennifer Kopra.

- This project will have an almost urban archaeological quality about it. It is reminiscent of old billboards along the highways that have been neglected and weathered. Layers have been torn away from these billboards, making an interesting abstract composition.
- On a 15″ × 20″ board center and rule a 6″ × 9″ picture plane. In this area randomly glue 10 to 20 layers of color magazine images with a glue stick. Each layer can have one or several images. Areas of large type with images can also be used. Let the images overlap the edges.
- After several layers are applied, trim the edges, and then continue layering. Avoid too many representational areas.
- When all the layers are completed, use a hand sander, an electric sander, rasps, files, and knives to scrape, tear, sand, and gouge sections of the surface to reveal portions of the layers below.
- As you remove layers, look for relationships that appear and affect the overall composition. You may add collage areas to aid the continuity of the composition.
- Trim composition and mat with white board. [7.30]

Chapter 8
The Principles of Design

INTRODUCTION

Design principles are theoretical concepts that guide the positioning of design elements within a two-dimensional or three-dimensional compositional space. Design process occurs in two major steps. First, there is a selection process of the art elements to be used: line, shape, space, texture, value, and/or color. The second step in the design process is the placement/organization of the chosen design elements in a picture plane, three-dimensional space, or another type of visual structure. The *design process* consists of both selection and location of elements in a piece of art, guided by the compositional principles of design.

Each design principle—unity, balance, emphasis, rhythm, and movement—correlates with a different aspect of constructing visual space. Design principles are guidelines crucial to the *selection, placement, scale,* and *positioning* of visual elements. Arrangement of art elements in a two-dimensional picture plane is a virtually infinite process. Imagine this visual problem: generating a series of compositions that contain only one design element each—one black shape on a white ground. The ground rules for this compositional problem are: The shape, a half circle, may be used only once per composition and can only vary in placement and/or scale. How many different compositions can be formed within these narrow limitations? Figure [8.1] illustrates several compositional options of the many available with even a limited visual structure. When organizational selections are completely unrestricted, visual problems may seem to present an infinite, endless series of options. These choices can completely overwhelm an artist with alternatives. Designing with every available compositional choice and design element—line, space, color, and texture—is challenging without a strategy for structure factored into the visual equation. In addition to the complex design process, how do we evaluate which compositions are the most visually effective? Design principles are tools that provide parameters for both the implementation and the evaluation of design. Unlike mathematical equations, design principles are theories meant to affect, not constrain, design alternatives.

ORDER AND CHAOS

Each area of human knowledge has its own rules, guidelines, theories, and information. Human nature requires visual order, structure, and harmony, causing us to seek order in the mass of visual information perceived by our eye and processed by our brain. If we cannot detect any measure of visual organization in what we perceive, we discern only chaos. In art and design, there is a fine balance between order and chaos of visual information. Visual

Figure 8–1 Design is about choices and possibilities. Shown here are several compositions made with a shape that has been used just a single time per composition. Only scale and placement have been varied. How many different compositions can be made within these limitations?

art engages the right side of our brain, which operates by intuition rather than logic. Because of this, some design decisions are made simply because they "feel" right. We should cultivate the practice of making art through our instincts. Instinctive art making is unencumbered by rules and can be viewed as actively using chaos. However, if artistic instincts are not grounded in concrete knowledge, we are only practicing trial and error experimentation. Artistic instincts are most effectual when augmented by familiarity with design theory, visual sophistication, and manual/technological skills. Compositional order is visually stable, but an excess of organization can create mundane, commonplace design. In design, the balance between order and chaos may be shifted either toward order or chaos, or it may be balanced between the two.

GESTALT THEORY IN DESIGN

Gestalt is an interdisciplinary theory with applications in the fields of psychology, therapy, memory, and visual perception. Three German psychologists—Max Wertheimer, Kurt Kofka, and Wolfgang Kohler—founded Gestalt theory in 1910. The word *gestalt* can be roughly translated from the German as configuration. Gestalt theory is based on the idea of a whole that is inseparable from its parts. The whole of human experience and perception is acknowledged to be greater than merely the sum of its parts. Gestalt theorists were interested in how human beings visually perceive and mentally organize information. There are substantial applications of gestalt theory to art and design because gestalt entails the study of human perception—the eye as a receptor working in conjunction with the brain. Perception of a visual configuration, pattern, or structure in art is the core of Gestalt theory. Gestalt defines the impulse that drives our inner search for visual structure and organization.

At the heart of Gestalt theory is the analysis of how elements in a visual structure interact to produce a coherent unit. Max Wertheimer wrote about visual perception in his essay *Theory of Form* (1923). In this essay, Wertheimer asserted that our innate need for visual order causes us to perceive elements in cohesive groups. *Similarity* of scale, color, shape, or any commonality of art elements creates visual groups. Visual groups cohere because we perceive objects with similar visual characteristics as belonging together. [8.2] Dissimilar objects can be visually grouped simply by being close to each other—by being in proximity. We also perceive compositional order through the visual devices of simplicity, called *economy* and *continuity,* which refer to the visual connection of elements in a composition. According to Gestalt theory, the manner in which parts of a composition in-

Figure 8–2 According to Gestalt theory, we tend to see objects in logical groups according to different criteria. In the top composition we may see the squares as one group and the brush strokes as another. Objects of a similar scale, value, or in proximity, may also form groups. In the bottom composition, objects of the same value or shape alternately form groups.

Figure 8–3 Gestalt theory also suggests that we "fill in the blanks" visually when looking at art. Each visual structure can read as (a) four squares or a cross, (b) rectangular shapes in a pattern or a diagonal-based shape, (c) lines or steps.

teract affects our perception of them. Our mind forms visual connections, to logically "fill in the blanks," even with a small amount of visual input. [8.3] Gestalt psychology establishes organizational theories that bolster the principles of design.

DESIGN PRINCIPLE—UNITY

Unity is a design principle that conceptually parallels Gestalt theory. *Unity* articulates the manner in which a composition holds together, the way that parts of a composition visually cohere. In a unified composition, the interaction of elements forms a configuration so interdependent that it bonds together visually. Unity is alternatively referred to as visual *harmony:* compositional components must harmonize in order to integrate. Unity is regarded as an indispensable design principle because visual harmony is essential for a successful piece of art. The compositional elements can be unified by two principal methods: thematic unity or visual unity. *Thematic unity* is utilization of a single coherent idea or theme in a piece of art. For instance, if the theme of an artwork is love of a pet dog, pictures of the dog could be collaged together, along with his leash, pictures of his favorite chew toys, pictures of his favorite people, and a label of his favorite dog food. Although this collage would have thematic unity because a single idea operates throughout, it may or may not have visual unity. Visual unity is a method of harmonizing or visually "gluing" together a composition. Visual unity is contingent upon a visually articulate selection and placement of elements in a composition. The following are some simple guidelines that aid in formatting visual unity.

Ways to Create Unity

REPETITION The simplest way to achieve visual unity in a composition is through the concept of repetition. Repeating any art element or strategy enhances cohesion in a design, due to our innate recognition of similar visual elements. When we perceive repetition in design, our mind interprets it as a pattern or configuration. Nature is full of repetitive elements, so we see repetition as a meaningful visual structure. Repetition of visual elements is evident in the natural world—in the patterns of tree branches against the sky or the repeated textural markings on a shell.

To unify a composition, one or more art elements can be repeated—line, form, shape, value, color, and texture. For instance, a shape, such as a triangle, may be repeated to give automatic unity to a design. Conceptual design strategies, such as position, direction, or scale, can also be repeated in a composition. [8.4] For example, placing objects in the same direction (such as vertically) will unify otherwise disparate elements in a design. Perfect repetition of art elements produces a configuration called a *pattern*. A pattern repeats the same formation endlessly in any direction. A pattern has perfect unity, but inspires limited interest compositionally due to its predictable nature. [7.30]

VARIETY Too much repetition in a design can be visually dull and monotonous. To make repetition more visually exciting, it can be paired with a design principle called variety. *Variety* is the differentiation or deviation of an element in a repetitious visual structure. Compositionally, a visual element such as line may be repeated, but some aspect of the element can be varied—such as diverse line widths or positions to spark interest. Repetition can be paired with variety as in the following examples: repetition of shape and scale with variety of position, the repetition of position with variety of shape, or the repetition of shape with variety of value and scale. [8.5] A highly repetitious composition applies order; a more diverse composition leans toward chaos. A high degree of variety is more challenging to unify, but will appear to be more instinctive. Conversely, a high degree of repetition is easy to unify, but more difficult to make exciting.

SIMILARITY Similarity is a concept that directly corresponds to repetition. According to Gestalt theory, when we perceive *similarity* in a design, our eye picks up a pattern or configuration of related elements. In Figure [8.2], top, squares and marks function together

Figure 8–4 Repetition of Direction. In this case verticals visually hold together different line widths. Line position/proximity study. Student work by Mimi Flierle.

Figure 8–5 This composition has repetition of position and shape, with variety of value and scale. Student work by Liza Palillo.

compositionally; however, we may see the squares as a separate grouping from textured marks. In the bottom part of the same example, elements of similar value although they are varied in shape also form visual groups. [8.2] The same idea applies to similarity of scale or position. Our eye innately constructs a visual unit of elements with common visual characteristics, thus creating compositional unity.

CONTINUITY A sound method to attain visual unity is through continuity. *Continuity* or *continuation* is a visual pathway through a composition. A pathway can have an actual physical connection between parts or have an implied relationship (like an implied line) between elements of a composition. [8.6] Continuity is especially effective in connecting the disparate elements of a highly diverse or varied composition. A line of continuity provides

Figure 8–6 Continuity is a visual path through a composition, which serves to unify.

Figure 8–7 Proximity is using the close positioning of elements in artwork to unify and organize a composition. Shape/Emphasis study, student work by Allison Carreon.

a "roadmap" that can guide the viewer through a composition. A line of continuity pathway can be varied in character—smooth and flowing or jagged and circuitous. Continuation visually unites the objects in a visual pathway, in an either obvious or subtle manner.

PROXIMITY *Proximity* is a method of visually organizing elements by grouping them together. According to this Gestalt concept, when even disparate objects in a composition are grouped closely together, they seem to relate visually. [8.7] Proximity groups can be implied by surrounding them with negative space. Our eye sees proximity groupings as cohesive units because of the physical closeness of their positions.

SCALE Scale is alternately referred to as either an art element or a design principle. *Scale*, also known as proportion, is the relative size of objects in an artwork. Scale changes can either signify depth or serve to organize dissimilar objects. Objects with similar scale will appear to visually unify.

The guidelines discussed here for achieving unity can be used either singly or in conjunction with each other to produce compositional harmony.

ECONOMY

Economy is a design strategy that uses a minimal amount of visual information. Economy is related to the concept of minimalism, in which "less is more" visually. Extreme economy of means or elements sets up a compositional challenge for the artist. Economical compositions are often visually arresting and bold due to extreme simplicity and clarity of thought. [8.8] Economy is a valuable technique of paring down the design process to its barest elements.

DESIGN PRINCIPLE—EMPHASIS

The design principle of *emphasis,* also called *focal point,* pertains to the formation of a specific area of interest in a composition. A focal point is not an essential component of design like unity, but an artist may choose to emphasize a specific portion of artwork to enhance a particular image or theme. To establish an area of emphasis/focal point, a com-

Figure 8–8 Economy is the use of a minimal number of elements to structure a composition.

position must provide the viewer with visual clues to direct the eye to a particular area of focus. Numerous points of emphasis in a composition can all be of equal importance, or one point can be primary, one secondary, in a type of visual hierarchy. Methods to establish a point of emphasis in design are described in the next section.

Ways to Create Emphasis

CONTRAST The clearest way to create emphasis in design is to develop some type of visual *contrast*. Our eye naturally focuses on whatever portion of a composition stands out visually as being different, unexpected, or contrasting within an overall composition. A contrast should be in visual opposition to its surrounding environment in some respect. Any art element may be deliberately contrasted with its surroundings—line, shape, color, form, texture, and so forth. For example, a dark shape may be contrasted with a light environment, a textured area contrasted with an area of solid shapes, a three-dimensional form contrasted in an environment of flat shapes, or a flat shape contrasted with a three-dimensional environment. [8.9] Design concepts such as scale, position, and complexity may also be

Figure 8–9 Emphasis established by contrasting line with form. Our eye goes to the textured mark because it contrasts with the forms of the composition.

Figure 8–10 An anomaly in design is an unexpected element that stands out as a departure from the overall visual structure.

employed in a contrasting manner to suggest a focal point. For example, a light value form with complexity will contrast a darker and simpler environment, a large simple form will stand out in an environment of complex textures, or a diagonal placement of a dark shape will diverge with an environment of light vertical lines. An area of visual contrast can also be conceptualized as an *anomaly,* which is an unexpected departure from a general visual structure. [8.10] An anomaly draws our eye because of its surprising nature in the overall strategy of a design.

ISOLATION Another fundamental method of producing a focal point is to use the concept of isolation. *Isolation* is the physical separation of a specific area or item from the rest of the composition, which makes the element or area become a point of emphasis. Isolation can come about in either of the following ways. First, a compositional object may be isolated by a large area of negative space, set adrift, so to speak. [8.11] In this type of iso-

Figure 8–11 Emphasis is created by isolation. Shape/Emphasis Study, student work by Allyson Carreon.

Figure 8–12 The directional force in a composition can create emphasis and tension points.

lation, negative space operates as a buffer to keep the isolated element(s) from interacting with the remainder of the composition. Second, by containing an element within a shape or particular area, an object will be isolated by enclosure, which is akin to circling or outlining the object. [8.7] Isolation by negative space or enclosure produces a solitary element that is a visual point of emphasis in a composition.

DIRECTION *Direction* is the usage of directional forces of shapes, lines, position, or forms to generate an area of emphasis. Direction makes use of implied lines to operate as visual forces that guide the eye to specific points of compositional interest. Our eye can be directed to a point of emphasis in either an obvious or subtle fashion. Elements that are nearly touching in a design form a type of visual tension, which can powerfully focus attention on a specific focal point in a composition.

A focal point may have any location within the picture plane. However, it can be risky to position a point of emphasis directly on the edge of or close to a corner of the picture plane. Either of these placements may cause a balance problem or inadvertently lead the viewer's eye out of the picture plane. Conversely, a focal point need not be placed consistently in the center of the composition. [8.12] The center of a picture plane is highly stable, but also it can be an overly predictable position for a focal point. Risk taking is integral to good design, so the locations of focal points should vary.

Value can also be placed in an arbitrary fashion for variety, balance, or to highlight an area of interest in a composition. Placing values arbitrarily will help us understand which values recede, advance, or draw our attention in a compositional context.

DESIGN PRINCIPLE—BALANCE

Balance is the equal distribution of visual weight in a piece of art. The design principle of balance is a vital component of any work of art. We all have an inner sense of visual balance, weight, and symmetry because of the movement and symmetry of our bodies. We are aware of our own balance and weight during everyday activities—walking, riding bicycles, carrying heavy objects, and so forth. To achieve balance in design, we must first grasp the concept of visual weight. *Visual weight* is the relative visual magnitude and importance of art elements and their characteristics in a composition. Art elements or art concepts are not equal but have disparate visual weights. Complexity, texture, dark value, and large scale

Figure 8–13 Elements with visual weight include those with dark value, complexity, large scale, and texture.

all have innate visual weight. [8.13] Visual contrasts that attract attention also have visual weight, such as strong contrasts in value, scale, position, and/or depth. [8.14] Art elements that contrast with their visual environments, such as a textured element within a smooth area, a dark element in a light environment, and a modeled form in a flat space, all have visual weight.

For the analysis of balance in a picture plane, an *axis* can be placed in the center of the picture plane to divide the composition into two halves. A picture plane subdivided by an invisible axis vertically, horizontally, or diagonally assists in gauging visual weight on both sides of the axis.

Symmetry

Symmetry is formal balance, or perfect balance, vertically, horizontally, or diagonally on either side of the central axis of a composition. [8.15] In a symmetrical composition, elements on each side of the central axis are perfectly equal. When compositional elements are mirrored on either side of the axis, the axis is called the *line of symmetry*. A line of symmetry is the center of formal balance in either two-dimensional or three-dimensional designs. We all have an inner sense of symmetry, as our bodies are essentially symmetrical in form, which makes symmetry feel "right" as perfect balance. However, symmetry can be static and predictable if often applied as a compositional structure, since it is a stable visual structure that yields balance easily. [8.16]

Figure 8–14 Contrasting elements carry visual weight. As shown here: (a) value contrast, (b) scale contrast, (c) position contrast, and (d) shape/form contrast.

Figure 8–15 The picture plane can be divided vertically, horizontally, or on either diagonal to assess balance. The central line is called an axis.

Figure 8–16 Symmetry is formal or perfect balance. Student work by Michelle Priano.

Asymmetrical Balance

Asymmetrical balance, also known as *informal balance,* is the balance of elements that have unequal visual weight. Using asymmetrical balance (also known as *asymmetry*) sensitizes us to comparative visual weights. We must carefully consider positioning unequal elements in the picture plane. Asymmetrical visual compositions can be equalized by the thoughtful placement of visually heavy elements. In this manner, the visually "light" half of a composition can be weighted to compete with the "heavy" half of a composition. Sensitivity to design elements and contrasts with innate visual weight assists our mastery of compositional asymmetry. In this example, a large-scale simple element is balanced by a complex element. [8.17] Here, a dark value complex line element is balanced by a focal point established by direction and isolation. [8.18]

An element's visual weight is often dependent on its placement in the picture plane. Elements positioned closer to the bottom of a picture plane seem heavy. The same elements

Figure 8–17 Asymmetry is also called informal balance. Here, a high-contrast small-scale complex shape balances a large-scale, simpler shape.

Figure 8–18 Balance by Direction. The heaviness of the left side is balanced by the directional force to the right.

become lighter when placed nearer the top of the picture plane. [8.19] This visual sensation is a result of our intuition about the gravity of objects.

Crystallographic and Radial Balance

Other forms of compositional balance include *crystallographic balance,* which is a pattern or subdivision of the picture plane, such as a grid, to achieve balance. Crystallographic refers to an interlocking crystal-like formation that integrates the positive with the negative spaces of the composition, often forming positive/negative ambiguity. [8.20]

Another simple form of balance is *radial balance,* which employs radiating or emanating forms that originate in a given point or area. The "vortex" of radial balance can

Figure 8–19 Objects at the bottom of the picture plane innately have more weight due to our sense of gravity. Notice that the elements can be made lighter in visual weight by moving them upward in the picture plane.

Figure 8–20 Crystallographic balance is based on some type of interlocking structure. Student work by Andrea Swieret.

Figure 8–21 Radial Balance. All the compositional forces radiate from one point for balance. Student work by Chu Chan.

be located virtually anywhere within the picture plane and still sustain compositional balance. [8.21]

Instinct plays an important part in all art, particularly in the design principle of balance. We sometimes innately "feel" that objects are misplaced, too heavy, complex, dark, and so forth. The guidelines outlined here are meant to supplement our visual instincts, not replace them.

DESIGN PRINCIPLES—MOVEMENT AND RHYTHM

Movement

The design principles of movement and rhythm are separate yet interconnected concepts. *Movement* is both literal and suggested motion in a work of art. There are also art forms that use actual movement, such as kinetic art and video. In installation art, for example, the viewer's actual movement through the art piece or interaction with it may be a factor in the impact of the piece. Artists also employ various means to depict motion in a static piece of art.

Frozen motion expresses movement by the static image of an animated object, such as a human body, caught in motion, our mind's eye filling in the "before" and "after" of the narrative. Motion can also be expressed by blurring, which suggests action or speed, as in a photograph of a moving object. Superimposed sequential views of an object moving through space also yield the illusion of movement.

GRADATION A gradation or gradient also indicates movement. A *gradation* is any type of gradual visual change that suggests motion. The sequence of a gradation is a primitive form of visual animation. [8.22] Scale, shape, color, position, texture, value, and color can all be gradated, or changes by degrees. A gradation implies movement because it simulates time: before, during, and after—are all contained in one composition. Our eye follows a gradation to its logical ending, as it presents us with a coherent progression. A gradation also functions to lead the eye to a focal point. [8.23]

DIAGONALS *Diagonals* suggest directional force in a composition, as they convey an innate sense of movement. [8.24] Diagonals that radiate from a given point, for example, move our eye both into and out from that center point. In contrast, compositions based on horizontals and verticals, like a grid, have a high degree of visual stability.

Figure 8–22 A shape gradation suggests movement. Student work by Julie Marks.

Figure 8–23 Movement can be expressed through a serial progression in a sequential composition. This gradation study moves from complex to simple and from textural areas to a single shape. Student work by Darlene Mastrangelo.

Rhythm

Rhythm is a concept directly corresponding to movement but with some distinct differences. Rhythm is a visual quality of movement, a pulsation in our eye's perception of a work of art. Visual *rhythm* describes the manner in which our eye moves through a composition.

Rhythm is a term that describes the essential beat and time structure of music. When an artwork possesses visual rhythm, it possesses a visual beat or repeating element that generates movement. Repetition of a similar direction, such as a repeated group of diagonals, for example, will cause our eye to move systematically and kinetically through a composition.

Two main types of visual rhythm are staccato and legato, terms that are borrowed from music. Legato rhythm in music is a sustained or unbroken sound, smooth and connected. Visual *legato rhythm* is a smooth unbroken path through a composition. [8.25] Staccato rhythm in music is a percussive sound or beat. Visual *staccato rhythm* is a broken "on and off" configuration of disconnected repetitious parts, a visual beat. [8.26] *Alternating rhythm* is achieved by alternating two or more different types of rhythmic structures to interact together in a composition. The alternating structures may be either interlocking parts of staccato and legato rhythms or layers of different type of rhythmic strategies.

Progressive rhythm utilizes a radiating or gradating progression to express rhythm. [8.27] Progressive rhythm correlates with radial balance, because forms emanate from

Figure 8–24 Repetition as well as diagonals suggest movement.

Figure 8–25 Legato rhythm is a smooth fluid rhythm.

Figure 8–26 Staccato rhythm is an on and off broken rhythm.

Figure 8–27 Progressive rhythm emanates or gradates from a given point. Student work by Cathy Van Galio.

one or more points. A visual analogy to progressive rhythm is a rock thrown into a pond, with ripples emanating in circles from the place where the rock splashes into the water. A *gradation* can also depict progressive rhythm because it describes a visual chain of events. A gradation sequence sets up a visual rhythm because gradual changes seem to encapsulate time.

Compositional excellence is achieved by the simultaneous engagement of manual, intellectual, and visual processes. Design principles provide us with guideposts for visual structures, each principle emphasizing a different method of composition.

ACTIVITIES

1. LINE POSITION PROXIMITY STUDY

Objective: For the student to understand the relationship of line position to the picture plane. Unity through the repetition of direction, line width, and continuity should be considered. Proximity of line groups can also be put into use.

Figure 8–28 Line Position Proximity Study. Student work by Amy Claroni.

Media: Marker on hot press illustration board.

- Using only straight ruler lines of different widths make a composition of vertical, horizontal, and/or diagonal lines. The lines should divide the picture plane.
- The concepts of unity to be used are repetition (of the line element), proximity, and variety. Lines can be grouped in several areas, adding areas of interest. All positions—vertical, horizontal, and diagonal lines—can be used, but you may want to select only two or three choices. Diagonals can vary within 360 degrees, but be careful to use some position repetition to organize the composition.
- There may be heavy black lines showing little white space, or the lines can be white against black. The main concept is to create a unified composition with as much variety as possible.
- Do several thumbnail sketches first, then draw one choice up to size on tracing paper and transfer it onto a board.
- The final piece should be accurately inked with marker. [8.28][8.4]

2. SHAPE EMPHASIS STUDY

Objective: The student will use invented shapes to create a visual point of emphasis in a composition. A structural manipulation of positive and negative areas will produce a strong composition.

Media: Cut black shapes on white illustration board.

- Create a shape with an interesting contour that is invented, or pick one from the group of shapes that you invented for the Chapter 7 Activity. The shape may be curvilinear, rectilinear, or a combination of both.
- The shape should be varied in scale either by drawing it in different sizes or by changing the scale on a photocopier.
- Cut shapes of different sizes out of good quality black paper. Use the shapes to make a collage, creating a point of emphasis at the same time. Carefully design the positive and negative compositional space.
- A point of emphasis can be established by the use of isolation, direction, scale contrast, position contrast, and so forth.
- The composition can be varied by the reversal of shape, overlapping, and cropping. Try to use only asymmetrical balance for this study. [8.29][8.11][8.7]

Figure 8–29 Emphasis study. Student work by Darlene Mastrangelo.

3. ECONOMY STUDY

Objective: To use and understand the concept of economy in a figure/ground relationship.

Media: Cut out white shapes on a black ground made with black paper, all presented on illustration board.

- Use the same shape as in number 2 to create a study that explores the concept of economy.
- The shapes of different sizes should be white shapes on a black ground for this study.
- Create a study using extreme economy of means. In this piece you should use five or less repetitions of the shape. The shape may be of any scale.
- The composition should be well designed, with thought put into the placement of the few shapes and figure/ground relationship.
- This study should be substantially different from the shape emphasis study. [8.8]

4. TEXTURE RHYTHM STUDY

Objective: The student will use experimentation with texture, to create a rhythmic visual structure in order to understand the design principle of rhythm.

Media: Mixed media in black and white and gray. Paint, drawing media, and textured surface, on illustration board.

- Use the concept of rhythm to create a composition. Keep in mind the use of repetitive elements to keep the eye moving throughout the composition. You may use legato, staccato, alternating, or progressive rhythm.
- Parts of this composition are to be made with various textures in black, white, and gray media. You can use the invented textures that you made for activity 4 (above). Or you can use actual textured surfaces, transferred textures, and patterns.
- The textures should be inset into your rhythmic structure. Some textures can be repeated to emphasize visual movement within the piece.
- The final study will be a collage that has a rhythmic design and uses some combinations of textures in all areas of the composition.
- The piece may be made in a traditional picture plane or have an alternative shape. [8.30]
- *Computer Texture Studies:* A computer version of this activity is to explore the preset textures in the graphic styles palettes and to vary them by using filters and or effects. Computer drawings can also be texturized by filters or effects, such as SVG filters or crystalize. [8.31]

Figure 8–30 Texture/Rhythm study. Student work by Mimi Flierle.

Figure 8–31 Computer Textures. An exploration of textures that are chosen from computer and modified by filters and other effects tools.

Figure 8–32 Movement Montage study. Student work by Matthew Marin.

5. MOVEMENT MONTAGE

Objective: To design and create the illusion of movement.

Media: Cut photocopies on board.

- Find several images from magazine photos that strongly suggest motion, frozen motion, or blurring. Or the nature of the form should suggest innate movement.
- Make ten black and white photocopies of one of the images.
- Make a montage using all ten photocopies in whole or in part to express the design principle of movement. You may overlap or cut apart the image, or use the whole image.
- The final piece should be an abstract version of the original image using the repetition of the image to convey an overall sense of motion.
- The motion study can break free of the traditional picture plane format and be a defined or irregular shape. [8.32] [8.27]

Chapter 9
Color Schemes and Harmonies

INTRODUCTION

A color scheme provides *color harmony,* a combination of color "notes" that are visually pleasing when grouped together. Color schemes are strategies to facilitate the selection of harmonious colors. Color schemes supply a framework for choosing base hues, which are then varied by value, saturation, or proportion, to form a set of harmonious colors. The strategy of each color scheme is adaptable, subject to the personal preferences of the artist or designer. Color harmonies free the artist and designer from lackluster, habitual color choices and supply a basis for the exploration of color in groups.

Standard (formal) color schemes are rooted in deliberate, controlled hue selections from the color circle. Each scheme utilizes the physical layout of the color circle as a guide for each type of color harmony. Every type of color harmony has its own personality, and color schemes can also be customized to personal preferences by use of hue variation and color proportion. Formal color circle-based schemes are standardized, but informal color schemes with looser guidelines can also be formulated by an artist.

Formal color schemes/harmonies are categorized in three principal areas: simple color harmonies, opposing/contrasting harmonies, and balanced harmonies. *Simple harmonies* are color schemes based on a small number of neutrals or hues. *Opposing/ contrasting harmonies* are founded on the notion of opposite hues or hue temperature contrasts. A *balanced color harmony* is a color chord with hue selections based upon their spacing on the color circle.

The following color schemes are formal/standard harmonies commonly used in fine art and design. Color schemes with the smallest number of hues have built-in color repetition and thus are quite harmonious and unified. A larger number of hues often make color harmony more difficult to achieve.

SIMPLE COLOR HARMONIES

Simple color harmonies are built on neutrals, a single hue, or a group of neighboring hues. The advantage of a simple color harmony is its high degree of color unity; its disadvantage is less color variation.

Figure 9–1 An achromatic harmony is an example of a simple harmony. It uses colors with low or no chroma.

Achromatic Harmony

An *achromatic color* is a neutral containing no hue. A *chromatic color* is a color that contains a discernable base hue from the color circle. An achromatic color scheme uses only achromatic colors: black and white and a full value tonal range of grays. [9.1] Achromatic colors can also be chromatic neutrals from complementary mixtures or muted earth colors mixed with black and white. Achromatic schemes are very harmonious and rely on light/dark value contrast for variety. An achromatic harmony is characteristically subtle and quiet in nature. Cubist paintings utilized achromatic harmony to portray planar forms. [12.9]

Monochromatic Harmony

A *monochromatic color scheme* is built upon a single hue choice from the color circle. Hue variation (see Chapter 3) demonstrates the many color alternatives available within a monochromatic color scheme. A blue monochromatic scheme, for example, may include pure blue; slightly warmer or cooler blues; tints, shades, and tones of blue; and blue intermixtures with other hues. By staying within the constraint of a single hue of blue, the resulting group of colors is very harmonious. [9.2] One disadvantage of this color scheme is the deficiency of hue contrast; value and saturation are the main contrast variables. Monochromatic color schemes are extremely unified, set a strong color mood and convey the personality and character of an individual hue. Pablo Picasso's blue period, for example, is distinguished by his almost exclusive use of blue variations. The painting *La Vie,* for example, establishes a color ambiance by its monochromatic palette, which is in sympathy with its somber subject matter. [9.3]

Figure 9–2 A monochromatic harmony has variations on a single hue, such as blue. The hue variations on blue, for example, could include slightly more BG or BV versions of blue, along with tints, shades, and tones of blue.

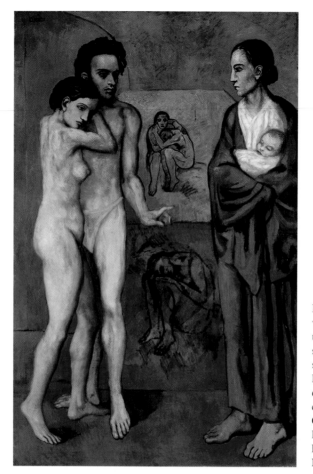

Figure 9–3 Picasso's blue period was characterized by his dominant use of a monochromatic blue color scheme to enhance the melancholy subjects of the paintings. Pablo Picasso (1881–1973; Spanish, produced in France), *La Vie* 1903. Oil on canvas. 196.5 × 129.2 cm © 2002 The Cleveland Museum of Art. Gift of The Hanna Fund 1945.24. Estate of Pablo Picasso, Artists Rights Society (ARS), New York/ADAGP, Paris.

Analogous Harmony

An *analogous color scheme* is based on the concept of a *color family.* Analogous hues are two or three neighboring hues from the color circle. An analogous harmony begins with two to three hue neighbors as its basis, for example, blue, blue-violet, and violet. [9.4] Analogous harmony is an expansion on a monochromatic system, supplying the artist with a greater number of hues than other simple color schemes. Most analogous harmonies have low hue contrast, with the exception of the range of yellow-orange, yellow, and yellow-green analogous group. To use the hues of an analogous color scheme, they may be intermixed, tinted, shaded, toned, and/or slightly modified with other hues. [9.5]

Simple color schemes can be thought of as "layman's" color harmonies because they are reliable, harmonious, and likable. Each simple color harmony has its own distinctive traits. An achromatic scheme is neutral, peaceful and can have high value contrast. Monochromatic or analogous schemes are very harmonious and emphasize visual unity. However, any one of these color schemes may be used in an atypical manner to produce unexpected effects.

CONTRASTING OR OPPOSING HARMONIES

Opposing or contrasting color harmonies maximize hue contrast. These color harmonies tend to generate a lot of visual excitement. As Kandinsky wrote about contrasting harmonies in his 1912 book, *On the Spiritual in Art,* "We can easily conclude that harmonization on the basis of simple colors is precisely the least suitable for our own time. . . .

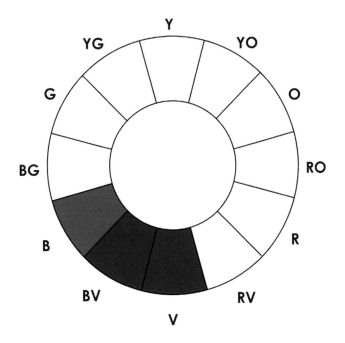

Figure 9–4 Analogous harmony is formed from an adjacent group of two to three hues from the color circle.

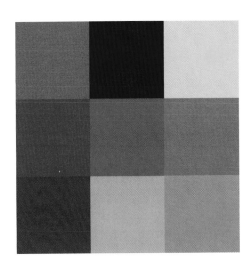

Figure 9–5 A group of analogous harmonious colors based on R, RO, and RV, along with tints, shades, and tones of these hues.

Clashing discords, loss of equilibrium, principles overthrown, unexpected drumbeats, great questionings, apparently purposeless strivings, stress and longing . . . chains and fetters broken . . . opposites and contradictions—this is our harmony."

Complementary or Dyad Harmony

A complementary color scheme is a perfectly balanced opposing pair (or *dyad*) from the color circle. Complementary colors are two hues positioned directly across the color circle from each other. [9.6] Common dyads have one primary and one secondary hue as follows: blue and orange, red and green, and yellow and violet. There are also three tertiary dyads: red-orange opposing blue-green, red-violet opposing yellow-green, and blue-violet opposing yellow-orange. By positioning full saturation complementary hues to directly abut to each other, visual effect called complementary vibration is generated (see Chapter 4).

A color scheme produced from a complementary pair yields a great deal of attention and visual contrast. A dyad can also be mixed together such as (red and green) to generate a soothing group of neutral or partially neutralized colors called chromatic neutrals. A complementary harmony consists of pure hues, such as yellow opposing violet, and then tints, shades, or tones, and their intermixtures (chromatic neutrals). [3.22] Color proportions of each complementary hue may be equally balanced or one hue of the dyad may be chosen to dominate a composition. [9.7]

The complementary color scheme is the magical yin/yang of color harmony, expressing polar opposites through color, yet balanced by its foundation on the three subtractive primaries. A complementary harmony, although it emphasizes contrast, may range from subtle to vibrant, expressing color harmony or movement by complementary vibration. Pure complementary hue pairs are characteristically vibrant and visually "loud," but they also can be muted and enriched by the quality of chromatic neutrals. Our visual reaction to complementary pairs is tied to the concepts of afterimage, color balance, and physical complementary vibration.

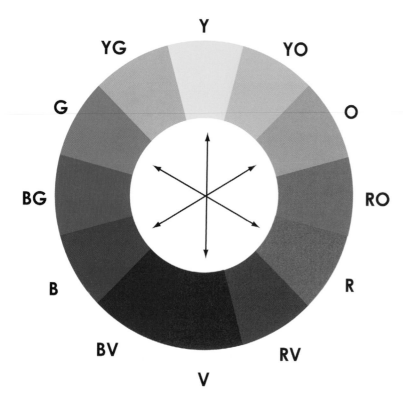

Figure 9–6 Complementary harmonies are based on opposing hues on the color circle. Red–green, orange–blue, and yellow–violet are complementary pairs.

Figure 9–7 A complementary harmony using the red–green complement in a line study (computer illustration). Student work by Michelle Brzezowski.

Cool/Warm Color Harmony

Cool/warm color harmony is a four-hue color scheme that is more loosely structured than most color schemes. Cool/warm contrast emphasizes divergence in color temperature. Color temperature is a metaphorical approach to color as it stems from human color associations: We *feel* that colors are warm (like red for blood) or cool (like blue for water), based on our personal and cultural experience. The cool side of the color circle ranges from violet to green. The warm side spans from red to yellow. [2.15] Borderline hues that are not definitively cool or warm are red-violet and yellow-green. RV and YG are the chameleons of color temperature, which means that they may be considered either warm or cool colors. A warm/cool color scheme is composed of one pair of neighboring warm colors and one pair of neighboring cool colors. Since RV and YG are mutable temperature hues, they can be either cool or warm depending on how they are paired with other hues. RV is cool when paired with violet and warm when paired with red. YG is cool when paired with green and warm when paired with yellow. An example of a cool/warm color scheme is orange and yellow-orange as a warm pair opposed to violet and red-violet as a cool pair. [9.8]

The advantage of this harmony is its extreme flexibility, because any two cool/warm pairs create a scheme, regardless of their placement on the wheel. For example, if desired, a cool/warm group could be red, red-violet, violet, and blue violet, which is also an extended analogous grouping, but technically correct for a cool/warm scheme. This flexibility gives each cool/warm scheme a contrasting yet diverse personality. A cool/warm color scheme retains contrast when the cool and warm hues are not physically mixed together. The problem with intermixtures of cool/warm hues is that they may produce low saturation colors, or too many colors to visually coalesce in a composition. However, cool or warm hues may be tinted, shaded, or toned without canceling out the cool/warm contrast. [9.9] Cool

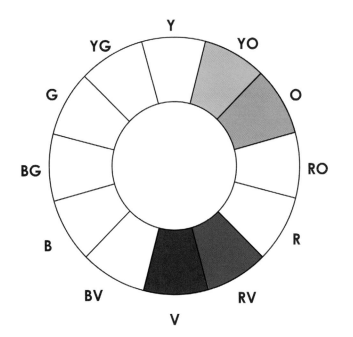

Figure 9–8 A cool/warm harmony uses a pair of any two adjacent cool hues with a pair of any two warm hues.

Figure 9–9 A grid study of cool/warm color harmony based on Y and YO opposite RV and V. No intermixtures between warms and cool colors are used, but hues may be tinted, shaded, or toned. Warm/Cool Grid Study, Student work by Lisa Webb.

or warm pairs can be intermixed (cools with cools or warms with warms) to form intermediate colors between the hues. For example, a color between yellow and yellow-orange may be mixed to widen color alternatives. The example shown here is the great work by Paul Cezanne entitled *The Large Bathers,* which utilizes a casual cool/warm harmony of yellow-YO and blue-BG. [9.10] The cool/warm contrast that Cezanne often employed creates a type of flickering rhythm throughout the painting, caused by small marks of adjacent, subtle temperature contrasts. The cool/warm harmony offers the artist numerous options, leading to a more open-ended scheme because hue selections are locked into particular positions on the color circle, but are more freely and instinctively chosen.

Double Complement Harmony

A *double complementary scheme* is a four-hue contrasting color scheme, which employs two adjacent complementary pairs. [9.11] A double complementary harmony softens and expands the opposing complementary color contrast. An example is green and yellow-green opposed to red-violet and red. A double complementary harmony may operate in varying ways: utilizing pure hues, intermixtures between complements, and tints, shades, and tones of any of these. This harmony is a further structured version of a cool/warm color scheme, emphasizing the contrast of opposing hues. [9.12]

Split Complementary Harmony

A split complementary harmony can be regarded as either a contrasting harmony or a balanced harmony. A *split complementary scheme* is a three-hue color harmony based on an opposing dyad. A split complementary harmony originates with a dyad but rather than having a direct hue complement, the two hues on either side of the actual complement are chosen, for example, violet opposes yellow-orange and yellow-green. This harmony is based on a narrow V configuration inscribed in the color wheel as shown. [9.13] Beginning on the opposite side of the color circle, the split complement of yellow is red-violet and blue-violet. This color scheme is traditionally viewed as a softened complementary scheme or a modified triadic harmony.

Figure 9–10 Paul Cezanne (1839–1906), *The Large Bathers,* an example of a cool/warm harmony that integrates together in this masterwork. 1906. Oil on canvas. 82 7/8″ × 98 3/4″ (210.5 × 250.8 cm). Philadelphia Museum of Art: Purchased with the W. P. Wilstach Fund. 1937. Acc: W1937-1-1 Photo: Graydon Wood.

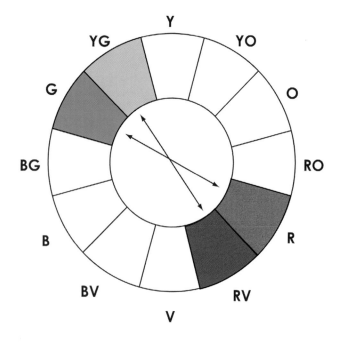

Figure 9–11 A double complement has two adjacent complementary pairs.

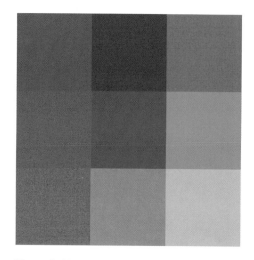

Figure 9–12 A double complementary harmony based on RV–YG and R–G. Hues can be mixed in almost any way within this scheme.

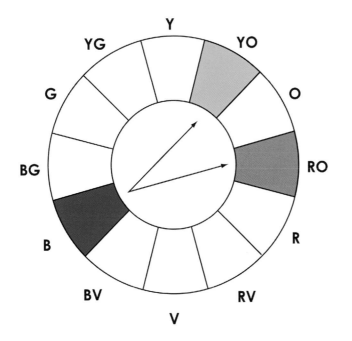

Figure 9–14 A split complementary harmony starts with three hues, along with their tints, shades, and tones. Shown here, a computer illustration line study based on red, BG, and YG. Student work by Bonnie Sue Bacon.

Figure 9–13 Split complementary harmony is an expansion on a dyad, although it uses the two adjacent hues rather than an actual complement.

Hue intermixtures, tints, shades, or tones can generate many colors in a split complementary harmony. Intermixtures between all three split complementary hues lead to numerous colors that can be difficult to unify. If a very harmonious and unified effect is desired, only pure hues and their tints, shades, and tones should be chosen. [9.14] Split complementary harmonies are characterized by their innate color balance and intense color combinations due to their visually arresting combination of contrasting hues.

BALANCED COLOR HARMONIES

Balanced color harmonies are comprised of separate, balanced hue selections from the color circle, sometimes referred to as color chords. The concept of a color chord is analogous to music as "color notes" (hues) are thought to have a pleasant "color sound," like the spaced notes of a musical chord. Two categories of balanced color harmonies are triads and tetrads. Both of these color schemes are based on a geometric figure, which is inscribed inside the color circle. A triangle defines a triad harmony, and a square or rectangle delineates a tetrad.

Triadic Harmony

An equilateral triangle inscribed in the color wheel points us to three equidistant hues, which form a *triadic color scheme*. The triad is a classically balanced color harmony used by many artists and designers. [9.15] There are four distinct triadic choices beginning with a primary triad of red, yellow, and blue and a secondary triad of violet, orange, and green. [9.16] There are also two tertiary triad harmonies: RO, YG, and BV; and RV, YO, and BG. All of the triadic color chords are extremely harmonious, yet have the advantage of being balanced but highly diverse. [9.17]

The triadic scheme retains harmony when used in an uncomplicated fashion, by utilizing only pure hues, their tints, shades, and tones, and by omitting intermixtures between hues. Artists have employed triads extensively, particularly the primary triad, for its purity. The

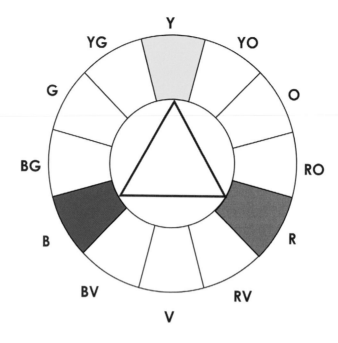

Figure 9–15 A triadic color harmony is based on a triangle inscribed in the color circle for hue selection. The primary triad is shown here.

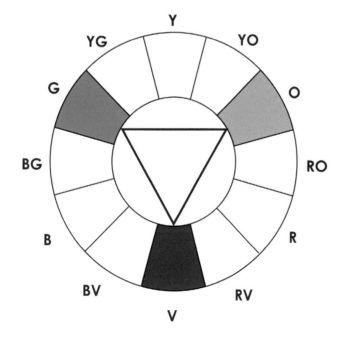

Figure 9–16 The secondary triad.

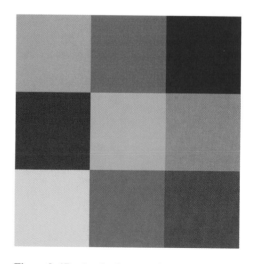

Figure 9–17 A color harmony based on the secondary triad. The hues are tinted, shaded, and/or toned but not intermixed.

Figure 9–18 *Deposition,* by the Northern Renaissance painter Rogier Van der Weyden (1399–1464) is an altarpiece that uses the primary triad of red, yellow, and blue in a balanced and rhythmic manner. 1436. Oil on wood panel, 220 × 262 cm. Museo del Prado, Madrid, Spain. Photo: Erich Lessing/Art Resource, NY.

modernist painter Piet Mondrian preferred the primary triad, using it almost exclusively for its clarity and distinct hue contrast. [12.10] The primary triad also formed a type of color balance that was an oft-used color language throughout the history of European painting. This painting, an altar piece of the *Deposition,* by Rogier Van der Weyden, has a rhythmic placement of brilliant reds, blues, and yellow (in the gold leaf) and opulent garments. [9.18]

Tetrad Harmony

A tetrad is a balanced four-hue color scheme, which gives it more complexity and depth than other color harmonies. Tetrads are defined by either a square or rectangle inscribed in the color circle. The three tetrads created by squares are: Y, V, RO, BG; YO, BV, R, G; or O, B, RV, YG. [9.19] Square tetrad harmonies employ two complementary pairs, which are more widely spaced on the circle than those of a double complementary scheme. The four hues in a tetrad create a contrasting yet stable group of colors.

 A traditional tetrad is based on a rectangle inscribed in the color circle to obtain the following four-hue combinations: YG, RV, YO, BV; Y, V, B, O; or G, R, Y, V. [9.20] Since tetrads are based on a larger (four-hue) selection of hues, they are somewhat less harmonious than the schemes with a more restricted number of hues. A tetrad thus may be paired with other methods of formulating color harmony, such as keying color values or saturation to the same level. The advantage of a four-hue color system is its flexibility and complexity, making it exciting in its color harmony.

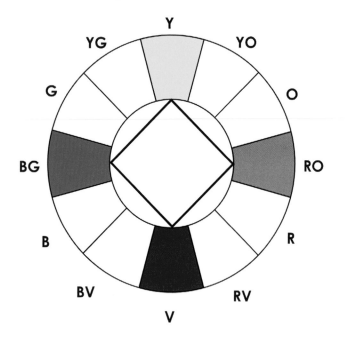

Figure 9–19 A tetrad harmony is based on a square inscribed in the color circle.

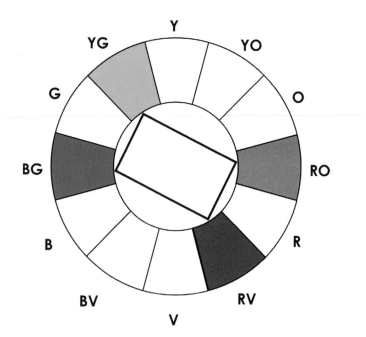

Figure 9–20 A tetrad harmony can also be based on a rectangle inscribed in the color circle.

KEYED COLOR HARMONIES

Value and saturation keys can be instrumental in creating visual coherence, harmonizing a large range of colors. Color keys visually join an array of hues by sharing common color characteristic, such as all dark or light values. [9.21] A consistent saturation level also can effectively harmonize a large number of colors, resulting in a group of colors with the same degree of high or low saturation. Color keys harmonize because common color traits equalize the diversity in color, forming a visual tapestry.

INFORMAL COLOR HARMONIES

Informal color harmonies have strategies that are more flexible than standard color schemes. The artist can customize these harmonies to meet the color requirements of a subject, theme, or function of an artwork. Informal color schemes are rooted in general color characteristics rather than programmed hue selections. The following is a list of informal color harmonies. The rules here are flexible and meant to formulate many possible color combinations.

SIMPLE COLOR SCHEME: A color scheme based on variations from any two to four hues. Hues may be tinted, shaded, or toned to create a group of colors.

HIGH-SATURATION COLOR SCHEME: All high-saturation key hues and colors form this color scheme. Any number of hues or colors can be used as long as they are pure and intense. Sometimes this scheme is called a high-key color scheme. [9.22]

LOW-SATURATION COLOR SCHEME: A color scheme of all low-saturation key hues and colors, made by the addition of black or varying amounts of gray to make tones. One or two purer colors can be added for contrast.

NEUTRAL WITH ACCENTS: Achromatic black, white, grays; nearly achromatic earth colors, chromatic neutrals, and very low saturation tones are selections for this color harmony. One or two stronger color accents can give the harmony some interest and variety.

Figure 9–21 A light, medium, or dark value key (as shown here) allows a large number of colors to harmonize.

Figure 9–22 A high-saturation key harmony is all high-intensity, pure, or almost pure colors.

LIGHT VALUE KEY COLOR SCHEME: Any number of hues keyed to medium light or very light values are in this color scheme. This is also called a pastel color scheme. Darker or stronger colors can be used for contrast.

DARK VALUE KEY COLOR SCHEME: The same as above but with very dark values and made with shades, complementary mixtures, or dark tones. [9.21]

LIMITED HUE SATURATION CONTRAST: Any one to three hues can be used to create a wide variety of saturations by using sequential tones, as in the Munsell system. Adding different amounts of varied values of gray into a pure hue can do this. There should be high-saturation versions of each hue as well. [9.23]

CHROMATIC GRADATION: A color scheme from hues with some distance between them on the color circle; pure hues, as well as subtle gradations between hues are used, for example: yellow, green, and blue. This achromatic scheme consists of Y, YYG, YG, G, GGB, BG, B, and variations. Chromatic gradation is most effective when presented in a sequence compositionally, since it is a logical progression. [9.24]

Figure 9–23 A limited hue saturation contrast scheme can be based on several hues that vary in tonal saturation. This can be made with mixtures of hues in different proportions with various grays. Student work by Molly J. Hughes.

Figure 9–24 A chromatic gradation is a progression of colors that connect adjacent hues from the color circle by using in-between colors. Shown here a gradation from Y to YG to G to BG to B.

VALUE GRADATION: Any two to four hues and their light to dark value gradations make another orderly color scheme. Approximately five value variations on each hue make the scheme more effective, especially when value gradations are in order as an integral part of the harmony.

TRIAD VARIATION: Two of the three hues chosen from a triad construct a strong harmony, for example, orange and green or green and violet from the secondary triad. [9.25]

Formal and informal color schemes or harmonies are the first step in exploring color combinations. Color schemes have rules that seem rigid, but in fact are flexible and amenable to change and manipulation by the artist. Color schemes furnish a stable base for formulating a broad range of color harmonies.

Figure 9–25 Becky Koenig, *Union*, 1999. Oil on canvas, 60″ × 48″ Collection of the artist. © Becky Koenig, 1999. The selection of two colors from a triad, such as blue and yellow from a primary triad, creates an informal color harmony.

ACTIVITIES

All of these compositions combine color harmony with design principles and elements for developing mastery of color design.

1. MONOCHROMATIC LINE STUDY

Objective: The objective of this study is for the student to work with line as a division of the picture plane. The student will use the line in varied directions (horizontal, vertical, and diagonal) and vary the line width. Unity by color, continuation, and line proximity should be explored. The student will also gain an understanding of the use of a monochromatic color system.

Media: Collaged paper or computer illustration on board.

- First, make some plan drawings, $10'' \times 10''$ or $10'' \times 12''$, using a ruler. The drawings should use straight ruled lines in any combination of three directions (horizontal, vertical, or diagonal) to divide the picture plane. Lines may end or crop out of picture area. Try to create unity by using the idea of continuation of the lines, either literally or implied.
- Pick out a monochromatic color scheme using Color Aid® paper or found colored paper. Try to get as much variation on the hue as possible, for example, for blue, use its tints, shades, and tones.
- Using colored pencils or markers, color the areas of your sketch with your chosen colors or photocopy your sketch and try the color scheme in multiple layouts.
- Inset colors into your design, by cutting out the lines or letting lines of color show between adjacent shapes.
- You can also execute this study on computer. Pick out colors and save them to your swatch palette first. Try various color arrangements in the design. [9.26]

2. INVENTED SHAPE COMPLEMENTARY STUDY OR SPLIT COMPLEMENTARY STUDY

Objective: The goal of this study is for the student to use a unique invented shape as a basis for a composition using figure/ground ambiguity, scale contrast, and overlapping shapes. A complementary or split complementary color scheme will be utilized and explored.

Media: Acrylic paint on board.

- Create at least ten invented shapes. Make sure they are not overly complex. The shapes can be curvilinear, rectilinear, or organic.

Figure 9–26 Monochromatic Line Study, student work by Noelle Hubert.

- Photocopy or draw your shape in multiple sizes. Design your composition to the desired size by tracing. Overlapping is encouraged.
- Try to make all areas of the composition equally interesting. Color will be used in all positive and negative areas.
- The composition can be completely filled with positive shapes if this doesn't become too complex. Then erase any unnecessary lines to simplify composition.
- Pick either a complementary color scheme or a split complementary scheme.
- If you pick a complementary color scheme, for example, RO and BG, you may use inter-mixes between the complementary colors. The color harmony choices are: pure complementary hues, intermixtures between the complementary hues, and tints of any of these hues or mixtures. Make a swatch sheet of possible colors.
- If you choose to use a split complementary system (for example, yellow, blue-violet, and red violet), you can use the pure hues, tints, shades, and tones.
- Work out a color placement plan with markers or colored pencils on a trace or a photocopy of the composition.
- Transfer drawing to illustration board and paint in all areas with flat color according to your chosen scheme or plan. Leave no white areas. [9.27]

3. WARM/COOL GRID STUDY

Objective: The student will use the design principle of unity by use of repetition and continuity, also emphasizing variety. The student should explore the idea of a theme and variations on several geometric shapes. The color scheme is a warm/cool color harmony.

Media: Acrylic paint on board.

- Start this study by making a 10″ × 10″ grid using 2″ increments. This can be drawn on sketch, trace, or grid paper. This grid has five 2″ squares, both horizontally and vertically.
- Pick two or three geometric shapes to start with from the following: circles, triangles, squares, rectangles, and diamonds.
- Use these shapes as starting points for designing each square increment in your grid. Divide each grid unit into variations on chosen shapes.

Figure 9–27 Invented shape split complementary study. Student work by Laura Shoemaker.

Figure 9–28 Warm/cool grid study. Student work by Simone Theriault.

- Make the sides of each grid unit integral parts of the design, with positive and negative spaces equally interesting.
- The composition should use the principle of unity by repetition and continuity, yet it should have variety and not be a consistent pattern.
- The design of a grid unit may be repeated, if position or color is changed, for variety.
- When designing the grid, use continuity. Connect one part of the composition to another. Some grid lines can be eliminated in the process, but the study should be visibly based on a grid.
- After drawing several plans for this design by hand or on computer, the colors should be chosen.
- A warm/cool color scheme will be used, emphasizing warm/cool contrast. Pick a neighboring pair of warm colors, for example, yellow and yellow-orange. Pick a pair of cool colors, for example, blue and blue-green.
- Remember that if RV or YG are chosen, you must decide whether these colors are warm or cool. RV is cool if paired with violet and warm if paired with red. YG is cool if paired with green, but warm if paired with yellow.
- Use the pure hues such as Y + YO, mixtures between Y + YO and tints of any color. Warm and cool colors should not be mixed together because this will diminish the contrast.
- A color swatch sheet can also be used to make color decisions.
- Transfer the design onto illustration board and paint, leaving no white areas. [9.28][9.9]

4. TRIADIC MASTERWORK STUDY

Objective: The objective of this study is to familiarize the student with the compositional structure of a particular museum quality artwork. The student will learn to analyze composition forces within the work. The textures, paint application, and surface of the work will be studied and reproduced. A triadic color scheme will be used to change the color message or theme of the work.

Media: Acrylic paint on illustration board.

- The student will look through art history books or survey some art history sites on the Internet to pick a color work that he or she wishes to study.

Figure 9–29 Triad masterwork study based on a painting by Gustav Klimt. Student work by Lisa Webb.

- The artwork should be a museum-quality work by a well-known artist.
- First the student should make a drawing from a good reproduction of the original work. The reproduction should be in color and a good size.
- A triad harmony should be chosen that is quite different from the original color scheme of the painting. Before painting, plan ahead of time where the colors should go.
- Remember, the point is to change the color system of the original as much as possible, while exactly emulating all the textures and the shapes as precisely as possible.
- The triadic system should be used. For example, red, yellow, and blue, along with tints, shades, and tones. Use no intermixes of the hues.
- The final piece should resemble the original in composition, but send a different color message. [9.29]

Chapter 10
Designing with Color

INTRODUCTION

This chapter is an exploration of color as a visual force in the creation of unity, emphasis, balance, rhythm, and illusionist devices in composition. Each design principle and color concept has been put forward in this book as a separate entity for clarity. In a real-life design or art-making process, however, an artist composes with formal design elements, principles, and color simultaneously. This chapter focuses on the interplay between color study concepts and design composition principles for an examination of design mastery through color. Color dynamics influence design choices and cognition of these dynamics reinforces an effective manipulation of color.

COLOR UNITY

When designing chromatically, the concepts of repetition, proximity, and continuity are connected with color concepts for visual unity. Unity in design also applies to compositional color selection and placement.

Color Repetition

Use of formal color harmonies is a straightforward way to establish color unity in design. Color schemes are really hue selection guides, each scheme possessing a different color character. Standard color harmonies have inherent color repetition built in by the limited number of hues in each scheme. This repetition effectively allows these color harmonies to visually unify a composition. [10.1] Most color schemes are based on one (monochromatic) to four hues (tetrads) and their variants. The hues of a color harmony may generate many colors, but the commonality of a small number of base hues (in an analogous scheme, for example) causes them to be visually cohesive.

The concept of color repetition can also be realized without the use of standard color harmonies. By using a single pigment in the many color mixtures of a painting, an understated color repetition harmonizes diverse images, shapes, and elements. The color mixtures of a painting can also be formulated from a restricted number of pigments, or *controlled palette,* which supplies a subtle harmony between compositional areas. Conversely, colors selected in an arbitrary, random manner lack a color strategy and therefore can disjoint a composition.

Figure 10–1 Color similarity. Top: Repetition by an analogous scheme (based on blue and BG) and continuity by a color gradation unify this composition. Bottom: The same composition with arbitrary color appears to be less unified than the previous illustration.

Consistent Color Key or Temperature

Color keys employ the consistency of a single color attribute or characteristic (such as saturation or value) to visually connect compositional elements. Matching colors to the same value (all light, medium, or dark value levels) or saturation (dull or bright keys) gives us the ability to organize a large number of colors into unified groups. [10.2] By choosing a consistent saturation, for example, we lend a uniform color *personality* to a composition; low-saturation colors seem quiet; high-saturation colors seem loud. The phenomenon of optical mixture is also a unifying factor in color keys because it blends a wide range of hues into one low-contrast unit. This blending occurs because colors of a similar value or saturation have a vague relationship, seeming to be interwoven together into the same spatial plane.

Consistency of color temperature also produces compositional unity: An all-warm or all-cool composition is easily perceived as a whole. [10.3]

Figure 10–2 Color keys can also effectively implement unity. Here, all the warm and cool colors are at a similarly high-saturation key. Student work by Marie Bosiaki.

Figure 10–3 Color unity can be established by a narrow selection of color characteristics, such as an overall warm *color for unity.* Line study, computer illustration. Student work by Colin Kahn.

Color Continuity

Color continuity can be articulated by progressive sequencing of colors. Our eye follows a logical color sequence in the same way that we follow a continuity path through a composition. A color progression should have a recognizable color continuity gradation such as a value gradation, chromatic gradient, some type of pattern/color alternation, or a saturation gradation. [10.4] In 1960s posters, very saturated color gradations were placed into elaborate psychedelic compositions in the prints that advertised rock concerts. In this example, by Victor Moscoso, the text forms a graduated pattern in color from the top to the bottom of the composition, which draws attention to the figure. The poster design from this period is both topical and sophisticated, capturing the spirit of the time in its graphic use of fluorescent-neon-colored pigments. [10.5]

Color Similarity, Proportion, and Distribution

The Gestalt concept of groups that have similar visual characteristics can be conveyed through color. Objects of the same color can link components of a composition together regardless of their location. The notion of color similarity also causes *color distribution or dispersal* to be an effective conceptual devise for unity. Similar colors that are dispersed throughout a composition produce an inner balance between the building blocks of an artwork. [10.6]

Color proportion or dominance is the relative physical area that is covered by each color in a composition. Visual unity can be achieved by allowing one color (from a group of colors) to dominate a composition. For example, a large proportion of blue in a blue-orange complementary harmony creates a more compelling color unity than equal areas of blue and orange. [10.7]

COLOR EMPHASIS

Color Contrast

A point of emphasis or focal point is the portion of a composition that visually attracts attention by creating some form of visual dominance. *Color emphasis* utilizes an opposite color strategy to the tactics of color unity. Rather than attempting to unify or blend colors together, the stratagem of color emphasis is to cause one color area to visually dominate by contrasting with the overall color appearance of a composition. Establishing a point of

Figure 10–4 A Color Gradient. Top: Colors can be chromatically gradated from one hue to another to lead the eye. Bottom: Colors can become progressively lighter or more saturated to lead us to the focal point of pure red.

emphasis with color is relatively simple because of color's ability to visually *contrast.* Johannes Itten outlined the methods in which colors contrast in his book, *The Elements of Color* (1970). Itten described principal types of color contrasts as light-dark contrast (value), hue contrast, cold-warm contrast (temperature), saturation contrast (purity), simultaneous contrast, complementary contrast, and contrast of quantity (proportion). Color contrasts are always relative to and dependent upon the color of their compositional environments. Specific examples of color contrast include a dark value green in light yellow environment (value contrast); a highly saturated orange in low-saturation, gray-blue surroundings (saturation contrast); or a cool blue-green in a warm, dark-red color environment (temperature contrast). Color contrasts lend the decisiveness that is suited to creating emphasis within a composition.

COMPLEMENTARY AND TEMPERATURE CONTRAST Complementary contrast cannot be overstated as a potent form of color contrast—for example, a composition that opposes pure yellow with muted violet brings attention to the yellow areas. [10.8] The additive color circle is an alternate guide for sets of complementary hues, such as magenta contrasting with green, blue (violet) opposite yellow, and cyan opposed to red. Cool/warm temperature contrast also effectively constructs a focal point as in the following: an area of warm color placed in a dominantly cool composition or a cool color used in a dominantly warm environment.

HUE CONTRAST Hue contrast may also produce a focal point, especially the strongest hue contrasts between the medial primary hues: red, green, yellow, and blue. For instance, a red focal point can be placed in a blue environment or a blue focal point in a yellow environment. Secondary hues can also be paired for divergence, such as an orange focal point in a green environment. The most powerful hue contrasts are between full saturation colors.

Figure 10–5 A psychedelic era poster by Victor Moscoso (1936–) has a gradation in spacing between the split complementary colors of red, yellow-green, and blue-green. The gradation in this spacing intensifies the cool warm contrast to draw the eye to the figure. *Junior Wells and His Chicago Blues Band.* 1966. Offset lithograph. Printed in color. 19 3/4″ × 14″. Gift of the designer (160.1968). The Museum of Modern Art, NY. Photo—Digital image The Museum of Modern Art/Licensed by Scala/Art Resource, NY.

Figure 10–6 Ewe Textile, twentieth century, Ghana. Cotton. The Tess E. Armstrong Fund. © The Minneapolis Institute of Art. Color unity is achieved by the colors distributed throughout a patterned textile, because our eye groups repeated colors.

Figure 10–7 The dominant blue in this composition unifies a blue–orange dyad. Student work by Laurie Stahrr.

Figure 10–8 In this study, the complementary contrast draws our eye to the yellow area. Student work by Bonnie Sue Bacon.

COMBINATION OF COLOR CONTRASTS Several types of color contrast can be combined for even stronger emphasis. For example, a light value warm color (such as a pale orange) in a composition of low-saturation, dark value, cool color (such as a dark muted violet) draws interest. Any type of chromatic contrast (contrasting hues) paired with value or saturation contrast is an effective way to allow a color to visually dominate.

COLOR CONTRAST GROUPINGS A color contrast grouping such as cool/warm colors or light/dark colors can also produce an effective visual hierarchy to generate a focal point. [10.9] Visual competition can weaken a focal point; thus, a contrasting color combination must oppose the overall color environment. For example, a strong light/dark contrast focal point should not compete with other value contrasts or the intended focal point will lose its visual impact. When a single color dominates a composition, an area that opposes it in hue, value, color temperature, complement, saturation, or strong color will contrast and be emphatic. [10.10]

Figure 10–9 An area of value and hue contrast stands out in an environment of low contrast colors.

Figure 10–10 Focal point study. Student work by Bonnie Sue Bacon.

Figure 10–11 Higher saturation and unique color or color anomaly establishes a point of emphasis. Student work by Christopher J. P. Guzdek.

Unique Color

A *unique color* diverges from the dominant colors of a composition by being placed only in a single location. A unique color in an artwork attracts attention because it stands alone in its color identity. [10.11] A color can be compositionally unique because of its complementary, hue, temperature, or value contrast with surrounding colors.

Color Gradation

A color gradation is a gradual change in color that functions to direct our eye compositionally. Color may be gradated by changes in saturation (getting purer or duller), by changes in value (lighter or darker), or by chromatically blending from one hue to another. A color gradient provides us with a logical progression to follow visually. [10.5] A gradation may end with a strong color that contrasts with the gradient or logically end with the final color in a given sequence.

COLOR BALANCE

Relative Weight of Colors

The relative weight of colors is a major consideration in *color balance*. The visual weight of any individual color is always relative to and interactive with its overall color surroundings. However, some colors are innately visually heavy, while others are inherently light in weight. [10.12] Inherently heavy colors include dark colors (dark values), high-saturation colors (pure colors), or powerful hues. Powerful hues include warm hues, which at full strength tend to visually dominate other colors: red, red-orange, orange, yellow-orange, and yellow. Lightweight colors are those that are pale in value or low in saturation (muted). Cool colors are traditionally considered to be less dominant than warms, but this is certainly not an ironclad rule. Light or medium value achromatic colors such as pale grays are also visually lighter in weight than, for example, saturated colors. A dark achromatic color like black or dark gray is almost always visually heavy. The relative weight of colors becomes more apparent in interactive color groups.

LIGHT		HEAVY	
	ACHROMATIC COLORS		HIGH SATURATION COLORS
	LIGHT VALUE COLORS		DARK VALUE COLORS
	COOL COLORS: LIGHT VALUE OR LOW SATURATION		WARM COLORS HIGH SATURATION
	LOW SATURATION LIGHT COLORS		HIGH SATURATION DARK COLORS
	LIGHT INHERENT VALUE HUES		DARK INHERENT VALUE HUES

Figure 10–12 Colors can be considered light or heavy because of factors such as value, saturation, and temperature.

High-contrast color combinations also have visual weight. [10.13] There are four main types of contrasting color groups, which have already been discussed: primary or secondary hue contrasts such as red opposite yellow-green, complementary contrasts such as orange opposite blue, cool/warm contrasts such as yellow opposite blue-violet, and value contrasts such as dark and light violet.

Asymmetrical Color Balance

Colors can be a decisive factor in a compositional equation for asymmetrical balance. A designer can fine-tune color positioning to balance even a seemingly unequal asymmetrical design. Color is such a forceful design element that both the selection and location of colors can bear the weight of a balanced design.

Relative color proportions in a composition can regulate color balance. The concept of color dominance is helpful in modification of color areas in design. Color weight is relative, dependent both on the placement of each color and the amount of physical area or mass covered by each color. To equalize balance, the color dynamic of a composition can

LIGHT/DARK CONTRAST

COMPLEMENTARY CONTRAST

COOL/WARM CONTRAST

HUE CONTRAST

Figure 10–13 Some types of color contrasts have visual weight.

Figure 10–14 Color placement equalizes an asymmetrical design: A small dark blue shape on the top right of the composition is balanced by concentric circles of light value hues on the left. Asymmetrical Balance Study by Nicole Land.

be manipulated. Color is compositionally balanced by counteracting visual weight from side to side, top to bottom, or diagonally in the picture plane. The bottom of a two-dimensional composition always has more inherent visual weight than the top because of our sense of gravity. Using heavy colors in the bottom half of a composition may cause an imbalance that can be remedied by placement of a counterweight of color in the top half of the composition. [10.14]

The placement of principal color groups affects the overall dynamic of a design. The optimal means of constructing a balanced composition is through experimentation with diverse placement options of the same group of colors. [4.27] Color balance exercises are easily executed on a computer, where colors can be moved and changed instantly. Color balance may also be accomplished by distributing weighted colors throughout a composition. [10.6]

Color and Symmetry

Visual forces in color balance may be grasped by manipulating formal symmetrical balance. A design mirrored on either side of a line of symmetry or axis is symmetrical or perfectly balanced. Perfect symmetry in color design thus has equal placement of colors on either side of an axis. A simple exercise can help us better understand the relative weight of colors. By positioning colors unequally on either side of the axis of a symmetrical composition we can attempt to "unbalance" it. By upsetting the symmetry of a composition, we can better appreciate color as a visual force or weight. Compositional balance may be radically shifted by simple color inconsistencies from one side of an axis to another. [10.15]

Radial Color Balance

The elements in a radial composition emanate from one or more points. The "vortex" of a radial color composition can also serve as a starting point for a color gradation. Colors may gradate darker from a light point, lighter from a dark point, and/or in hue or saturation. In a radial composition, a gradient constructs both a point of emphasis and compositional balance. [10.16] A radial compositional format also lends itself to color luminosity.

Figure 10–15 A symmetrical structure can be shifted in balance by an asymmetrical color placement.

Figure 10–16 Radial balance is enhanced by a radial color gradation. Student work by Kristen Walkowniak.

COLOR TO DEPICT FORM, LIGHT, AND SPACE

Artists use colors to depict reality by reproducing close observations of the play of light upon objects. A primary focus of illusionistic art is the creation of form, light, and space by color selection, nuance, mark and position.

Form and Color

Local color is a concept that in reality is tenuous, based on our assumption on the color of objects. The reality of color is based on the subtraction and reflection of light wavelengths as described in Chapter 1. A novice painter looks at an object, such as an apple, and sees its local color. Upon closer observation, he or she notices that the apple has assorted colors due to both the color and textural variations on the apple's skin and the quality of light upon it. The amount and type of light that illuminates an object drastically affects our perception of its color. Forms or volumes are of two main types—either rounded or flat-sided. This affects the way that light describes them. When lit, a round or irregularly shaped object has a color/value gradation. Flat-sided objects or planar forms have distinct shapes of light and dark colors defined by the edges of each plane. Upon close observation, numerous distinct colors are evident in even a solid-colored object. Perceptible light/color variations are described as highlight, light, shadow, core of shadow, and reflected light. The rendering of an object is subject to form and color considerations, which can become a complex process for a painter. A painter must perceive chromatic distinctions, identify the colors seen, and be able to re-create the colors by paint mixtures. Areas of color must be handled and placed accurately to render an illusion of form. Accurate color in correct locations imparts a rendered object with volume and light through shifts of hue, value, and color temperature. [12.2][12.3]

Color and Light

The manner in which objects are described by color and light is an important aspect of Western art. In an illusionary painting, the quality of light affects all of the objects in the painting. A cloudy, diffuse light, the light of a candle in a dark room, or warm sunny light at noon all present the artist with diverse color problems. The light striking reflective objects or a lighted atmosphere (sky) presents particularly difficult challenges. Time of day is interconnected with the quality of light and shadow depicted. Strong midday sunlight casts small crisp shadows and is cooler than light in the morning or evening, making colors

appear highly saturated. Cool light on an overcast day will mute warmer colors and illuminate cool colors. Dim twilight illuminates blues and violets and subdues reds and greens. Nighttime is about the harsh contrasts of dark and light. The darks of night are depicted as blues, black, or violets. A light illuminating a dark setting is translated in painting into white, yellow, or orange. Artificial light, like fluorescent light, is cool, in contrast to warm quality of incandescent light or firelight. Identical objects painted or photographed in varied settings change substantially in color. Paintings that are depictions of light itself, such as sunsets and lit skies are particularly difficult to achieve. The artist is, in essence, trying to recreate an additive effect of light with subtractive pigments. The results for many inexperienced artists are heavy and unattractive. A highly refined sense of color and paint application is necessary for the rendering of light in artwork. It is akin to painting "air." [10.17]

A small area of light that seems to glow or emanate can portray the illusion of *luminescence*. Luminescence is depicted by a sequence of gradated values or hues into a darker or more muted saturation, a chromatic gradation, or complementary gradient. These effects form an illusion of light emanating from the artwork. [10.18] The illusion depicted in this painting by Georges de la Tour is through the device of chiaroscuro (high value contrast). Candlelight illumination was a favorite strategy of De la Tour, casting warm glowing reds, oranges, and yellows upon the flesh and clothing of the figures in this dramatic tableau. [10.19]

Iridescence is a color effect that can depict the type of rainbow that we see in an oil/water mixture, on the inside of a shell, or in some satin fabrics. Iridescence is also referred to as *scatter color* because the light wavelengths are scattered by surfaces that are iridescent.

Figure 10–17 John F. Kensett (1816–1872, American), *Lake George,* 1869. Oil on canvas. The Metropolitan Museum of Art, New York. Bequest of Maria Dewitt Jesup, 1915. (15.30.61) Photograph © The Metropolitan Museum of Art, New York. In this painting, spatial illusion is formed by atmospheric perspective by colors gradually becoming lighter, less contrasting, and grayer as they recede into space.

Figure 10–18 Luminescence is produced by a subtle gradation of one hue into another, using saturation or value steps. An illuminated area should be lighter or brighter than its surrounding colors.

Figure 10–19 *Nativity,* Georges de La Tour (1593–1652), oil on canvas. Musee des Beaux-Arts, Rennes, France. SCALA/Art Resource, NY. Georges de La Tour was known for his paintings of extreme lighting contrasts that effectively conveyed the sensation of candlelight.

This effect is achieved in painting by the layering of colors or using all light value colors that have subtle hue differences, such as pastel colors.

Color and Space

Color adds another level of complexity to the creation of a spatial illusion. To produce a spatial illusion chromatically, there should be a perceptible light source on all three-dimensional forms to give them volume. In a spatial illusion, colors must change in some fashion as they recede into illusionary space. [10.20] Two specific value strategies will depict space when consistently applied. Colors can be sequentially lightened or darkened, but usually should be muted somehow in order to recede spatially. In a "daylight" picture, the background should be paler and lower in color saturation than the foreground. The colors in a pale background spatial depiction should lighten in value as they recede into the imaginary "space." [10.21] Bright, highly saturated colors advance spatially. For this reason, foreground areas should be stronger in saturation, contrasting in value, very defined, or textural. Muted low-saturation colors recede spatially, duplicating reality by a sequential graying of color caused by the atmosphere. For this reason, distant background areas should be lower in chromatic contrast. Distant mountains, for example, seem to lose their color as they recede toward the horizon. A second value strategy is used for a "nighttime" setting that depicts spatial depth into darkness. To achieve this, light foreground items can gradually become darker and less saturated as they move back into space, enhancing a spatial illusion. [10.22]

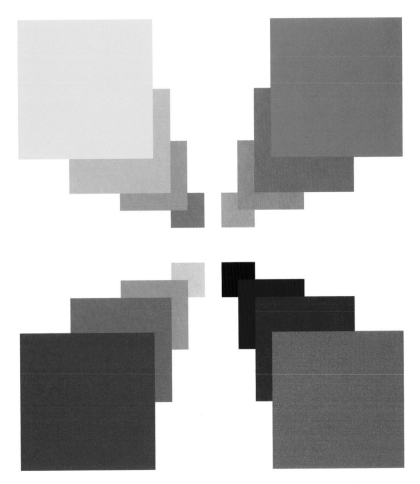

Figure 10–20 Some ways that color can gradate in order to appear to recede into space: clockwise, from top left: Yellow is muted by the addition of its complement of violet; green is dulled by additions of gray; red is shaded in steps; and blue is tinted in steps.

Colors should be lowered in saturation to depict space by using a series of tones or chromatic neutrals as an effective way to formulate *color atmosphere.* [10.20] Color atmosphere is also known as *film color,* meaning color that we see through as a filmy transparency, instead of being opaque like surface color. Pure, high-saturation colors advance spatially, and duller low-saturation colors tend to recede spatially. A traditional color space may also employ color temperature to define foreground and background. A traditional perception that warm colors advance and cool colors recede can be applied by "cooling" color temperature along with lowering color saturation to enhance spatial depth. Warm colors and/or light values can also enhance the impression of light on an object. Cool colors and/or dark values magnify the illusion of shadows.

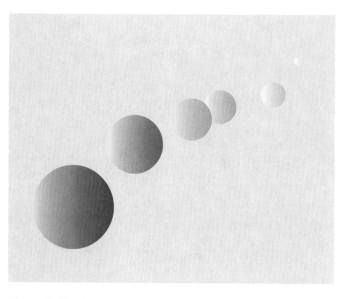

Figure 10–21 Space can be established by giving the illusion of recession into light by sequentially lightening and lowering the saturation of colors (dark into light).

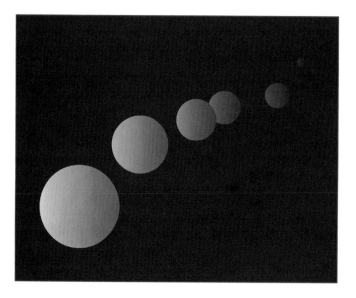

Figure 10–22 Space can be established by giving the illusion of recession into dark by sequentially darkening and lowering the saturation of colors (light into dark).

Figure 10–23 *Construct and Destruct,* 1940, by Yves Tanguy (1900–1955, French), Galleria d'Arte Moderna di Ca' Pesaro, Venice, Italy. Photo: Camera-photo Arte, Venice/Art Resource, NY. © ARS Artists Rights Society, NY. Yves Tanguy made surrealist paintings that suggested space and form in an ambiguous way, yet still portraying a powerful spatial illusion.

Light and Color Atmosphere in Abstraction

Color depiction of form and light is not limited to representational art. Illusion of luminescence, light, and spatial depth is frequently used as a device in abstract and nonobjective painting. Abstract forms can be painted with the illusion of a light source. Color atmosphere is established by the application of luminous colors seen in the atmosphere at varying times of day, colors that are transmitted through transparencies, or masses of color that appear to be reflected from brightly lit surfaces. A luminescent quality may arise from heightened cool/warm contrasts and contrasts of value and saturation. The cubists and surrealists, for example, were fond of using color and value gradations to enhance volumes. [12.9] In this painting by Yves Tanguy, we as viewers are uncertain of the identity of the surreal otherworldly objects, but we can perceive that they have true weight and volume. Even the environment of the painting forms a misty color atmosphere full of depth, yet having the mystery of a dream state, the goal of surrealism. [10.23]

COLOR RHYTHM AND MOVEMENT

Rhythm and movement can be articulated with color in the same manner that the repetition of a line, shape, or a mark conveys kinetic properties. Internal compositional rhythm produced by a systematic color repetition causes the eye to travel through a composition.

Figure 10–24 Islamic Architecture. This polychrome glazed tile dome is an example of rhythmic color and motif. Masjid-I Shah, Isfahan, Iran, built by Abbas I, Safavid Dynasty 1611–38. Photo: Art Resource, NY.

Optical movement is formed from a juxtaposition of opposing hues (complementary vibration), color gradations, or alternating colors or color patterns. Marks, gestures, or repeated motifs in color also enhance a sense of movement. In this Iranian piece of architecture, the dome and the entire outside of the building is covered with an elaborate all-over pattern that interlocks and relates to the volume and scale of each architectural form. The placement of the motifs on the elegant surface of ceramic tile that covers the entire building establishes an all-over richness as well as a sense of rhythm and movement. [10.24]

Color rhythm can also be emphasized by a systematic repetition of color as in the *Deposition* by Van der Weyden shown in [9.18]. Here, the drapery of each garment provides a color rhythm of red, gold, and blue across the altarpiece, also articulated by the rhythmic structures of the curved figures themselves. Gestural marks also give us a sensation of speed because of the character of paint application or brushwork. Small marks or lines of vibrating colors cause vibrant optical effects. [4.28][11.7] Optical kinetic effects that are based on the perception and knowledge of optical mixtures are simultaneously exciting and disturbing.

Color unity, emphasis, weight, contrasts, space, and movement are all factors in the placement of color in a composition. A thoughtful placement of color selection can generate emphasis, make the eye move, balance or unite a composition.

ACTIVITIES

1. COLOR EMPHASIS STUDY

Objective: The student will create one or more point(s) of emphasis both compositionally and with color.

Media: Colored paper on board.

- This study involves an organic shape or a shape derived from a man-made shape. Design a composition using the shape flexibly in the picture space, using repetition with variety.
- For variety, the shapes can have varied scale, also using the shape's parts.
- Do not create a traditional pictorial composition. The shape should be positioned for design purposes regardless of any subject.
- For variety, use overlapping and make sure that both the positive and negative spaces are well designed. The composition may have large or small areas of negative space.
- One area of the composition should be established as a point of emphasis. Remember the techniques for creating emphasis: isolation, types of color contrast, and also contrasts of scale, position, and direction.
- The color scheme is a group of two to three analogous hues, such as red, RV, and RO along with the tints, shades, and tones of these hues. Make sure that the point of emphasis is reinforced by color.
- A color, size, or position gradation can also be used to direct the eye to a specific point in the composition. [10.4] [10.25] [10.11] [10.10]

2. COLOR BALANCE STUDIES

Objective: For the student to demonstrate knowledge of compositional and color balance by working from an asymmetrical, symmetrical, or radial compositional model.

Media: Colored paper, paint, or computer illustration mounted on board.

A. Asymmetrical composition
- Line, shape, form, texture, or space may be used to execute this study. Choose one to three of these elements.

Figure 10–25 Color emphasis study. Student work by Laurie Stahrr.

Figure 10–26 Color asymmetrical balance study. Student work by Simone Theriault.

- Shapes may be invented or symbolic, but the overall composition should be nonrepresentational.
- Draw a horizontal, vertical, or diagonal axis through the center of the composition before you start. This will help to assess balance.
- Create a composition that takes an asymmetrical balance risk. Make at least three compositional sketches in colored pencil for a composition that has more visual weight on one side of the axis.
- Manipulate the elements and colors that have visual weight: forms, complexity, dark values, high-saturation colors, textures, etc.
- Using a formal or informal color scheme, try to balance the composition with color. [10.26]

B. Symmetrical composition
- For this composition, divide the picture area with an axis, as in A (above).
- Design a perfectly symmetrical compositional structure. Make several different sketches of symmetrical compositions, varying the positioning of the axis.
- Use colored pencils to plan color on one of the sketches using color scheme. [10.15]
- Use the relative weight of colors to "unbalance" the composition by color placement. Using the symmetrical composition, place the colors in such a way as to create a feeling of asymmetry merely by color placement. Keep in mind the relative weight of colors and color contrasts.
- This study can also be executed easily on the computer, using shape tools and copying, mirroring, and pasting half of the composition. Colors can be then readily changed from one side of the axis to the other.

C. Radial Balance Study
- Make a composition with radial balance. Radial balance has sequential components, radiating from one or more parts of the composition.
- A hue, value, or saturation should gradate from one or more points in the composition. Colors may gradate from light to dark, from brighter to duller, or chromatically from the main point(s) of the composition. [10.4] [10.16]

3. COLOR SPACE ILLUSION STUDY

Objective: The student will use both perceived and invented color to create form and space in color.

Figure 10–27 Color spatial illusion study. Student work by Branden A. Kautz.

Media: Choice of colored paper, collage, and/or paint on board.

- Start with one or more invented or geometric shapes. Make sure that they have volume.
- Create depth by repeating the shapes and diminishing the scale. You may use any of these three formats: a linear perspective interior, an architectural exterior, or a ground/sky plane. You may also float overlapping forms in a spatial environment for your shapes.
- The composition should have a foreground, middle ground, and background. It should be imaginative rather than realistic.
- You may choose your own colors, but keep in mind the color and spatial guidelines that follow.
- Pick a group of colors, using a formal or informal color scheme.
- The shapes should have some sense of a light source. [10.27]

GUIDELINES FOR CREATING DEPTH IN COLOR:

A. Foreground should:
- Have large-scale items.
- Have more highly saturated colors.
- Have more detailed items.
- Have light value objects if background is dark and dark value objects if background is light.
- Use warm colors, which appear to advance spatially.

B. Background should:
- Use diminishing scale.
- Have less detail.
- Have less value contrast.
- Have less-saturated colors.
- Use cool colors, which appear to recede spatially.
- Let items get darker as they recede into a dark background.
- Let objects become lighter as they recede into a light background.

C. Remember to:
- Pick the value of your background first.

Chapter 11
Expressive Color

INTRODUCTION

The color concepts, design elements, and principles discussed thus far are the purely visual components of art known as *formal* elements. *Form* is a single facet of the three aspects of art: form, history, and content.

The *content* of art covers several concepts: *subject matter* (what a work depicts), *iconography* (the symbols present in a work), and *theme* (the ideas behind the work of art). Due to its complexity as an art element, color functions either formally or expressively. Color used expressively can impart content to a work of art.

A viewer responds to the colors of an artwork based on his or her personal, cultural, environmental, symbolic, and psychological preferences. The collective unconscious combines with our experience of the world to influence these color preferences. The term *collective unconscious* has its origin in the theories of Carl Gustav Jung (1875–1961), a Swiss psychiatrist who distinguished the personal unconscious from the collective unconscious. He defined the *collective unconscious* as the inner feelings, thoughts, and memories that we all inherit and share as human beings. Color preferences are guided by instinct rather than by rational color systems. Color communicates visually because it is an essential part of our psychological makeup.

The most expressive tool available to the artist, color is also the art element most enriched with associations. Color plays a role in cultures worldwide, aesthetically, symbolically, and through the media. Through color, an artist or designer communicates definite ideas in an artwork.

COLOR PSYCHOLOGY

Psychology can be broadly defined as the science of the conscious and unconscious mind and of mental functions, behaviors, feelings, and dreams. Color is an external visual experience, but also part of our psychological makeup. Our ability to respond emotionally to color, and our ability to visualize color internally, demonstrates that color is part of our psyche. For human beings, color is both a physical and an emotional experience.

Color is directly linked with light because it is a component of light, and our color perception is also dependent on light. The effect of light on our psychological and physical well-being is profound. The amount, type, and variation of light in the day/night cycle and throughout the seasonal year is closely tied to human life. Light determines our pineal and endocrine functions as well as our behavior, sleep, and metabolic patterns. It has an

acute effect on our cognitive and emotional well-being. In sunlight, there is a balanced array of spectral colors that enters our body not only through our eyes but also into our skin through UV rays (hence, our fondness for sunbathing).

Our visual sense is a conduit that connects the external world to our inner mind and psyche. Color associations are thought to be embedded in our collective unconscious upon birth. A factor in our color likes and dislikes may also arise from our personal history with color. Color preferences may be rooted in childhood and life experiences with certain foods, toys, picture books, and special places. [11.1]

Color psychology has been studied by documenting of human reactions to both strong colors and color environments. Studies conducted to document common human reactions to the basic hues and neutrals aid in understanding color and human response. Commonly held color associations by a cross-section of people and cultures link specific colors to human emotions.

Throughout human history, the notion of a physical reaction to specific colors has been used to assist healing. The Egyptian physicians prescribed colored minerals such as malachite (green) or red and yellow ochres to heal various maladies. The Greeks employed color along with music and poetry to assist healing. Colored plasters for wounds were used by the ancient Greeks to speed healing. The Greek Claudius Galeneus (A.D. 129–199) framed classic human personality types based on color associations: choleric—red (angry), sanguine—yellow (calm), melancholic—blue (depressive), and phlegmatic—green (stoic and self-possessed). Red continues to be associated with anger and "the blues" with sadness. Picasso strikes a melancholy blue color note in the painting *La Vie.* [9.3] The physician and philosopher Ibn Sina (A.D. 980–1037) of Persia found that red light stimulated the movement of blood and blue light slowed it, findings that still have merit today. Dr. Edwin Babbit wrote the *Principles of Light and Color* in 1878, in which he described his color therapy or "chromotherapy" for various illnesses. He used yellow and orange, for example, as nerve stimulants. Chromotherapy is still practiced in some countries, although not in the United States.

Recent research has been conducted to study human reactions to various colors by exposure to colored light or environments. In a recent study, colored light was projected into the eyes of human subjects and the reactions were recorded. Red light was found to be arousing because it increased blood pressure and quickened the pulse. Yellow felt sunlike to the subjects and provoked nervous responses, elevating their activity level. Blue-

Figure 11–1 Our color preferences may be rooted in experiences of special things and places.

Figure 11–2 Color is also associated with music, sound, or tastes; candy colors are "sweet"; colors are also named after many foods such as "tomato red."

violet was pleasant and calming and elevated concentration levels of the subjects. Green was also calming, with an overall positive effect.

Color responses also have been measured by situating human subjects in highly saturated colored rooms. Subjects in a red room found the color overstimulating, and red heightened both blood pressure and pulse levels. A blue room lowered blood pressure and slowed the activity of the subjects. A yellow room had no effect on the subjects' blood pressure but caused eyestrain. A green room caused no physical reactions and was considered a calm but monotonous environment by the subjects. All these reactions were based on exposure to pure intense hues. Less intense versions of these hues (lower in saturation or different in value) provoke similar but less strong responses in the viewer.

Color association often engages other senses in addition to our visual sense. For instance, colors are affiliated with food or taste associations, such as candy colors: mint green, candy apple red, or bubble gum pink. Food references are also directly used as descriptive color names such as pumpkin, persimmon, tomato, tangerine, and celery. [11.2] Analogies are often made between color and the aural sense because color is often described in terms of sound or music. Colors are loud, soft, quiet, harmonious, or discordant. Colors have tactile associations as well; earth reds or yellows can be thought of as dry colors and blues, greens, or grays as wet colors. The association of color with other senses is known as synaesthesia, the simultaneous response of two or more senses to a single stimulus.

Conceptual ideas often connect with individual colors. Subjects asked to link colors with specific concepts, for example, tied love to red and red-violet, hate to black, peace to blues and greens, and happiness to yellows and oranges. Generalized associations with specific colors are revealing: Green is thought to be relaxing, refreshing, and quiet, but also is linked with illness and poison. [11.3] Blue is affiliated with calmness, contemplation, and yearning, but also with melancholy. Red is erotic and conveys excitement as well as pain. [11.5] Violet is connected to dignity, magic, and royalty, but is also mournful. Orange is stimulating, extroverted, and suggests sunsets and sunlit rocks. Brown is comforting, conveying earth, wood, and warmth. Yellow is luminous, hopeful, joyful, and warming. White stands for light and hope. Black conveys evil, darkness, but also formality. Gray signifies the calm and conservative. Colors have also been associated throughout time with gender, notably by the artists of The Blue Rider, an art movement in Germany formed in 1911, which led artists like Wassily Kandinsky and Franz Marc to associate blue with the male and yellow with the female. Marc's words on this association: "Blue is the male principle, sharp and spiritual, yellow, the female principle, soft, cheerful and sensual, red, the material, and ever the color which must be resisted and overcome by the other two!"

Figure 11–3　Green is considered a calm, relaxing color.

COLOR SYMBOLS

The symbols, or iconography, of particular colors which communicate definite meanings, have been utilized throughout art history. Color iconography is based on cultural or universal factors. Red for sexuality and black for death are examples of culturally based color associations. Other color symbols are cross-cultural or universal—for instance, blue often symbolizes the concept of the celestial, heavenly, or spiritual, as seen in the garment of Mary in Van der Weyden's *Deposition* [9.16].

　　　Some standard color symbols cross cultural boundaries to symbolize similar ideas. Various meanings of traditional Western or cross-cultural color symbols are listed as follows:

	Western	Cross-Cultural
Red	Blood	Fire
	Martyrdom	The sun
	Sin	Sexuality
	War	Evil
	Anger	Fertility
		Masculinity
		Festivity
Yellow	Treachery	Spirituality
	Cowardice	The sun
	Light	Gold
	Truth	Radiance
	Warning	Earth
	Cheerfulness	
Blue	Heaven	Coolness
	The celestial sphere	Eternity
	Water	Faith
	Baptism	Serenity
	Space	Wisdom
		Feminine

Green	Spring	Holiness
	Resurrection	Charity
	Envy	Regeneration
Black	Death	Sadness
	Evil	Mourning
	Darkness	Time
	Void	Rebirth
	Witchcraft	
White	Light	Death
	Air	Redemption
	Purity	Innocence
	Marriage	Surrender

Throughout history, artists have employed colors that are ingredients of their own cultural iconography. Color symbolism may be indicative of a specific period of art; for example, the Virgin Mary in medieval, gothic, and Renaissance art was often portrayed wearing a blue robe, symbolizing her heavenly or celestial presence.

To symbolize the virginity and unspoiled youth of a woman, a Western artist might portray her in delicate whites. In contrast, in Asian culture, a woman in white might be in mourning, because white symbolizes death and rebirth in Asian cultures.

Graphic designers exploit our bias toward color symbols. Many car advertisements, for example, display a bright red-colored vehicle. In addition to being eye-catching, the cultural color message sent by a bright red car is power, heat, and masculinity. In advertising design, the designer manipulates color symbols to promote a particular product. Color selection is a critical part of the communication design used to convey a product-specific message to the consumer. For example, the appropriate color packaging for a fragrance might be pale blue-green, while the packaging of a power tool could be red and black.

ENVIRONMENTAL COLOR

We often identify objects in relationship to their environments. Animals either contrast in color or visually intermingle with their environmental habitats. Brightly colored birds contrast with their environment to conspicuously identify their territory. Other animals adapt to their environment by colors and textures that camouflage them, like a snake that blends with a desert environment of gold and brown. Human beings use color perception to identify warm-colored fruits like raspberries or apples that stand out against the complementary green of the foliage.

Color associations are also derived from the physical environment. An urban, northern, tropical, or arid environment each suggests a correlating color personality. For example, an arid environment can be articulated by earth colors—oranges, reds, and browns. Colors can be affiliated with each season: winter: blues, grays, white; spring: light value colors such as pale greens, yellows, pinks; summer: highly saturated greens, blues, reds, yellows; fall: brown, oranges, reds, yellows.

Environmental designers should be sensitive to color selections to reflect and enhance the function and mood of an interior space. A place of worship, for example, may not be appropriate for very high saturation warm colors such as red or red-orange, because they stimulate, warm, and increase blood pressure. Meditative colors such as blues, neutrals, greens, and violets might be more suitable choices for a house of worship.

Architects often use nature as a color inspiration for their building designs. This approach visually unites the building with its site. Color temperature is an important factor in environmental color design. The warm or cool climate of a site can be reflected in the actual design of a building as well as in its colors.

Figure 11–4 Senufo, "Granary Door," nineteenth century, African. © The Minneapolis Institute of Arts. This decorative door is made out of environmental materials from an African village.

Art of indigenous peoples often concerns their visual and spiritual connection to the environment; for instance, this African granary door is carved from indigenous wood. [11.4] African village granaries were constructed of wood and mud. This granary door is richly colored with pigments readily available to the village, directly relating to the colors in artist's environment. The stylized fish, horse, and crocodile are related to Senufo myths, symbolically protecting the grain stored behind this door.

COLOR HARMONY VERSUS COLOR DISCORD

Formal color harmonies are a reliable mode of color selection, but often artists prefer to organize colors subjectively. Formal color schemes are restricted, unlike subjective or expressive color, which lacks formal color "rules." An intuitive approach to color frees the artist to devise personalized color harmonies. Artists working with color subjectively must refine their color instincts, which are founded on color experimentation, color associations, personal color symbols, and color preferences.

Color preferences inform personal color harmony. Harmonious colors produce a pleasing visual experience for both artist and viewer, called a *positive visual effect*. In contrast, color discord denotes color combinations that produce a *negative visual effect*. A color combination that contrasts, clashes, or "fights," rather than harmonizes is known as *color discord*. A color discord is a color dissonance similar to the purposeful dissonance caused by the harsh, strong combination of notes in a musical composition. In a similar fashion, a visual artist uses color discord to produce unease in the viewer, perhaps to enhance a powerfully negative or disturbing theme. For example, *Portrait of Paris von Gütersloh*

Figure 11–5 Egon Schiele, *Portrait of Paris von Gütersloh,* 1918. Oil on canvas. Gift of the P. D. McMillan Land Co. © The Minneapolis Institute of Arts. The dominant red conveys a powerful personality in this expressive portrait.

by Egon Schiele depicts a man in a tempestuous red and green environment. [11.5] The subject of the painting, a friend of the artist, was a writer, painter, actor, and designer. Expressively posed with raised hands, the figure is further accentuated by the strong color dissonance and brushwork of the background. The red/green dyad also has striking light/dark contrast, emphasized by the purposefully crude expressionistic brushwork. Schiele gives the overall composition a rhythmic, chaotic quality—a commentary on his friend's personality. Another artist could use the same theme of chaos and express it in a completely different personal color dissonance.

There are no set guidelines for discordant color combinations. However, strong value, hue, and saturation contrasts, singly or combined, create a discordant effect. Analysis of color discord, like that of personal color harmony, is highly subjective. This is the nature of color expression.

COLOR PREFERENCE

Like everyone, the artist has "favorite" colors. An individual's preferred colors may range from one particular hue to favorite color combinations. Color preferences are based on personality types, culture, inner psychology, the subconscious mind, the physical environment, and past color associations. The colors that we wear, the colored objects we buy or collect, or the colors from our home environment are all manifestations of our color

Figure 11–6 Signature colors are a group of individualized colors that express the personality.

preferences. Personal color expression begins with the acknowledgment of our color preferences through exploration of favorite colors and color combinations.

Johannes Itten employed a color exercise at the Bauhaus School that allowed students to choose (from paper) or create (with paint) a set of personally significant colors. Students generated a group of colors that were indicative of their personality or character. The initial step in this process is to select preferred primary, secondary, tertiary, or neutral colors. Light, dark, saturated, and unsaturated variations on these hues (totaling ten or more) can be then made from colored pencils, paint, markers, colored papers, or printed from the computer. A personalized group of harmonious colors is called *signature colors*. [11.6]

COLOR EXPRESSION

Through color choices, cultural, symbolic, and personal themes can be expressed. Instinctive color has an inner rather than a formal logic. Many times colors just "feel" right for a particular subject matter or design. Color iconography can be personal as well as cultural. Personal color symbols are colors that an artist chooses based on his or her inner life and subjective experience; for instance, an artist might use yellow for love and black for purity. Several periods and styles of art were instrumental in freeing color for expressive purposes. The Neoimpressionists (Post-Impressionists) Paul Gauguin and Vincent van Gogh, in particular, liberated the use of color for expressive purposes. The Fauves later expanded on color expression, notably the painters Henri Matisse and Andre Derain. Several Expressionist artists also explored personal color, including Edvard Munch, Gustav Klimpt, and Egon Schiele. A common ideal upheld by these artists was a desire for self-expression through color. Expressionist artists sought freedom from perceptual color, applying color sensitively to enhance personal aspects of their subjects. Expressive colors are chosen based on artists' inner reality and personal reactions to their subjects and themes, rather than their retinal perceptions of the external world. In this way, the individualized meaning of color led the way from representational to nonrepresentational painting.

High-saturation colors do not always add up to shock and color discord. In van Gogh's painting *Gauguin's Chair*, blue-green and earth red contrast to emphasize his commentary on the artist Paul Gauguin's personality. [11.7] Van Gogh's color choices were based on his "portrait" of Gauguin through the depiction of his empty chair. The dramatic color shifts and images of a candle and French novels are meant to convey the essence of Gauguin's powerful and dynamic personality.

Figure 11–7 Vincent van Gogh, *Gauguin's Chair,* 1888. Oil on canvas. Van Gogh Museum, Amsterdam. Vincent van Gogh Foundation. The chair depicted is meant to be an expressive color "portrait" of Paul Gauguin.

FREE-FORM COLOR HARMONY

Since expressive color has no formal rules, how can color instinct or expression be learned? A "free-form" study made from associative color choices offers the student the experience of communicating emotionally with color.

Free-form color harmonies link color with identifiable concepts. A list of verbal/conceptual opposites is a springboard for the color-association process. Color association affiliates a group of harmonious or discordant colors with each verbal idea. This process initiates communicating with color. [11.8] A sample list of visual/verbal opposites follows.

VISUAL/VERBAL OPPOSITES

Bright–Dull	Close–Far
Night–Day	Ordered–Random
Morning–Evening	Light–Heavy
Light–Dark	Stationary–Moving
Uniform–Gradated	Open–Contained
Expanding–Contracting	Cold–Hot
Simple–Complex	Wet–Dry
Natural–Technical	Crude–Refined

Figure 11–8 Part of free-form color study is selection of colors that illuminate specific concepts for color expression. Top: color selections for the words, light (left) and heavy (right). Bottom: stationary (left) and moving (right).

In this exercise, two to ten colors are directly tied with each verbal/visual concept. For example, the word "simple" might be associated with a group of primary hues or a monochromatic color scheme, as they are simple color groups. On the other hand, the opposing concept, "complexity," may correlate with a wide range of full saturation colors. A second step in this exercise prompts a synthesis of a vocabulary of lines, marks, media, texture, scale, or shapes that correlate with each verbal concept. [11.9] Color used in either abstraction or image based art provokes meanings and symbols.

Figure 11–9 Free-form studies based on the words cold (left) and hot (right). Paint, collage, and assemblage. Student work by Bonnie Sue Bacon.

THEMATIC COLOR

Art represents virtually any subject matter or idea in a visual format. The content of art consists of its subject, underlying theme, and iconography (symbols). Subject matter in art is what is perceptually evident in an artwork. In other words, the subject of a piece of art that is obviously depicted—a house, a face, or lines and shapes. *Traditional subjects* of perceptual art are the human figure, portrait, still life, and the landscape. *Conceptually based art* differs from perceptual art because it pertains to ideas: our inner world of feelings—our dreams, our ideas—expressed about the world, rather than depicting the outward appearance of things. Conceptually based art ranges widely in subject: distortions of reality, expression of inner thoughts, fantasy or dream images, formal subjects such as texture or line, unconventional views of everyday life, and ideas about political or gender subjects. Color is a vehicle that can influence and convey the underlying theme of an artwork.

An example of a concept-based work is this painting by Frida Kahlo, entitled *The Two Fridas,* 1939. In this dual self-portrait, the artist depicts herself in two modes, one as a bride-like figure, the other in a traditional Mexican costume, portraying her roles as a wife of the artist Diego Rivera and as a symbol of her own culture, respectively. [11.10] The white costume is a colonial-style wedding dress, and the traditional costume is brightly colored. The figure in the traditional costume holds a picture of Diego as a child in her right hand. The figures are connected by a vein that is clamped with a surgical tool by one of the Fridas; an artery drips blood into her lap. The hearts of both Fridas are exposed, the figure in the traditional

Figure 11–10 Frida Kahlo (1907–1954 Mexico), *The Two Fridas (Las Dos Fridas),* 1939, oil on canvas. 59″ × 59″ (173 × 173) cm. Museo Nacional de Arte Moderno, © 2001 Banco de Mexico Diego Rivera & Frida Kahlo Museums Trust. Av. Cinco de Mayo No. 2, Col. Centro, Del. Cuauhtemoc 06059, Mexico, D. F. Reproduction authorized by the Instituto Nacional de Bellas Artes y Literatura. Bob Schalkwijk/Art Resource, NY.

Figure 11–11 William Blake, *The Good and Evil Angels,* 1805. Color print on paper, finished in ink and watercolor. Tate Museum, London © 2000 Tate Museum. Presented by W. Graham Robertson, 1939. Blake presents a good versus evil dichotomy expressed by dark/light color contrast.

costume has a whole heart, while in the right figure with the white dress, we can actually see inside of the heart, indicating both the vulnerability of her persona and her unhappy relationship with Rivera. The painting also denotes her double cultural and ethic identity through the colors of her clothing, which is not entirely European or Mexican.

The theme of an artwork is distinct from yet dependent upon the subject. A theme is the underlying meaning or idea in an artwork: its inner statement. For example, if the subject matter of a painting is a deserted street, the theme of the piece could be human alienation. The thematic content of art touches upon the environmental, political, sexual, universal, or spiritual aspects of living. A theme can address any aspect of life visually conveyed in a functional or aesthetic manner.

The inner message of an artwork can be gleaned from distinctive visual hints provided by the artist. An artist supplies visual clues that may be in the subject, symbols, style, media, and color qualities or an artwork. A theme can generate a statement about moods, social issues, human characteristics, spirituality, and everyday situations.

In Henri Matisse's *The Egyptian Curtain,* the artist uses the visual exuberance of pure colors to convey sunlight streaming through a window. Matisse's color has a positive energy that stimulates ideas and the joy of making art. Matisse said of his work, "What I dream of is an art of balance, purity, and serenity, devoid of troubling or depressing subject matter." Matisse's subject matter is a view of everyday life, his theme is joy, and the vehicle of his message is color. [12.8]

Much of the art of William Blake lies in an opposite, spiritually disturbing thematic territory. *The Good and Evil Angels* juxtaposes the enlightened spiritual side versus the dark side of human nature. [11.11] This hand-colored engraving alternates dark and light value

keys and strongly saturated colors versus pale colors to convey good versus evil. The evil angel is depicted hovering against an earthy, orange-brown flame like drapery that surrounds him like an aura. In contrast, the good angel holds a child, is represented in pale, delicate colors, and is backed by a view of an elegant, pale sunrise. Blake's color selections present us with a strong dichotomy between two floating figures, a dark wicked image and a light saintly one.

The separate disciplines of art and architecture can meld perfectly in thematic content. Leon Baskt (1866–1924) was a great designer of costumes and scenic art for the Ballet Russes in the early part of the twentieth century. [11.12] Bakst designed sets with the power of color in mind saying, "I have often noticed that each color has some specific shades which sometimes express frankness and chastity, sometimes sensuality, and even bestiality, sometimes pride and despair. It can be felt and given over to the public by use of certain effects. . . . The painter who knows how to make use of this . . . [and] . . . can draw from the spectator the exact emotion which he wants them to feel." Baskt designed an environment of a tented harem that used exaggerated perspective, textural motifs, and strong saturated color contrasts to set the emotional stage for the ballet *Scheherazade* by Rimski-Korsakov.

An artist can express any theme by a combination of subject matter, art elements, design, and color selections. The construction of a two- or three-dimensional study based on a specific theme can broaden our comprehension of color expression. Two common thematic subjects are either human characteristics/emotions or cultural/environmental conditions. A verbal list (either individualized or the one provided here) is invaluable to help specify a theme. For this exercise, the student selects a specific theme, then brainstorms

Figure 11–12 Leon Baskt, *Set Design for Scherazade,* 1910. © Collection of the McNay Art Museum. Watercolor and graphite on paper. (Gift of Robert L. B. Tobin.) Bakst's use of color in set design was meant to establish a color atmosphere for the audience.

ideas for the study to stimulate many alternate approaches to the same idea. Formal aspects of the artwork are usually dictated by the conceptual idea.

For example, the shapes, textures, style images, and colors that express a theme of worship are vastly different from the elements selected to express a theme of war. A sample list of themes for an expressive color study follows.

HUMAN STATES, CHARACTERISTICS, OR MOODS

Anger	Serenity	Meditation
Thoughtfulness	Mourning	Whimsy
Greed	Animation	Paranoia
Envy	Tenseness	Victory
Compassion	Obsession	Hostility
Hunger	Callousness	Growth
Confusion	Health	Worship
Lust	Arrogance	Frailty
Alienation	Calmness	Death
Illness	Hate	Love

ENVIRONMENTAL AND CULTURAL THEMES

War	Pollution	Justice
Peace	Humidity	Celebration
Richness	Urban	Darkness
Austerity	Aridness	Coldness
Silence	Infinity	Oppression
Noisiness	Confinement	Imprisonment
Dirty	Winter	Airy
Cleanliness	Summer	Pastoral
Wealth	Purity	Poverty

To begin a thematic piece, process of brainstorming utilizes writing or sketching any possible ideas without prejudging their appropriateness. Brainstorming is a spontaneous technique for making instinctive color and image selections. A stream-of-consciousness approach to idea generation can be more effective than laboring pictorially, which sometimes leads to locking into an intial idea. To articulate a theme by images or abstraction, appropriate words, images, shapes, and colors are selected. [11.13] When compiling thematic verbal lists and sketches, one may omit the overly obvious, clichéd, or tired ideas.

The final step in the brainstorming process is to select the optimum idea, refine the composition, and choose the art elements to be used, such as line, texture, along with the media, mode, and style of representation. For any theme, colors should be a major factor in expression of the theme, selected from cultural or personal color choices. This type of planning, of course, should be somewhat flexible, because the art-making practice is a process of discovery and change as a piece progresses. However, students have more success when an ambitious piece is planned, because idea development and execution is such a significant part of art making.

For example, if a theme of the senses such as hearing/sound is chosen, art elements, words, and images associated with the aural sense can be drawn or written down. How can the theme of sound be expressed abstractly or with specific images—by color, mark, shape, and composition? What colors are culturally associated with the idea of sound, or oppose it? A color correlated with sounds could be red, as red may seem to be visually "loud." What colors does one personally associate with hearing or sound? Should color harmony or discord be used to express sounds? The student example shown here represents hearing/sound and uses materials in an inventive manner. [11.14]

Figure 11–13 Thematic study on the word arid. Assemblage and paint. Student work by Marlene Shevlin.

Figure 11–14 Thematic study on sound: found objects, paint, and marker. Student work by Brendan King.

Materials that are found and modified can broaden the language of an artist's expression. Objects, because of their functions and associations, can form potent expressions of ideas. One of the seminal artists of the found was Joseph Cornell, an American artist who worked with the "flotsam and jetsam" of life that he found on the streets and in junk shops. With these objects, he either found the colors to express his ideas or he mod-

Figure 11–15 Joseph Cornell (1903–1972), *Untitled (Paul and Virginia)*, c. 1946-48. Construction. 12 1/2 × 9 15/16 × 4 3/8 in. Coll. Mr. and Mrs. E. A. Bergman, Chicago, U.S.A. Photo Edward Owen/Art Resource, NY. © Estate of Joseph Cornell, VAGA, New York.

ified them with paint. [11.15] Even though Cornell was not formally trained, he had an eye for personal subtle color harmonies that he cobbled together from his beloved collection of objects. The assemblages that he constructed have the imagination of a rendered work, combined with the resonance of the found object and its color.

The above exercise can be continued by more types of brainstorming—for example, the theme of worship. A list of adjectives or verbs for the word "worship" can then be compiled—for example: spiritual, religious, nirvana, bliss, radiance, heavenly—to assist in choosing specific images that associate with these words. Images extracted from this written list might include skies, flowing robes, clouds, light, luminescence, reflective gold or silver. A two-dimensional or three-dimensional format can then be determined along with a list of possible media, objects, or textures to communicate the theme. Images do not necessarily have to be locked into a traditional pictorial structure, but can be taken out of context and/or juxtaposed. Once multiple ideas have been generated the piece of art can be executed. [11.16]

Expressive color is highly subjective, entailing a process of personal and cultural self-discovery by the artist or designer. Color expression leads art making away from merely a formal study to the inner world of ideas, symbols, and imagination.

Figure 11–16 Thematic study on the word worship, goauche and pastel. Student work by Kari Lund.

ACTIVITIES

1. SIGNATURE COLORS

Objective: To understand one's color preferences and learn to develop a selection of personal color harmonies or signature colors.

- Pick or create one or two groups of colors that form a personal harmony and/or represent an aspect of your personality. Start with several hues and variations or make colors according to descriptive color names. Colors can be pure hues, neutrals, or any variation.
- Use markers, colored pencils, computer color, or colored paper swatches for one or two sets of signature colors with ten colors each.
- Present these color sets in a nonimage pattern, such as stripes or a grid, so that the colors make a statement that is independent of image or composition. [11.6]

2. FREE-FORM COLOR STUDIES

Objective: This study helps the student discover free association of colors with verbal concepts. Also, the student should to be able to express the idea of visual opposites by color, media, and composition.

Media: Cut or torn papers or paint on board.

- From the list of verbal and visual opposites on page 200, pick a set of opposite concepts, for example, light and heavy. You can start by making a verbal list of colors that you consider light and those you consider heavy. For example, some people may consider dark shades of colors heavy; others might think that full saturation colors are heavy.
- The best way to approach this is by an instinctive word/visual association process. Try not to prejudge your choices. Come up with a group of five to ten colors for each concept. Make swatch of each palette of colors with markers, printed out computer color, or colored pencil.
- As you create these groups of colors, think in terms of color harmonies or dissonances. Which is appropriate for the chosen concept?
- Free associations can also be utilized to produce some quick sketches that express the concepts with other art elements, such as line, scale, and texture.

- The products of the free associative process can be synthesized into a composition with color, and at least one other design element, such as shape, to fully express the visual pairing.
- There should be one composition per concept and:
 - A composition for each one of the pair of visual opposites.
 - Visual opposites together in one composition.
 - Totally nonobjective or abstract means to express each concept.
 - Images to symbolize each concept.
 - Simplified or abstracted images to express each concept.
- Remember, in whatever manner the words are expressed, color should be the primary means of communication of each concept in the composition. [11.9] [11.17]

3. THEMATIC COLOR STUDY

Objective: The process here is to use color to express a human characteristic or an environmental or cultural theme. This study is also an exploration of creating a piece in two or three dimensions with color, image, and/or found objects.

Media: On foam board, wood, or illustration board, or a free-standing object constructed with glue. This study may include found objects, painted, and/or colored paper.

- Pick out several themes from the list of human states and characteristics or environmental and cultural themes on page 205.
- Brainstorm images, shapes, colors, symbols, and compositions by a free association process. Take into account personal reactions as well as the cultural views of each theme.
- Write lists of ten or more images, shapes, or colors that you connect with each theme.
- Pick the five best ideas from the verbal list and sketch out possible compositions to be executed in two or three dimensions. If three-dimensional, draw top and side views.
- If the structure is complex, make a paper model to prevent any possible structural problems.
- Plan colors that enhance and strengthen your thematic message. If the theme is a negative one, such as war or tension, color discord may be used to more aptly express the theme.
- The final piece should not be overly obvious, clichéd, or appropriated from media sources, but the viewer should have some indication of what theme is being expressed. Imagery should be used in a symbolic fashion to avoid a literal reading of the subject. The structure can be made from wood, foam core, illustration board, or another material. Use hot glue or craft glue. You may use some found objects to enhance your idea. [11.14] [11.15] [11.16] [11.18] [11.19]

Figure 11–17 Student studies on verbal opposites organic and man made. Student work by Laura Shoemaker.

Figure 11–18 Thematic piece on the words nature and technology, collage, paint, and assemblage. Student work by Molly Hoelke.

Figure 11–19 Thematic study on nature vs. technology, paint and assemblage. Student work by Lisa Webb.

Chapter 12
Color in Art

INTRODUCTION

Color has been a primary aspect of art since prehistoric times. The color's role in art is always in flux, shifting throughout art history. The artist uses color perceptually, symbolically, intuitively, expressively, and formally to create light and form illusion. Artists and art movements have altered and shaped the role of color in art history.

Before written history, in 13,000 B.C., paintings were being made. While the specific rites or function of the cave paintings of Lascaux, France, remain a mystery, we have to admire the resourcefulness of the artist(s). Red and brown ochre along with manganese dioxide black pigment was applied with the fingers or sprayed on the cave walls using a hand as a template. The Lascaux paintings are remarkably fresh in their depiction of bisons, horses, and men. Most amazing, perhaps, is the evidence of man's compulsion to make art, which was akin to making magic. We share the inner drive to create art with our primitive ancestors.

REFLECTED LIGHT—BYZANTINE MOSAICS

Color and symmetry were regarded as the foremost elements of art from ancient times through the medieval period. During this period color was principally interpreted in terms of value, because of the theories of Aristotle, which placed all of the colors between white and black. In Byzantine art (A.D. 550–1450), color was also equated with precious stones, symbolic of wealth and spirituality. The reflective colors of glass, stone, gold, and silver were their most prized materials, because of their qualities of reflecting and redirecting light.

Mosaic is a type of painting made with small pieces of stone, glass, or ceramic that is built onto a wall to become an integral part of architecture. [12.1] Byzantine mosaics made use of optical mixtures to formulate complex color relationships and iridescence. Candle and lamplight reflected from the uneven surfaces of mosaics on church ceilings and apses to make the walls sparkle and bring them to life. Mosaics realized the concept of divine light in a concrete fashion with iridescent glass tiles, made by encasing gold or silver foil inside transparent glass cubes. Byzantine art employed color for its iconography: gold, silver, and white depicted divine light; blue symbolized the celestial or the heavens; and purple indicated royalty. In mosaics, colors were modulated by slight color variations of tiles in close proximity; these modulations formed optical mixtures. Pure colors were equated to jewels, representing the preciousness of the Christian image. Jewels were thought to contain light and expressed the highest aesthetic in Christian art, divine power. The

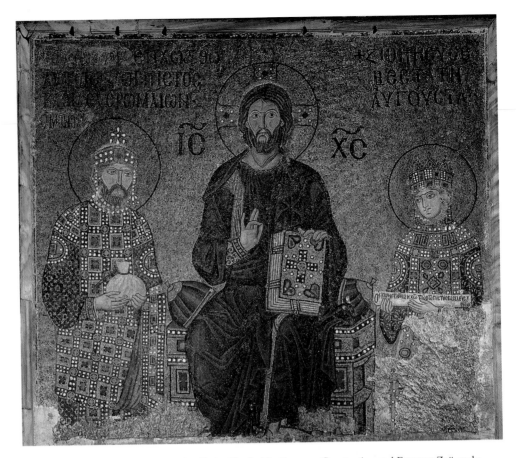

Figure 12–1 Byzantine Mosaic, *Christ Flanked by Emperor Constantine and Empress Zoë,* early eleventh century. Votive mosaic, south gallery, Hagia Sofia, Istanbul, Turkey. © Erich Lessing/ Art Resource, NY. Byzantine mosaics reflected actual light off the tile surfaces to symbolize divine light.

Gothic period of Christian art continued this tradition by transmission of colored light through divine images depicted in stained-glass windows.

PRIMACY OF FORM—THE RENAISSANCE

Sistine Frescos—Michelangelo Buonarroti

The Renaissance spans a wide period of time and range of geography, covering approximately the years 1400 to 1560 in northern and southern Europe. High Renaissance painting in Italy was characterized by the correct depiction of forms in space, the employment of perspective, and classical ideals. Michelangelo Buonarroti (1475–1564) exemplified the Italian High Renaissance in his mastery of painting, sculpture, and architecture. Michelangelo's Sistine Chapel ceiling is considered an apex of Renaissance art. [12.2]

During the Renaissance, art guilds controlled the quality of pigments for the execution of commissioned paintings. Certain top-quality pigments could be requested and provided by the art patron when a painting was commissioned. Red and vermilion were the most expensive pigments and dyestuffs, so only important personages were represented wearing these colors.

In the Renaissance, color was considered to be subject to form. Form, line, and the volumetric aspect of an image reigned over color, which was regarded as merely a deco-

rative element of art. Form was regarded as a masculine art element and color as a feminine art element. This was based upon a classical model of Greek sculpture, idealized at this time. Greek sculpture marbles, originally polychromed, were only known during the Renaissance as pure white, and this ideal of monochromatic purity persisted throughout the history of Western art. Michelangelo, who thought of himself primarily as a sculptor mainly occupied with volumes, created a neutral color trompe l'oeil architectural framework in the Sistine frescos to contain his modeled figures. Old Testament prophets and classical sibyls (which were female Greek prophets believed to have foretold the birth of Christ) flank the Old Testament scenes from the Creation to the Flood. Characters in Michelangelo's Old Testament drama were distinguished by beautifully painted drapery, meant to depict the iridescence of the "shot" silks of the artist's time.

For many years, Michelangelo's color aesthetic was regarded as dark, subtle, and muted. This may have been influenced by the attitude of Western art toward color as a frivolous component of art. Years of candle soot and dirt in the Sistine Chapel obscured the artist's original color nuances. When the Sistine ceiling was cleaned during 1989–1994, a revelation was uncovered concerning Michelangelo's color aesthetic. The colors of the frescos still emphasize the volumetric figures, but the colors were paler, more delicate, yet also chromatically richer than previously suspected. Controversy surrounded the newly cleaned work. Some art historians believed that some of the artist's subtleties were being removed along with the dirt. The cleaned frescos, however, have compelled scholars to reevaluate Michelangelo's vision and color language.

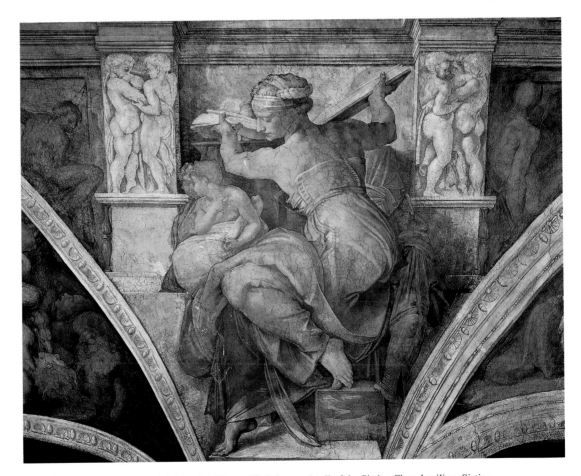

Figure 12–2 Michelangelo, *Libyan Sibyl,* fresco, detail of the Sistine Chapel ceiling. Sistine Chapel, Vatican Palace, Vatican State. © Scala/Art Resource, New York. The Sistine frescos display the primacy of form favored by Renaissance artists. The newly cleaned colors, however, are pale, saturated, and rich.

LIGHT AND MOVEMENT—THE BAROQUE

Caravaggio

The Baroque period of Western art spanned the late sixteenth century through the seventeenth century. Movement of figures and drapery in space and potent light/dark value contrasts are the hallmarks of the Baroque period of painting. The naturalistic high contrast lighting of forms is called *chiaroscuro*. A *luminist* strategy in painting emphasizes the color effects of light. Several artists of this time employed the luminist approach of chiaroscuro, including Rembrandt van Rijn and Georges de La Tour [10.19]. Michelangelo Merisi, an Italian artist commonly called Caravaggio (1573–1610) after his birthplace, rendered scenes from the Christian gospels with unparalleled naturalness and realism. A principal theme of his paintings is light itself, which subtly indicates the presence of God. Caravaggio did not employ older devices to convey spirituality such as halos or gold-leafed surfaces. Instead, he plunged his figures into a dark space with narrow depth and illuminated the scenes with dramatic, harsh light and shadow. In Caravaggio's *The Crucifixion of St. Andrew* (1607), the executioners of the saint are miraculously frozen in space, by divine intervention, to allow the saint to die on the cross as a martyr. [12.3] In the painting, the onlookers' faces appear to be immobilized and are naturalistic in their contemporary dress. The directional forces of two flanking figures, whose eyes are transfixed by the crucifixion, reinforce the painting's dynamic. Caravaggio directs light to convey divine power. The light source emanates from the left to illuminate key sections of figures and faces, ra-

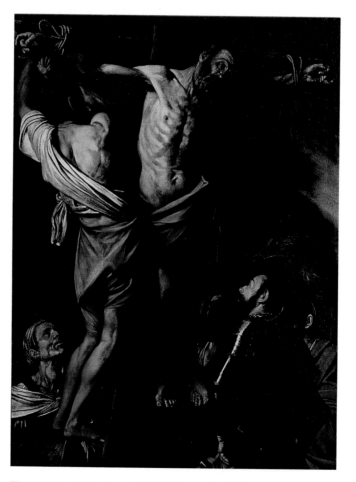

Figure 12–3 Michelangelo Merisi Caravaggio (1573–1610, Italian), *The Crucifixion of St. Andrew,* 1607, oil on canvas, 202.5 × 152 cm. © Cleveland Museum of Art 2001. Leonard C. Hanna, Jr. Fund 1976.2. Caravaggio used chiaroscuro, a dynamic light/dark contrast, to dramatize his subjects.

diating to the right, as an indicator of the light of God. The drama of the painting is provided by its high light/dark value contrast, a metaphor for the horror and redemption of the sacred event. The "gloomy darkness," called *tenebrism,* is the manipulation of light and color to heighten the narrative of the painting.

POETRY IN COLOR—ROMANTIC PERIOD

Joseph Mallord Turner

From the late 1600s onward, artists were influenced by the discoveries of Newton and later by the color theories of Goethe. The art of the Romantic period, from the late 1700s to the 1860s, involved human emotions, man's relationship with nature, and self-expression. The English painter Joseph Mallord Turner (1775–1851) was a luminist and also a color innovator. Turner's paintings were a documentation of history and a unique depiction of dramatic light, as in the painting *Sun Setting over a Lake* (1840). [12.4] This painting signifies color as light, space, time, and atmosphere. Turner achieved luminosity by the progression of sequential mixtures from hues to gray. His style of painterly marks accentuated the nearly formless areas of color in his paintings. Turner seems to have adopted Goethe's prejudice to warm colors as positives and cold colors as negative forces in his pictorial strategy.

Turner's work is often viewed as a precursor to the art movements of Impressionism and Abstraction; however, his attention was not only on the formal color manipulations in his work, but on great romantic themes. In addition to the luminous depiction of light, his themes celebrated monumental ships and architecture of the past. Turner's romantic

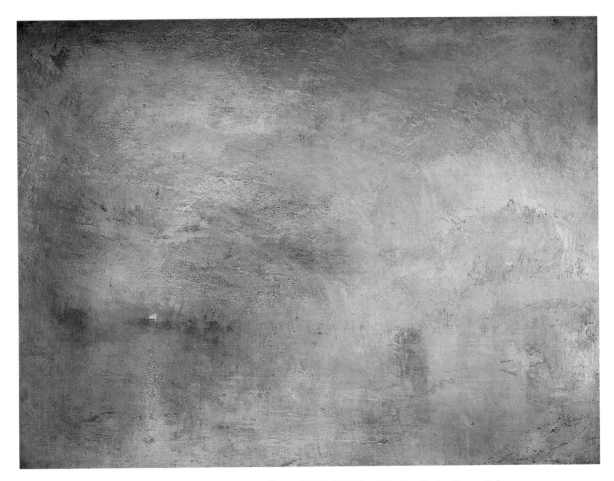

Figure 12–4 James Mallord William Turner (1775–1851, English), *Sun Setting Over a Lake,*
1840, 911 × 1226 mm. Bequeathed by the artist, 1856, NO 4665. © Tate Gallery, London 2001.
Turner's paintings established color atmosphere by brushwork and gradients of hue and value.

philosophy of painting motivated him to increasingly merge subject with pure color, demonstrating the spirituality of nature. Turner employed both luminist and colorist strategies in intuitive and theoretical color combinations. His paintings reflect the writings of Goethe who said "from these three: light, shade and color, we construct the visual world," through his use of cool and warm colors. He also acknowledged Newton in his recognition of color as a component of light.

TIME AND PLACE—IMPRESSIONISM

Claude Monet

The Impressionists were directly engaged in a formal study of color and light. Several factors led to the Impressionist's stylistic and colorist developments. By the late nineteenth century, the artist's physical studio became portable, because of the availability of artist's colors in tubes. This portability allowed artists to work outside on the actual site of the landscape. Cheveruel's writings on simultaneous contrast and optical mixing had an enormous influence on Impressionist painting. The advent of photography was also a factor in transforming the role of artists from recorders of reality to creators of a more subjective, expressive art.

The French Impressionist painter Claude Monet (1840–1926) was both a great colorist and color innovator. [12.5] His work parallels the Impressionist stratagem, conveying the fleeting effects of light and weather on a particular time and place. Monet's "objective" observations of color and his painting work on site (plein air) were often subjectively finished in the studio. Theoretically, his small marks of color were meant to be optical mixtures; however, Monet's paint application was more painterly than either Seurat or Pissaro. Monet's marks unite with his forms in a light and tenuous manner. Upon close inspection, Monet's paintings are essentially an abstract array of marks, a fact that shocked viewers of his time.

In his specification of color to the quality of light, Monet is a pure colorist. Cool and warm tints of hues weave together to formulate light, temperature, and a particular time and place. With only spectral hues on his palette, Monet broke with the past tradition of earth colors. His late paintings of water lilies forged new territory that moved toward completely unfettered color.

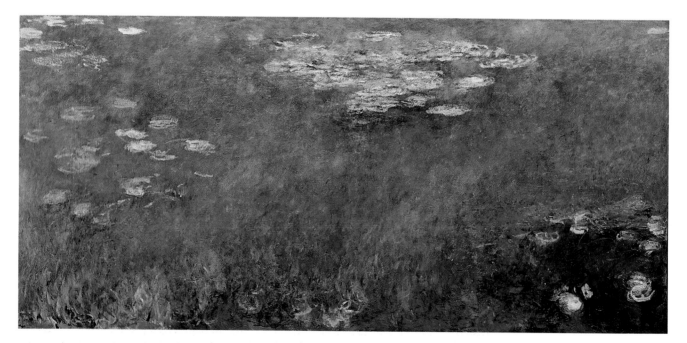

Figure 12–5 Claude Monet (1840–1926, French), *Water Lilies (Agapanthus),* 1915–1926, oil on canvas, 201.3 × 425.8 cm. © Cleveland Museum of Art 2001. John L. Severance Fund 1960.81.
Monet broke ground by his palette of spectral colors and small marks of color to optically mix.

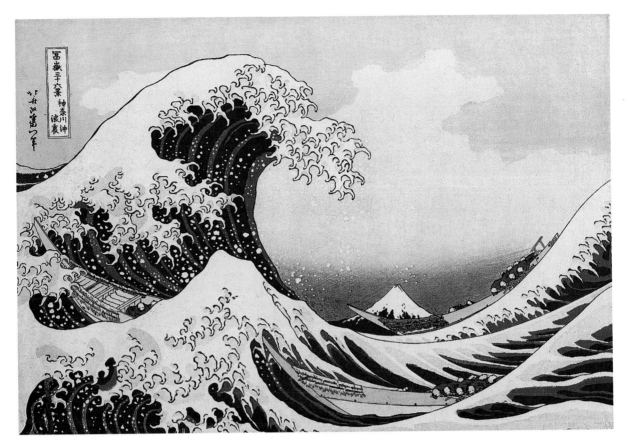

Figure 12–6 Katsushika Hokusai (1760–1840 Japanese), *The Great Wave at Kanagawa* 1831–33, from the series, "Thirty-six Views of Mount Fuji," polychrome wood block print. The Metropolitan Museum of Art, NY, H. O. Havermeyer Collection, bequest of Mrs. H. O. Havermeyer, 1929. (JP 1847). Photograph © The Metropolitan Museum of Art, NY. The Japanese refined the art of relief printing in their polychrome wood cut prints. These prints were instrumental in a new approach to color in Western art.

SIMPLE ELEGANCE—JAPANESE ART

Woodblock Prints

Japanese art emphasizes balance, color, and a strong compositional aesthetic. Areas of flat color emphasize the graphic quality of both Japanese prints and screens from the eighteenth and nineteenth centuries. In Asian art, shape and line are dominant over both color and form. Color masses are either flat or textured but always have highly structured contours. The preferred harmonies of Japanese color can be either contrasting complements or analogous hues, in addition to black, white, and red. The neutral black and white aesthetic stems from traditional ink paintings and calligraphy, which emphasized line and mark. Japanese ink paintings have sensitive modulations of light and dark that are not quite as apparent in the color prints and screens.

The famous wood block print *The Great Wave at Kanagawa* (from a series of *Thirty-six Views of Mount Fuji*) by Katsushika Hokusai exemplifies the refinement and stylization of Japanese wood block prints. The graphic flatness of color and linear quality of this image is enhanced by the dynamic force of the stylized wave. Mount Fuji is a stable point, far in the background, and the fishing boats present a counterpoint to the great wave, balancing the composition. The flat areas of color function as design elements, contrasting with Western color usage of the time, which used color to depict light, form, and atmosphere. When the United States commenced diplomatic and trade relations with Japan in the late nineteenth century, Japanese art was a revelation to Western artists. The impact of Japanese art on Western art was highly influential on developing modern styles. [12.6]

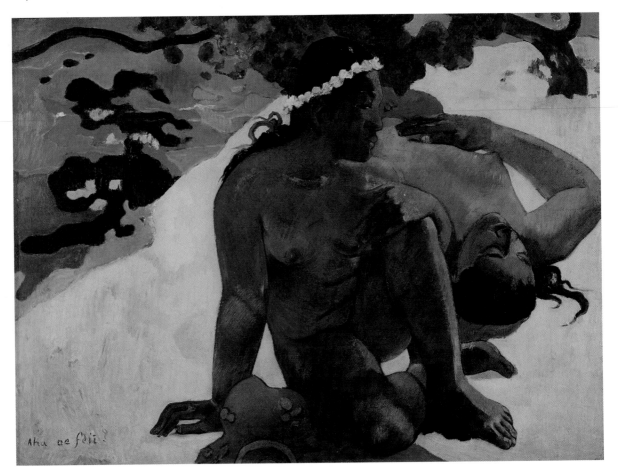

Figure 12–7 Paul Gauguin (1848–1903), *What, are you jealous?*. Pushkin Museum of Fine Arts, Moscow, Russia. Erich Lessing/Art Resource, NY. The paintings of Gauguin employed a dual color strategy, partly tonalist in his subtle color shadings of the human figure and partly engaged with pattern-like flat areas of subjective color.

COLOR EXPRESSION—NEOIMPRESSIONISM

Van Gogh and Gauguin

The influence of Japanese art on the Neoimpressionists Vincent van Gogh (1853–1890) and Paul Gauguin (1848–1903) was profound. Van Gogh's approach to color was revolutionized by his exposure to Japanese art. Both Gauguin and van Gogh were influenced by both the linear quality and juxtaposition of flat colored areas in Japanese prints. Post-Impressionism, or Neoimpressionism, is a loose category for a highly individualized group of artists that include Georges Seurat, Paul Cézanne, and Toulouse Lautrec, whose work succeeded Impressionism.

Gauguin and van Gogh, who lived together for a time, sought to revolutionize art through a fresh approach to color. Van Gogh's color was drawn onto the canvas with individual linear marks and highly saturated complementary hues, which accentuated the expressive quality of his subjects. The visual force in van Gogh's painting results from his aggressive color application with thick impasto paint. [11.7] Van Gogh's mode of expression can be partly attributed to his place in the history of painting materials, as the availability of thicker consistency tube colors and the expansion of the artist's color palette with new pigments and dyes factor into his painting style. The physicality of his textured surfaces emphasizes color contrasts in a dramatic fashion. Instead of painting his subjects in local colors, van Gogh employed imaginative color as an indirect mode of thematic communication. The color freedom investigated by both van Gogh and Gauguin should be

contextualized as a shift in Western painting tradition; non-Western cultures had color traditions that did not always have the color inhibitions of European and American painting.

Paul Gauguin was also drawn to the dramatic "flat" effects that he saw in Japanese art and in the sculptures and motifs of Tahiti, where he lived his later life. Despite his interest and use of flat color, Gauguin can also be considered a tonalist in his stylistic devises in painting. A *tonalist* applies subtle tonal steps in a narrow range of hues to create volume. Gauguin lived in Tahiti for several long periods of time starting in 1891. His desire to live a primitive life devoid of Western culture motivated his artistic growth. In this painting, *What, you are jealous?*, both of Gauguin's painting strategies are in play, the background is built from flat, vivid color, and the figures are modeled in subtle tonal and color temperature gradations. [12.7] Gauguin made this work in Tahiti, in which he explored not only the local culture and spiritual beliefs, but everyday activities, hopes, and fears of indigenous people, primarily women. This work captures a moment of conversation between two women, one of his preferred subjects.

Gauguin's work was informed by Egyptian, Asian, and Indian art, which at the time was thought of as "primitive art." Van Gogh and Gauguin released color from representation and utilized it for self-expression.

FAUVISM AND BEYOND

Henri Matisse

In his youth, Henri Matisse (1869–1959) was affiliated with the Fauves, a group of young French painters. The Fauves were known as the "wild beasts" because of their vivid colors and distortions of reality in their paintings. [12.8] Fauvism established an expressive colorist tradition in French painting. Henri Matisse's early paintings of faces and figures

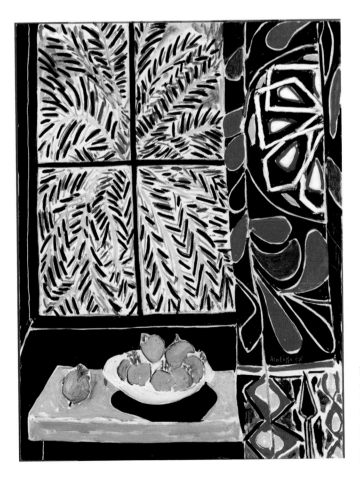

Figure 12–8 Henri Matisse, *Interior with Egyptian Curtain,* 1948. Oil on canvas, The Phillips Collection, Washington, DC. © 2002 Succession H. Matisse, Paris. © Artists Rights Society (ARS), New York. Matisse used expressive, flat color, to project a theme of ease and joy.

were modeled with very saturated contrasts of cool and warm color. Later in his career, he introduced flat color into his paintings, and line, color, and shape became his primary elements. The fresh, direct quality of his paintings unsettled viewers of his time. The quality of direct, pure, saturated colors painted in a spontaneous manner is the same feature that attracts us to his art today. Matisse freed color from depiction and form saying, "I cannot copy nature in a servile way; I am forced to interpret nature and submit it to the spirit of the picture." His joyful paintings have a color resonance due to the transparent, almost watercolor-like surfaces of his oils. The decorative, flat colors of his subjects—figures, foliage, and themes of the joyful essence of life—led to his later colored paper cutouts, which are the distillation of his work.

STRUCTURED SPACE—CUBISM

Picasso and Braque

In 1909, after Pablo Picasso (1881–1973), the Spanish artist, painted the revolutionary *Les Demoiselles d'Avignon,* he joined forces with Georges Braque (1882–1963), a Frenchman, to produce one of the most influential styles of art in the twentieth century. Color had become an expressive element through the innovations of the Fauve and Expressionist art movements, but most subjects were recognizable in painting until this time. From 1909 to 1914, Picasso and Braque worked in close proximity to develop a new art movement subsequently called Cubism. Cubists viewed the subject (mostly traditional still lives, figures, and portraits) in a revolutionary manner. While the Fauves abstracted reality by flattening space and color areas, Cubism readdressed spatial and form issues. Multiple views of the subject existed simultaneously, in an attempt to deconstruct reality. The views were fractured into a cubic structure, virtually eliminating the negative picture space and making fig-

Figure 12–9 George Braque (1882–1963, French), *Violin and Palette,* 1909, oil on canvas, 36 1/2″ × 16 1/4″. Solomon Guggenheim Museum. 54.1412. George Braque © 2002 Artists Rights Society (ARS), NY/ADAGP, Paris. Cubism deconstructed reality into planes with nearly achromatic colors.

ure and ground ambiguous. Forms merged together into a single surface obscuring the identity individual objects.

In the painting, *Violin and Palette* (1910) by Georges Braque, recognizable objects such as a violin, music, and an artist's palette are arranged in a vertical composition. [12.9] Braque enjoyed the tactile quality of the fragmented surfaces; a metaphor for the processes of both visual art and music. Subtle color, value, and tonal shadings built the shattered cubic planes into a Cubist vision of reality. Most early Cubist paintings are almost achromatic, but subtle tonalities and gradients of cool/warm low saturation colors cause areas to advance or recede spatially as well as to differentiate objects. The resultant simultaneous views prompt the viewer to continuously move through the shallow space of the painting. Cubism set the stage for abstraction as the artist's alternate visual language.

COLOR UTOPIANS—MODERNISM AND DE STIJL

Mondrian

Modernism began in the early twentieth century, and reached an early century culmination in the Bauhaus School, a pre–World War II art school in Germany. Modernism sought to put aside the traditions of art in favor of a newer, purer form of utopian art.

Piet Mondrian (1872–1944) was a Dutch artist and one of the founders of the De Stijl (The Style) art movement in the Netherlands, which spanned the years 1917 to 1931. The De Stijl movement adhered to the belief that there were two kinds of beauty, sensual and subjective, or rational and objective. The De Stijl group concluded that rational objective art was art in its highest, purest form. Modernism thus set up a dichotomy between expressionism and formalism.

Mondrian honed his art to only formal elements: using geometric shapes, eliminating representation, refining his color to the three subtractive primary hues and using the two essential values of black and white. [12.10] Mondrian used exclusively horizontal and

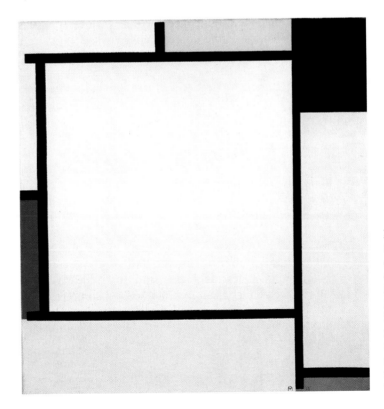

Figure 12–10 Piet Mondrian, (1872–1944, Dutch), *Tableau 2,* 1922, oil on canvas, 21 7/8″ × 21 1/8″ (55.6 × 53.4 cm). Solomon R. Guggenheim Museum, New York. 51.1309. Photograph by David Heald © The Solomon R. Guggenheim Foundation, New York. Mondrian/Holtzman Trust c/o Beedrecht/Artists Rights Society (ARS), NY. Mondrian purveyed a modernist aesthetic through his restriction to the three subtractive primary hues in balance.

vertical directions to symbolize opposing forces. These forces were symbols for either opposite genders or the spiritual versus the material worlds. In his compositions, Mondrian wished to obtain "dynamic equilibrium"—his definition of the balance between opposing forces. The Modernist aesthetic was both rational and anti-organic, its color aesthetic of purity persisting into and beyond the first half of the twentieth century. Modernism viewed color as an aesthetic ornament that was meant to be controlled. This attitude hearkens back to the Renaissance notion of color as a foreign, feminine element of art. Mondrian took many of these attitudes to an extreme: to him the subtractive primary hues of red, yellow, and blue were the only true colors, sources for all the other colors. He saw yellow and blue in opposition to red for balance. In Mondrian's personal color iconography, red represented anger and sensuality, blue stood for spirituality, and yellow for the intellect. The aim of De Stijl was similar to other types of Modernism in its attempt to forge a universal visual language through art.

The Delaunays

Robert (1885–1941) and Sonia Delaunay (1885–1979), the French artists previously discussed in Chapter 4, were part of the modernist movement concerned with the exploration of color and its effects. Robert Delaunay made paintings in which he used the concept of *simultaneé* (simultaneous contrast) to create color dynamics and movement. His paintings were, in part, a reaction to the works of Seurat, whose small dots and dashes of complementary hues were meant to scintillate, but at times instead formed chromatic neutrals by optical mixture. Sonia and Robert Delaunay both worked on paintings that employed larger areas of complementary colors, to maintain their separation, hence creating a contrast of color dynamics and vibration. [4.5] The paintings are composed with sun- and moon-like colored discs juxtaposed in intersecting circular rhythms. The objective of these works was to achieve a color effect called luster, a type of optical mixture in which colors blend imperfectly to create a sparkle or glimmer.

PIERRE BONNARD—PREMIER COLORIST

The paintings of Pierre Bonnard (French, 1867–1947) have been associated stylistically to the nineteenth rather than the twentieth century. This conception stems from the superficial perception of his work as being Impressionistic in style, which also omitted his work from being part of the mainstream in Modernist European painting. Bonnard's paintings seem to elude categorization. In his twenties, Bonnard was a strong colorist, part of a group of artists called the Nabis, who desired to formulate color into mood. An artist who is known as a *colorist* has an interest in color contrasts and interactions applied for formal and/or expressive purposes.

Bonnard's later paintings show "qualities of daring" (the critic John Russell) that were conceptually on a similar level as the inner worlds portrayed by the Surrealists. [12.11] Bonnard's subjects—domestic life and nudes—are really explorations of the sensation of light, in which he represents the complexities in our perception of color. Bonnard's paintings are a visual challenge to modernism in their engagement of the "feminine or other" realm of color. He was not interested in the masculine deconstruction of form that was at the center of Modernism. Bonnard's approach to painting was a synthesis of symbolism and impression. Unlike Impressionism, the paintings seem to occupy memory rather than being built from perception. The spaces in his paintings are defined by color, distorting traditional ideas of depth and making the forms fluctuate. Spaces are not merely flattened but completely rethought in a visual language of colored pattern that weaves a color tapestry of colored marks. Bonnard unifies a wide number of hues, saturation, and color temperature shifts seemingly without effort. His highly pitched colored saturation is visually exuberant yet thematically melancholic.

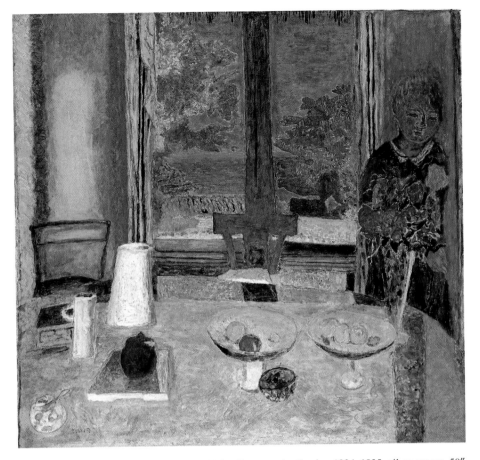

Figure 12–11 Pierre Bonnard (French), *Dining Room on the Garden,* 1934–1935, oil on canvas. 50″ × 53 1/4″. Solomon R. Guggenheim Museum, NY. Gift, Solomon R. Guggenheim, 1938. Photograph by Carmelo Guandango © Solomon Guggenheim Foundation, NY. © Artists Rights Society (ARS), New York/ADAGP, Paris. Bonnard demonstrated his ability as a colorist in his tapestry-like patterns of color.

INNER LIGHT—ABSTRACT EXPRESSIONISM

Mark Rothko

Abstract Expressionism, the first American art movement, came into the forefront of world art as a style in the late 1940s through the 1950s. The Abstract Expressionists returned to the instinctive color of Expressionism, putting aside the theoretical approach of Modernism in favor of subjectivity. The automatism of Surrealism was applied to large-scale paintings that were expressive, abstract in form, and indicative of the painting process itself. Jackson Pollack, William de Kooning, and Mark Rothko, among others, further released color from form and shape, using marks and drips to record the encounter of artist and canvas. One of the strongest colorists of this period was Mark Rothko (1903–1970). His paintings are more reflective and contained in mark than the work of either Pollack or de Kooning. Operating within the spiritual, meditative quality of color, Rothko's soft rectangles of color counteract and balance each other. [12.12] Like Albers, in each painting Rothko set up a new color situation. However, unlike Albers, Rothko's color juxtapositions resonate emotional states, rather than formal color relationships. In this way, color in the twentieth century gained even a greater independence from the identity and depiction of objects.

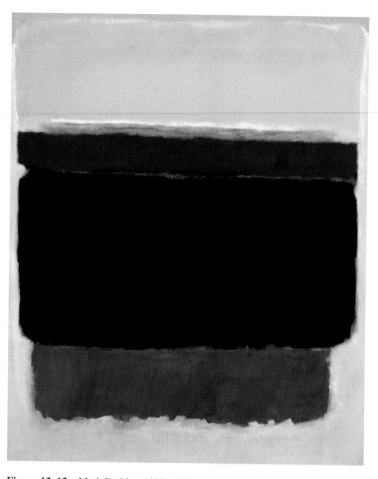

Figure 12–12 Mark Rothko (1903–1970, American), *Untitled.* 1949. Oil on canvas, 90 1/4″ × 66 1/4″. National Gallery of Art Washington, DC. Gift of the Mark Rothko Foundation, Inc. Photograph © Board of Trustees, National Gallery of Art, Washington, DC. © 2001 Estate of Kate Rothko Prizel and Christopher Rothko/Artists Rights Society (ARS), New York. Rothko's meditative juxtapositions of color were expressive rather than formal.

COMMERCIAL COLOR AND CULTURE

Andy Warhol

Andy Warhol (American, 1928–1987) is one of the most influential art figures of the twentieth century; his work is a commentary on cultural commodity. His art points out the way that Americans are targeted as a mass market for products, people, and ideas. Warhol's experience as a graphic artist informed all aspects of his paintings and prints. His color aesthetic was more indicative of commercial packaging color than being rooted within the tradition of painting. Warhol used silkscreen as a principal medium, which was primarily a commercial process at the time when he started his mature works in the 1960s. This printing process allowed him to produce his trademark photographic images that were underlaid with strong, often fluorescent colors in striking yet elegant combinations. Warhol's works were based on his principal idea that U.S. culture is glutted with information, and the public experiences many events only through the media of TV and print. When public is bombarded with images such as consumer goods, celebrities, and new events, these images lose impact and yet become iconic by their very repetition. These blank or consumer images are then appropriate to become cultural currency, a type of image sans emotion. The role of color in his work is twofold in his seemingly arbitrary combinations—for instance, in the face of a movie icon like Marilyn Monroe—both celebrating her emblematic power

while also flattening her face into a formal motif. His color style reflects contemporary art's movement away from the tradition of painting with artist's pigments toward a color aesthetic with a commercial, graphic look. [5.18]

LIGHT REFLECTED—MINIMALISM AND BEYOND

In the late 1960s and the 1970s, two U.S. art movements followed Abstract Expressionism and Pop Art, namely Minimalism and Op Art, see [4.28]. Both of these styles, which are also referred to as Post-painterly Abstraction, revisited earlier Modernist ideas of formal color and composition, but these styles refined the earlier Modernist ideas to bare essentials. The subjects for minimalism and op art were generally nonobjective, involved with pure, geometrically based shapes and lines. Post-painterly Abstractionism was primarily concerned with formal visual relationships rather than with emotional or symbolic content.

COLOR AND CONCEPT—YVES KLEIN

The artist Yves Klein (French, 1928–1962) was engaged in a wide range of painting, sculpture, and performative strategies, an important part of which was the actual physical engagement in development and the production of a new pigment. Klein made "monochrome" paintings in orange, pink, red and green, and from 1957 on, he worked mainly in blue. The pigment that he helped to develop, in collaboration with a chemist, was a variation of ultramarine blue that he dubbed *Klein Blue*. This color operated as a symbolic and conceptual core to his work that also became somewhat of a personal trademark, as shown in this work, *Blue Sponge*, relief, 1960. Klein's art demonstrates a new attitude toward the artist's engagement with his materials. [12.13]

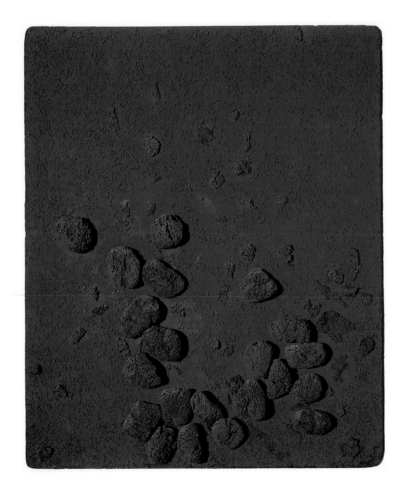

Figure 12–13 Yves Klein, *Blue Sponge-Relief,* mixed media. Wallraf-Richartz-Museum—Fondation Corboud, Cologne, Germany. © Artists Right Society (ARS), NY. Photo: Erich Lessing/Art Resource, NY. A monochrome relief piece painted with Klein blue, a pigment formulated by the artist.

Dan Flavin

Dan Flavin (1933–1996) was a sculptor associated with Minimalism, who worked with light itself, in one medium—commercial colored fluorescent light. Flavin's light sculptures interrelate to architectural contexts, for they are as much about reflected color and light as about the actual bars of fluorescent light. The light sculptures are installed in corners, staircases, or as freestanding units, casting a complex color glow on their surroundings. Flavin thought of his work, often dedicated to other artists or religious figures, as icons "of limited light." The ordinary commercial light of these sculptures contrasts with their central theme: light as a symbol of the divine. *Greens Crossing Greens* (1966), shown here, is dedicated to Piet Mondrian, whose antiorganic modernist philosophy instigated him to exclude green from his palette. [12.14] Flavin's sculptures construct space with light and color alone, independent of any traditional matrix.

COLOR IN INSTALLATION AND IMAGE

Sandy Skoglund

Sandy Skoglund (American, 1946–) is an installation artist unique in both media and subject matter. Her installations are constructed in human scale with real figures as parts of room-like environments. Photos of these installations are another facet of her art. Skoglund's

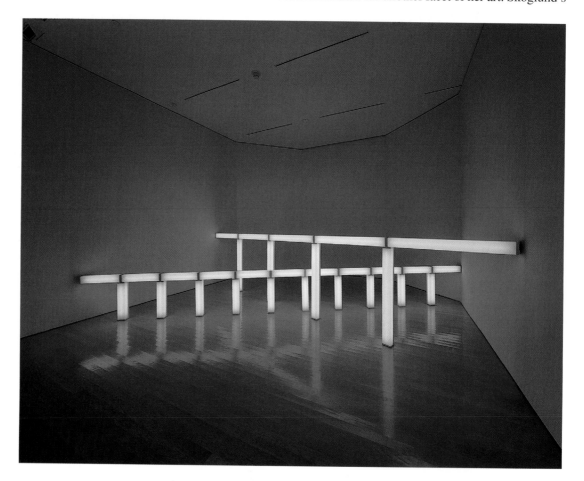

Figure 12–14 Dan Flavin (1933–1996, American), *greens crossing greens (to Piet Mondrian who lacked green)*, 1966, fluorescent light fixtures with green lamps. 2′ and 4′ fixtures 52 1/2″ × 230 1/2″ × 120″ (133.4 × 585.8 × 303.6 cm). Solomon R. Guggenheim Museum, New York. Panza Collection, 1991. 91.3705. Photograph by David Heald © The Solomon R. Guggenheim Foundation, New York. © 2002 Estate of Dan Flavin/Artists Rights Society (ARS), New York. Flavin made sculptures from illumination, the reflected light is as important as the piece itself.

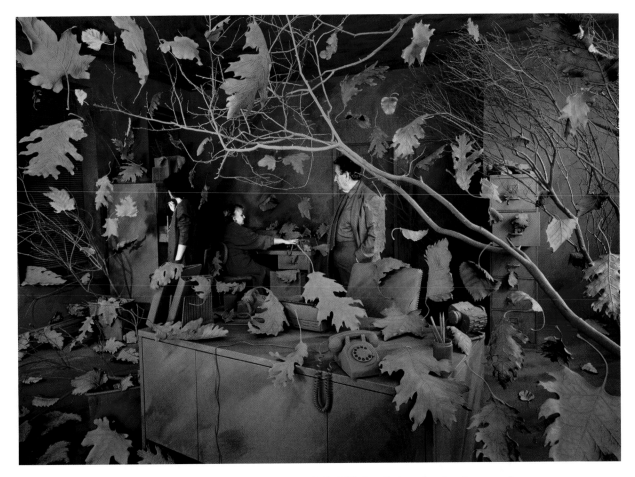

Figure 12–15 Sandy Skoglund, *A Breeze at Work,* 1987. Installation: plastalene leaves made from bronze molds, furniture, live models. Cibachrome photograph 40 × 60″. © Sandy Skoglund. Sandy Skoglund uses color in room-sized installations (also presented in large scale photographs) that shift our perceptions of reality.

installations are commentaries on suburban life, dreams, and religion, which have unexpected colors that communicate, contrast, and glow visually. These colors unify the considerable number of objects that occupy her spaces. The installations are balanced between fantasy and reality, often addressing serious political and human issues. The mystery of Skoglund's work is in the everyday settings that are radically transformed by two things, an unexpected event and color. In *A Breeze at Work,* this unexpected event is the presence of leaves blowing through an office environment. [12.15] The surreal or disconcerting twist of Skoglund's art is color being utilized for its own sake, in an artificial relationship with the reality of the spaces. In *A Breeze at Work* (1987), the office surfaces are painted with oranges and red-oranges, which make the dreamlike blue leaves to visually vibrate as they float through the orange space. A mundane day in the office thus has a strange infusion of nature, captured both in time and space.

PIGMENT AND RITUAL—ANISH KAPOOR

Anish Kapoor's works address metaphysical opposites, presence and absence, solid and intangible. In the 1980s, he made groups of sculptures with forms distilled from symbolic objects. *As if to Celebrate I Discovered a Mountain Blooming with Red Flowers* is an example of a work from this period. [12.16] This sculpture contains references to Hindu temples and rituals in Indian culture. The sculpture specifically refers to a myth of a Hindu goddess who was born from a fiery mountain made from the bodies of male gods. One of

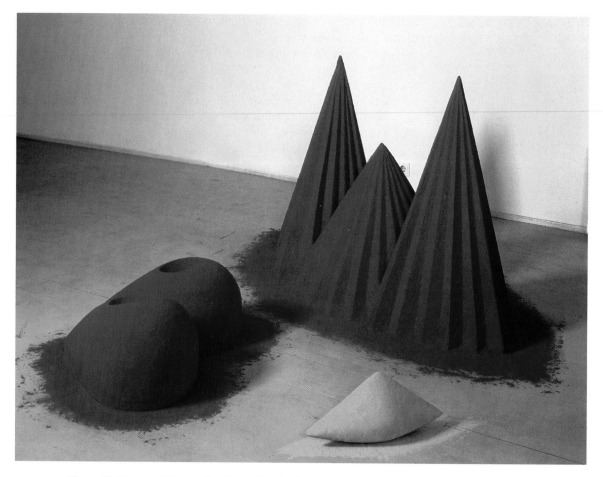

Figure 12–16 Anish Kapoor (British, 1954–), *As if to Celebrate, I saw a Mountain Covered in Red Flowers . . .* , 1981, sculpture with wood and various materials. Tate Museum: Modern, London, UK. Photo: Tate Gallery, London/Art Resource, NY. Reproduced by permission of the artist. This sculpture by Anish Kapoor is covered with pure pigment that has an untouched quality.

the principal formal and symbolic elements in this piece is the application of pure pow-dered pigment, which is flicked onto the surface of the sculpture in order to leave no trace of the hand. The powdered pigment gives the artist a rich, pure surface color that would be unattainable in another medium. Since it is fine powder, the appearance of the pigment imparts the piece with an ephemeral quality. This piece recalls rituals and the tradition of *arte povera* or "poor materials."

ART OF LIGHT—JAMES TURRELL

James Turrell (American, 1943–) is an acclaimed light and space artist who currently works in color and physical light. His work is founded on a lifelong fascination with the qualities of light, an offshoot of his Quaker upbringing when he was exhorted to as a child to: "Go inside and greet the light." He majored in mathematics and perceptual psychology in college and proceeded then to study art.

James Turrell's primary medium is light, real and artificial. His principal work is a large, lifelong monumental land art project in the Painted Desert, Arizona, entitled Roden Crater. Roden Crater is a site that Turrell owns and that he has constructed internally to form a series of architectural solar light pieces. Inside Roden Crater are spaces that have actual window-like openings, or apertures that capture the light or darkness at different times of day. Our perception of the interrelationship of the sky, light, and atmosphere and how they affect a created space is the central concept of Terrell's work. Turrell has said, "My work

is about space and the light that inhabits it. It is about how you confront that space and plumb it. It is about your seeing."

The work shown on the cover of this book is entitled *The Light Inside,* a light installation commissioned by the Museum of Fine Art, Houston, in a tunnel between two buildings. This piece prompts confusion in the viewer's perception of depth and triggers individual emotional responses to the experience of being surrounded by color.

Artists have been colorists throughout the span of all periods, media, styles, and locations in art history. Artists have embraced color as a central part of their emotional symbolic, formal, and structural language.

Glossary

ACHROMATIC Achromatic colors are neutrals, meaning that they contain no chroma or hue. An achromatic color scheme uses all achromatic or neutral colors; black and white, and a full value tonal range of grays.

ACTUAL COLOR TRANSPARENCY The perception of or use of transparent materials. When we perceive a transparent object the light is transmitted; that is, it is allowed to go through the object to create a color sensation.

ADDITIVE SYSTEM The system of color that uses light. When all the light primaries are combined, the result is white light.

ANALOGOUS COLORS Colors that are adjacent to each other on the color wheel, for example, blue, blue-violet, and violet. An analogous color scheme is based on the idea of a color family, using two or three neighboring hues from the color circle as a starting point.

ASYMMETRICAL BALANCE The balance of unequal art elements in an artwork; also called informal balance.

ATMOSPHERIC OR AERIAL PERSPECTIVE The differences we see between foreground, middle ground, and background objects in space that are caused by effects of atmosphere.

BALANCE A design principle that addresses the equal distribution of visual weight in any given piece of art.

BASE HUE A hue from the color circle to which a color is related. The concept of a base hue means that the thousands of colors that we perceive can be traced back to the twelve hues on the traditional color wheel.

BEZOLD EFFECT The effect of changing the dominant color in a given design and the subsequent varying of all the other colors.

BITMAP Images that use pixels to create areas of color on the computer screen; sometimes they are called raster images.

CHROMATIC NEUTRALS Subtractive intermixtures of complementary hues that create neutral colors based on chromatic, rather than achromatic, colors.

CIE The Commission International D'Eclairage introduced a standard color table in 1931 based on the additive primaries of red, green and blue. It uses a mathematical formula to create its color areas, providing an objective perceptual color model. A more recent incarnation of the CIE system (1976) is called CIE L*A*B* color.

COLOR A color is specifically a wavelength of light received by our eye that causes a color sensation to be produced in our brain. The word color also means any color derived from

any hue; for example, violet is a hue and light violet is a color. A color is not necessarily chromatically pure and a hue is.

COLORANT A compound that imparts its color to another material.

COLOR ATMOSPHERE A color effect produced by the suggestion of luminous colors seen in the atmosphere at varying times of day. Also defined as color transparencies, or colors reflected from brightly lit surfaces.

COLOR ATTRIBUTES The variables or characteristics of color, which are hue, value, and saturation.

COLOR CHORD A group of hues chosen from the color circle that are spaced apart, such as red, yellow, and blue. The music chord–color chord analogy refers to the spacing of three or four color "notes" to produce harmony.

COLOR CONTRAST The manners in which colors may contrast are by value (light/ dark), hue, temperature (cool/warm), complementary, and saturation (muted/ brilliant).

COLOR DISCORD Discordant colors are color combinations that contrast, clash, or "fight" rather than harmonize. Color discord can make the viewer uncomfortable, but it can be used to enhance the thematic content in a piece of art.

COLOR DOMINANCE A dominant color effect can be achieved by letting a single hue, value, or saturation dominate a composition. This influences all the other colors in the composition.

COLOR ENVIRONMENT Color choices that reflect and enhance the function and mood of an interior or architectural space.

COLOR EXPRESSION Color can function as the most expressive tool in art. Expressive color is a subjective, personal, cultural, or symbolic use of color in art or design.

COLOR INTERACTION A color illusion that occurs in our perception of color due to the interconnected relationships of colors. Also called relative color.

COLORFASTNESS Defined as the resistance of a color to the loss of its original color quality. High colorfastness means that a color will not darken, fade, bleed, or washout.

COLOR KEYS The notes on a piano keyboard are analogous to the concept of color keys. Two types of color keys are value keys, which are levels or light (high) to dark (low) colors, and saturation keys, which are levels of pure to muted colors.

COLOR PHYSICS The science of color, particularly the science of light and color perception. Color is defined as a visual sensation caused by the components of light either transmitted or reflected to the receptors in our eye.

COLOR PROPORTION Johann Goethe conceived of a system of color proportion in which a simple ratio system is used for balancing areas of pure hues in a composition.

COLOR SCHEMES OR HARMONIES Color circle–based formal hue selections used to achieve color harmony.

COLOR SYMBOLS Color associations that stand for ideas and/or are culturally based, for example, red for sexuality and black for death.

COLOR TEMPERATURE Refers to our sense of warm or cool colors. For example, red is warm in temperature because it refers to blood, fire, and the sun; blue is cold in temperature because of its reference to water, ice, and the sky. Each primary and secondary hue also has a cool or warm aspect; for example, red is cooled when blue is added, creating red-violet.

COLOR WEIGHT The visual weight of colors is relative to their interactive color environment. Some colors are innately heavy or inherently light in weight. For example, yellow is light and black is heavy.

COLOR CIRCLE OR COLOR WHEEL Newton is commonly credited with the origin of the color circle or wheel format. By adding purple to the spectral band, Newton attached the spectrum to itself in a circle. The color circle provides a format to understand hue relationships.

COMPLEMENTARY COLORS Chromatic opposites directly across from each other on the color circle. These are called complementary hues or dyads, since they are in pairs. The major subtractive complementary opposites are blue to orange, yellow to violet, and red to green. A complementary color scheme is a perfectly balanced opposing pair (or dyad) from the color circle.

COMPLEMENTARY VIBRATION Complementary vibration occurs when two full saturation complementary hues are in close proximity. When these conditions exist, the colors will generate the illusion of movement.

COMPUTER COLOR Color generated by a computer in digital format. It also refers to display color on a computer monitor and the various color modes contained within a graphic program. A computer can produce 16 million colors from which to choose.

CONTENT Content in art can be subject matter (what a work depicts), iconography (the symbols present in a work), and theme (the ideas behind the work of art).

COOL/WARM COLOR HARMONY A four-hue color scheme that is less structured than most. Cool/warm contrast emphasizes differences in color temperature. Example: RO and red opposite BG and blue.

CONTINUATION OR CONTINUITY A visual pathway through a composition.

CRYSTALLOGRAPHIC BALANCE A pattern or subdivision of the picture plane, such as a grid, used to achieve balance.

DESIGN ELEMENTS The visual tools used to create both two-dimensional and three-dimensional art and design. The design elements are line, shape, space, form, value, scale, texture, and color.

DESIGN PRINCIPLES Theoretical guidelines for the compositional placement of art/design elements.

DOUBLE COMPLEMENTARY A four-hue contrasting color scheme. This scheme uses two adjacent complementary pairs, for example, yellow, YO, violet, and BV.

DYES Soluble colorants. Dyes transfer their color by being dissolved in liquid and staining or absorbing into a given material or surface.

ECONOMY The use of a minimal amount of visual information in art or design.

ELECTROMAGNETIC SPECTRUM Energy waves produced by the oscillation of an electrical charge. Electromagnetic waves do not need any material for transmission, that is, they can be transmitted in a vacuum. Light is part of this spectrum.

EMPHASIS A design principle that establishes a particular place of interest in an artwork. Emphasis is synonymous with a point of focus or focal point in art.

FORM Referring to the purely visual characteristics of art.

FORM OR VOLUME A shape that is realized in three dimensions is called a form or a volume.

GESTALT The perception of a configuration, pattern, structure, or wholeness. The word *Gestalt* can be roughly translated from the German as *configuration*.

GRADATION Anything that changes gradually in a visual sense. Scale, shape, color, position, texture, value, and color all can be gradated.

HSB OR HSV A computer color mode. The H stands for hue, the S for saturation, and the B or V for value or brightness. All three color attributes can be manipulated to produce a huge variety of colors.

HUE Hue means any wavelength from the visible spectrum. A hue is a specific color selection from the spectral color circle in its pure state, sometimes referred to as a spectral hue. Hues may be a primary, secondary, or tertiary color.

INHERENT VALUE The light/dark value of a pure hue at its maximum saturation.

INFORMAL COLOR HARMONIES Harmonies with flexible rules, created by an artist.

LINE A pathway, the closest distance between two points, a moving point. A line is a mark with length greater than its width.

LINEAR PERSPECTIVE Lines and vanishing points used to depict the diminishing sizes and recession of objects as they seem to move further away in the picture plane.

LOCAL COLOR The general color of an object under normal lighting conditions.

MEDIAL PRIMARY COLORS Red, green, blue, and yellow—a combined group of both the subtractive and additive primaries also called the psychological primaries.

MONOCHROMATIC A color scheme based on one hue choice from the color wheel.

MOVEMENT Both the literal and the suggested motion in a work of art.

OPAQUE Refers to media through which light cannot pass. Opaque paint is also called body color because it uses white as part of the paint mixture and completely covers the surface onto which it is painted.

OPTICAL MIXTURES Colors that use tiny amounts of two or more colors that visually blend to create another color. An optical mixture can mix either pigmented materials or light.

PHYSICAL COLOR MATERIALS Those materials that are used directly, such as paints, colored drawing materials, and textile dyes.

PICTURE PLANE A given entity of art and design, the rectangle or square that is used to contain the composition.

PIGMENT A colored powder that gives its color effect to a given surface, when distributed over that surface in a layer or when mixed with a substance.

PIXEL A square unit that subdivides the computer screen is the words picture and element combined, thus a pixel is a picture element.

PLANE A shape that has height and width, but no breadth or depth. It is two-dimensional and flat but can have any type of outer contour.

POINT Either a dot or a location in space. A point can be visible or invisible and be of any size, but refers to a particular location or place in a composition.

PRIMARY COLORS Hues that are not obtainable by any other color mixtures.

PROCESS COLORS The four colors used for commercial printing and color photography: cyan, magenta, yellow, and black, also abbreviated as CMYK. Cyan, magenta, and yellow are close to the traditional subtractive primary hues of red, yellow, and blue. The CMYK color mode on computer is meant to match with process printing colors.

PROCESS MATERIALS Those materials that are used indirectly through printing, photography, and computer graphics.

PROXIMITY Referring to the Gestalt concept of the physical grouping of objects.

RADIAL BALANCE This form of balance employs radiating or emanating forms from a given area or object.

REPETITION To repeat any art element or concept in order to unify a design.

RGB Red, green, and blue are the additive primaries of light. RGB also is a color mode used by both the computer monitor and scanner.

RHYTHM A design principle that encompasses the visual quality of movement, describing the manner in which our eye moves through an artwork.

SATURATION The property of color that refers to its purity, intensity, or chroma. High saturation key colors are pure, bright, and intense. Low saturation key colors are duller, subtle, and muted.

SCALE Refers to the relative size of objects in an artwork.

SECONDARY HUES The halfway points between the primary hues, for example, a mixture of red with blue will yield violet (red + blue = violet). Violet is a secondary hue.

SHADE A hue plus black which makes a darker value of a hue.

SHAPE A two-dimensional closed form or plane. A shape can have any contour, height, and width, but no depth. A shape has mass or area defined by its edges.

SIMILARITY According to Gestalt theory, when we perceive similarity in a design, our eye picks up the pattern or configuration of the similar elements.

SIMULTANEOUS CONTRAST Refers to colors that interact and affect each other, which can give them a different or varied appearance. Also refers to when the eye simultaneously "wants" to see the complement of any given hue, affecting our perception of color in relationships.

SIMULATED TRANSPARENCY A color illusion, in which opaque media is used to create an illusion of transparency.

SPACE Actual physical space has three dimensions, height, width, and depth. Three-dimensional space can also be depicted on a two-dimensional format by spatial illusionary devices such as overlapping, diminishing size, vertical location, form and modeling, linear perspective, and atmospheric perspective.

SPLIT COMPLEMENTARY HARMONY A contrasting or a balanced harmony. A split complementary scheme has three hues and is based on an opposing dyad. Instead of using a direct complement, however, the two adjacent hues to the actual complement are chosen. Example: The split complement of violet is YO and YG.

SUBTRACTIVE SYSTEM In our perception of surface color some light waves are subtracted resulting in a reduction of the amount of light reflected to our eye. The subtractive color system is also in use with physical colors such as pigments and dyes, which lose intensity as they are mixed.

SUCCESSIVE CONTRAST A spontaneous color image produced in direct succession to the eye's overexposure to a single full saturation color. Also called *afterimage.*

SYMMETRY Formal balance, which is perfect balance vertically, horizontally, or diagonally along an axis. In a symmetrical composition, the elements of the composition are perfectly equal.

SYSTEMS OF COLOR NOTATION Color theorists have developed various systems of notation for the three color attributes of hue, value, and saturation.

TERTIARY HUES Those hues produced by the mixtures of a primary and a secondary: RO, RV, YO, YG, BG, BV.

TETRAD A four-hue color system that is balanced based on either a square or rectangle inscribed in the color wheel.

TEXTURE The characteristic surface quality of an object. Texture is related to our tactile sense, but we also experience texture visually.

TINT A hue or color plus white, which makes lighter values of a color or a hue.

TRANSPARENT MEDIA Media that light can pass through to the support below. Watercolor, oil glazes, markers, dyes, and some inks are transparent.

TRIAD An equilateral triangle inscribed in the color circle describes three equidistant hues that compose a triadic color system. The triadic system is a classically balanced color scheme and is used by many artists and designers. Example: orange, green, and violet.

UNITY A design principle that addresses the way the parts of a composition visually hold together. Unity is also referred to as harmony.

VALUE Value simply refers to all the perceptible levels of light and dark from white to black and the lightness or darkness of achromatic or chromatic colors.

VARIETY The variation of any art element or art concept in a repetitious visual structure.

VECTOR Computer graphic programs based on line drawing. Defined by math objects called vectors. Vector programs use mathematical locations or points to form lines and shapes.

VEHICLE OR BINDER Pigment is mixed with a vehicle or binder to become paint. A vehicle or binder must support and bind pigment particles as a well as easing the application of a pigment to a surface.

VISIBLE LIGHT SPECTRUM A small part of the electromagnetic spectrum that we can actually see.

VOLUME A plane that has been pushed back or comes forward into space. It has three dimensions: height, width, and depth.

WAVELENGTHS OF LIGHT Each hue in the visible spectrum has a corresponding wavelength measured in nanometers, which are only one billionth of a meter. Hue differences are tiny measurement differences between the crests of each wavelength. Red has the longest wavelength and violet the shortest.

Bibliography

ALBERS, JOSEF. *Interaction of Color,* rev. ed. Yale University Press, New Haven, CT. 1971.

ARHEIM, RUDOLF. *Art and Visual Perception.* University of California Press, Berkeley. 1971.

BATCHELOR, DAVID. *Chromophobia.* Reaktion Books Ltd., London, UK. 2000.

BANN, DAVID AND GARGAN, JOHN. *How to Check and Correct Color Proofs.* Quarto Publishing, London. 1990.

BALL, PHILIP. *Bright Earth—Art and the Invention of Color.* Farrar Straus and Giroux, New York. 2001.

BIRREN, FABER. *Color, Form and Space.* Reinhold Publishing Corp, New York. 1961.

BIRREN, FABER. *Creative Color.* Van Nostrand Reinhold, New York. 1961.

BIRREN, FABER. *Color Perception in Art.* Van Nostrand, New York. 1976.

BIRREN, FABER. *Principles of Color.* Van Nostrand, New York. 1969.

BUSER, THOMAS. *Experiencing Art Around Us.* West Publishing, New York. 1995.

CHEVREUL, M. E. *The Principles of Harmony and Contrast of Colors.* Van Nostrand Reinhold, New York. 1981.

COHEN, SANDEE AND WILLIAMS, ROBIN. *The Non Designers Scan and Print Book.* Peachpit Press, Berkeley, CA. 1999.

COLE, ALISON. *Eyewitness Art Color.* Dorling Kindersley, London and New York. 1993.

CURRENT, IRA. *Photographic Color Printing.* Focal Press, Boston. 1987.

ELLINGER, RICHARD. *Color Structure and Design.* Van Nostrand Reinhold, New York. 1963, 1980.

ESSERS, VOLKMAR. *Matisse, Master of Color.* Barnes and Noble Books, New York. 1996.

FEISNER, EDITH ANDERSON. *Color Studies.* Fairchild Publications, New York. 2001.

FABRI, RALPH. *Color.* Watson Guptill, New York. 1967

GAGE, JOHN. *Color and Culture.* Bullfinch Press, Little, Brown and Co, London. 1993.

GAGE, JOHN. *Color and Meaning.* University of California Press, Berkeley and Los Angeles. 1999

GARDINER, HELEN. Revised by Horst de al Croix and Richard G. Tansy. *Art Through the Ages,* 6th ed. Harcourt Brace, NY. 1970.

GASSAN, ARNOLD. *The Color Print Book.* Light Impressions Corp. Rochester, NY. 1981.

GERRITSON, FRANS. *Evolution in Color.* Schiffer Publishing, Westchester, PA. 1988.

GLENDINNING, PETER. *History, Theory and Darkroom Technique.* Prentice-Hall, Englewood Cliffs, NJ. 1985.

GOLDSTEIN, NATHAN. *Design and Composition.* Prentice Hall, Englewood Cliffs, NJ. 1989.

GUPTILL, ARTHUR. *Color Manual for Artists.* Van Nostrand Reinhold, New York. 1962.

HOPE, AUGUSTINE AND WALCH, MARGARET. *The Color Compendium.* Van Nostrand Reinhold, New York. 1990.

ITTEN, JOHANNES. *The Art of Color.* Van Nostrand Reinhold, New York. 1973.

ITTEN, JOHANNES. *The Elements of Color.* Van Nostrand Reinhold, New York. 1970.

KANDINSKY, WASSILY. *Point and Line to Plane.* Dover Publications, New York. 1979.

KIERAN, MICHAEL. *Desktop Publishing in Color.* Bantam Books, New York. 1991.

KNUEPPERS, HARALD. *The Basic Law of Color Theory.* Barrons, New York. 1982.

KUEHNI, ROLF. *Color, Essence and Logic.* Van Nostrand Reinhold, New York. 1983.

KUWITCH, JOHN AND EAKIN, GARRET. *Interior Architecture.* Van Nostrand Reinhold, New York. 1993.

LADAU, ROBERT, PLACE, JENNIFER, AND SMITH, BRENT. *Color in Interior Design and Architecture.* Van Nostrand Reinhold, New York. 1989.

LAING, JOHN AND SAUNDERS-DAVIES, RHIANNON. *Graphic Tools and Techniques.* North Light America, Cincinnati, OH. 1986.

LAMBERT, PATRICIA. *Controlling Color.* Design Press, New York. 1991.

LAUER, DAVID A. AND PENTAK, STEPHEN. *Design Basics,* 5th ed. Harcourt Brace, New York. 2000.

LECLAIR, CHARLES. *Color in Contemporary Painting.* Watson-Guptill, New York. 1991.

LELAND, NITA. *Exploring Color.* North Light Books, Cincinnati, OH. 1985.

MAHKE, FRANK. *Color, Environment and Human Response.* Van Nostrand Reinhold, New York. 1996.

MARTINEZ, BENJAMIN AND BLOCK, JACQUELINE. *Visual Forces,* 2nd ed. Prentice Hall, Englewood Cliff, NJ. 1995.

MARX, ELLEN. *Optical Color and Simultaneity.* Van Nostrand Reinhold, New York. 1983.

MAYER, RALPH. *The Artist's Handbook of Materials and Techniques,* 3rd ed. Viking Press, New York. 1978.

NORMAN, RICHARD. *Electronic Color.* Van Nostrand Reinhold, New York. 1990.

OCVICK, OTTO G., STINSON, ROBERT E., WIGG, PHILIP R., BONE, ROBERT O., AND CAYTON, DAVID L. *Art Fundamentals, Theory and Practice.* McGraw Hill, Boston. 1998.

OSBURN, ROY. *Lights and Pigments—Color Principles for Artists.* Harper & Row, New York. 1980.

PARRAMON, JOSE. *The Book of Color.* Watson-Guptill, New York. 1993.

POLING, CLARK. *Kandinsky's Teaching at the Bauhaus: Color Theory and Analytical Drawing.* Rizzoli International Publishing, New York. 1986.

PYLE, DAVID. *Prints and Colors.* Krause Publications, Iola, W.I. 2000.

SARGENT, WALTER. *The Enjoyment and Use of Color.* Dover Publications, New York. 1964.

SIDELINER, STEPHEN. *Color Manual.* Prentice Hall, Englewood Cliff, NJ. 1985.

SIMON, HILDA. *Color in Reproduction.* Viking Press, New York. 1980.

STOKSTAD, MARILYN. *Art History,* rev. ed. Prentice Hall, Upper Saddle River, NJ. 1999.

SWIRNOFF, LOIS. *Dimensional Color,* 2nd ed. W. W. Norton and Co., New York. 2003.

VERITY, ENID. *Color Observed.* Van Nostrand Reinhold, New York. 1980.

WONG, WUCIOUS. *Principles of Color Design.* John Wiley and Sons, New York. 1997.

ZELANSKI, PAUL. *Color,* 3rd ed. Prentice Hall, Upper Saddle River, NJ. 1999.

ZELANSKI, PAUL. *Design Principles and Problems,* 2nd ed. Harcourt Brace, New York. 1996.

INTERNET SOURCES

www.colorsystem.com

www.handprint.com

www.enabling.org

www.humboldt.edu

www.nga.gov

www.smithsonianmag.org

www.webexhibits.org

Index

Abstract expressionism, 223, *224*
Achromatic color harmony, 157, *157*
Achromatic colors, 26–27, *27*
Acrylics, *87,* 87–88
Actual line, 122
Actual space, 127
Actual textures, 132
Actual transparency, 71–72
Additive color circle, 23
Additive color media, 8–9
Additive color system, 1, 4–5, *5*
 complementary hues, *12,* 13
 relationship to subtractive color, 12, *13*
Afterimage, 31, *55,* 56–58
Aguilonius, Franciscus, 19
Albers, Josef, 58, *58*
 color interaction studies, 63–65, *64, 65*
Alberti, Leone Battista, 18
Analogous color harmony, 158, *159*
Anomaly, 144, *144*
Anuszkiewicz, Richard, 69, *70*
Apollinaire, 57
Aristotle, color theory of, 17–18, *18*
Asymmetrical balance, 147, *148*

Babbit, Edwin, 193
Background, 128
Bacon, Francis, 19
Balance, 145–149, *148*
 asymmetrical, 147, *148*
 crystallographic, 147, *149*
 radial, 147, *149*
 symmetry, 146, *147*
Baroque period, *184, 214,* 214–215
Baskt, Leon, 204, *204*
Bauhaus School, 58, 199
Bayer array, 92
Bezold, Wilhelm von, 69–71
Bezold effect, 69–71, *71*
Binders, *80,* 80–81, *82*
Bit depth, 100
Bitmap programs, 101
Blake, William, *203,* 203–204

Bocour, Leonard, 87
Body color, 82
Bonnard, Pierre, 222, *223*
Braque, Georges, *220,* 220–221
Byzantine mosaics, 211, *212*

Caravaggio, *184, 214,* 214–215
Cézanne, Paul, 161, *162,* 218
Chevereul, Michel Eugene, 54–55
Chiaoscuro, 214
Chroma, 44
Chromatic aspect of color, 24
Chromatic neutrals, 48
Circle, 123, *124*
CMY (cyan-magenta-yellow) color system, 6, *6*
 subtractive primaries, *10,* 10–12, *11*
CMYK (cyan-magenta-yellow-black) color system, 37, 96, *110,* 110–111, *111*
Collective unconscious, 192
Color. *See also* Design; Design elements; Design principles
 aspects of, 1–2
 attributes, 36–49 (*See also* specific attributes)
 basic concepts, 1–2
 defined, 1
 physics, 2–4
 styles for employing, 211–229
Colorant, 78
Color atmosphere, 186
Color balance, 179–181
 asymmetrical, *177,* 180–181, *181*
 color and symmetry, 181, *182*
 radial, 181, *182*
 relative weight of colors, 179–180, *180*
Color blindness, 7
Color chords, 32
Color circles, 23–26
 achromatics and, 26–27
 additive, *3, 6*
 analogous harmony and, 30, *31*

cool/warm contrasts, *29,* 29–30, *30*
 of Goethe, 21, *21*
 of Harris, 20, *20*
 of Hering, 22, *22*
 hue relationships on, 28–32
 of Ives, process color, 21
 of Newton, *3,* 19, *19*
 of Ostwald, 22, *22*
 process, 10–11, *11*
 of Rood, 21
 secondary hues of traditional, 24
 tertiary hues of traditional, 25–26
 traditional, *11,* 23, *24*
Color control bars (SWOP), 97
Color discord, 197–198, *198*
Color dominance, 71, *72*
Color emphasis, 175–179
 contrast and, 175–178, *178*
 gradation and, *177,* 179
 unique color and, 179, *179*
Color expression, 199, *200, 218,* 218–219
Color families, 30, 158
Color gamut, 100
Color harmonies, 30, 156–168
 achromatic, 157, *157*
 analogous, 158, *159*
 complementary/dyad, 159, *160*
 cool/warm, 160–161, *161, 162*
 discord *vs.,* 197–198, *198*
 double complement, 161, *162*
 informal, 166–168, *167, 168*
 keyed, 166, *167*
 monochromatic, 157, *157, 158*
 split complement, 161–163, *163*
 tetrad, 165, *166*
 triadic, 163, *164, 165*
Color interaction, 54–73
 Albers and, 63–65, *64, 65*
 Bezold effect, 69–71, *71*
 broken color, 67
 color dominance, 71, *72*
 color transparency, 71–73, *73*